"*Face Of Hope* is gripping, emotional and cathartic—the story of one woman's call to a deeper faith than most of us can imagine. Uncompromising and honest, it inspires us to trust, so that, as Carol says, we can learn more in the darkness than we can in the light."

—Helen Hunt, Oscar-winning actress,
film producer/director

"*Face Of Hope,* is a true winner…you will win in your journey of life as you discover God's Great, Amazing Grace!"

—Ken Wales: filmmaker/producer

"When Carol came to this country in search of healing, she embarked on a journey not only to repair the physical devastation that had been done to her, but more importantly, to share the healing power of her indomitable spirit. *Face of Hope* documents that journey and allows us to stand in amazement, to recognize the capacity for resilience in each of us, and to be healed."

—Mim Eichler Rivas author

"This book is proof of the power of faith to strengthen us."

—Della Reese Lett Actress/singer

Carol Elliott

FACE

of

HOPE

Carol Guscott

FACE

of

HOPE

The Carol Guscott Story

TATE PUBLISHING & *Enterprises*

Published by Tate Publishing & Enterprises, LLC
127 E. Trade Center Terrace | Mustang, Oklahoma 73064 USA
1.888.361.9473 | www.tatepublishing.com

Tate Publishing is committed to excellence in the publishing industry. The company reflects the philosophy established by the founders, based on Psalm 68:11,
"The Lord gave the word and great was the company of those who published it."

Book design copyright © 2011 by Tate Publishing, LLC. All rights reserved.
Cover design by Blake Brasor
Interior design by Christina Hicks

Published in the United States of America

ISBN: 978-1-61777-466-9
1. Biography & Autobiography / Personal Memoirs
2. Religion / Christian Life / Inspirational
11.04.26

He saw the city and wept over it, saying, "If you had known, even you, especially in this your day, the things that make for your peace! But now they are hidden from your eyes. For days will come upon you when your enemies will build an embankment around you, surround you and close you in on every side, and level you, and your children within you, to the ground; and they will not leave in you one stone upon another, because you did not know the time of your visitation."

<div align="right">Luke 19:41–44</div>

TABLE OF CONTENTS

FOREWORD

I had been working as a volunteer at the small homeless ministry at our church every Tuesday for five or six years giving out food, clothing, and other resources to two or three families most days. I casually mentioned to the volunteer director that it was an excellent ministry that helped a lot of people, and I could see myself giving more time to it in the future when he could not continue.

Within two years we expanded operation from three to five days a week, added volunteers, and became listed on the Internet, helping ten to twelve families a day. Sometimes it was difficult to leave the courthouse where I had worked as a superior court judge for nineteen years in time to open the ministry, but it somehow always worked out.

When I found on the desk in the office one day a copy of the letter he had sent to the church, I was shocked, to say the least. He had resigned, naming me as the new director of the Good Samaritan Center. I had meant I'd help more when I retired. That would not be for at least five years. I knew I would not be able to coordinate and direct fifteen volunteers five days a week, arrange food collection, resource management, etc., without losing my job or my family. I told our pastor the story and agreed to do the best I could until he could recruit someone or a team, because I couldn't stand the idea of closing it down and abandoning our truly needy clients in the community.

By this time I had heard our author, Carol Guscott, tell her story in church at Sunday services, and I had introduced myself to her afterward. Her story was interesting, inspiring, heartbreaking, and articulate. She was not regularly attending church because she didn't often find someone to give her a ride. I offered to take her as she also lived in Fullerton, and I began taking her every Sunday. She sits with my wife and me; then, I take her home or to an adult fellowship. We became friends, and she did other things with us—special events, dinners, and such. We had plenty of time to talk about things of all sorts, including her life and her faith in God. She rarely missed church, except when she would have again another of her many surgeries to restore her eyesight. I learned so many things from her and began to see life from her perspective of pain and disability and disappointment. I marveled at her positive attitude, her inner strength, and her laughter in adversity.

One Sunday morning, for example, after one of the best of her several cornea transplants, I picked her up for church. She had some cloudy eyesight for the first time in years. She proudly but carefully walked out her gate to my car before I could go in as usual to escort her out. She took a long "look" at me and casually remarked, "I thought you were taller than that!" Then her infectious laughter exploded. "I didn't know your car was red!"

After a year of serving as director of the homeless ministry five days a week after work, no one, of course, had been found to take the job, so I kept on showing up in faith. Now, four years later, we serve thirty or forty families a day with our forty volunteers, and I can't remember why I thought I would not be able to do it. I also can't imagine not doing it. Carol taught me to show up for life and see what God does with it. Her book offers a unique look at disability, victimization, and disappointment in life. Her perseverance and faith are contagious, as is her insight on forgiveness. This is a must read that will reward the reader with new insights about life and change your thinking about the challenges in your life.

Judge Richard Stanford was a deputy district attorney for twelve years prosecuting violent, drug, and sex crimes and career criminals. In 1985 he was appointed as a judge by Governor George Deukmejian where he still serves after twenty-five years. He lives in Fullerton with his wife of forty-one years, Melodie, and has two children and three grandchildren.

INTRODUCTION

Like many people, I've had a hard life. Though my experiences are unique to me, as yours are to you, we've all had struggles. Our trials shape us and mold us into who we are today, for good or for bad.

In this book, I'd like to share some of the difficulties I've been through. You might relate to many of them on some level; other experiences may shock or even disturb you.

As a result of things done to me, I am blind and disfigured. I am unable to earn a living and have to depend on others to help me. I sense strangers turning away from me in horror. Yet God has strengthened me and taken care of me. I know He loves me and that I'm valuable, regardless of my circumstances.

The men who hurt me in July of 1994 have not been brought to justice, but the only way I can move on with life is if I forgive them. I'm determined to defeat the evil inflicted on me through the power of God's love.

I still don't know why God allowed this tragedy to happen to me, but I believe He has a bigger dream for my life than I do.

I challenge myself daily to live the best way I can with what I have left. I have set my sights on continually becoming a better person. I have no control over my afflictions, but I can control my heart and my actions.

To paraphrase 2 Corinthians 4:8-10, I have been "hard-pressed on every side, yet not crushed...perplexed, but not in despair;

persecuted, but not forsaken; struck down, but not destroyed." I carry in my body "the dying of the Lord Jesus, that the life of Jesus also may be manifested" in my body and so that "the excellence of the power may be of God" and not of me.

My hope and prayer is that as you read my story, you will see God's hand and His purpose even in the midst of horrific, violent, soul-crushing life events. If you can see God at work in the course of my life, maybe you'll be able to see Him in the depths of yours as well.

THE FIERY HELL

I stared at the piled lengths of rotted wood scattered about my Jamaican lumberyard, many with holes large enough for me to stick my head through.

"I can't buy this," I told the middle-aged woman standing by the Dodge truck.

"You already did." She waved my $10,000 check in my face.

The woman had asked for a cash advance so she could pay her hungry workers. Once they were properly fed, she promised they'd have the strength to unload the wood and help me with the measuring and stocking. The men on top of the big truck had handed down several nice pieces, and I agreed to the purchase. When I returned to check on their progress, I found them unloading termite-infested trash.

I held out my hand to her. "Give me my money, and load this back up."

The workers surrounded me, eyes seething with anger and hatred. "You let us unload a whole truckload of lumber," one said, "and now you're refusing to purchase it?"

I swallowed my fear and replied in my no-nonsense business voice, "I provide high-quality material to craftsmen so they can build furniture. A few of these pieces might work for cabinetry, but most of it isn't good enough to make a shack."

Snarls and grumbles surrounded me. The men called me terrible names, cursed me, and even threatened to hurt me, but I stood my ground.

The lady slung her big red purse over her shoulder. "Okay," she shouted above the men's jeers, "take up the lumber, and let's get out of here."

For several long moments, none of the men moved. Finally they shuffled about the yard, their eyes piercing me with sideways glares. They picked up one piece at a time, dragging their feet to the truck, where they piled the lumber back in.

One tall man, who seemed to be the foreman, strode up to me. He sneered at me, his fists clenched. "We'll be back to take care of you," he whispered. Then he climbed into the truck with the woman.

The other men clambered onto the lumber truck. The engines roared to life. The workers shouted more obscenities and threats as they left.

My heart swelled with fear and anger.

When I got home that night, I told my brother Dennis about the incident. Being a police officer, I figured he would know what to do.

He told me to forget about the whole thing. "Let it go. Walk away from it. Holding on to a grievance will only extend your pain."

All weekend I tried to follow his advice, but my mind kept wandering back to the ugly confrontation.

On Monday morning I went to work as usual. I entered through the big lumberyard gate and walked to my office. My sole employee—a strong, rough-looking ape of a man with a black beard, hard eyes, and hands as big as the circumference of my leg—had not yet come in. Not too surprising. He had a habit of partying too much on the weekends and not making it to work on Mondays.

Without his protective presence, I tried to push my negative thoughts aside, but the ominous feelings lingered.

Hoping to find peace and calm for my soul, I busied myself with rearranging lumber, but I shuddered whenever a car, truck, or person passed by. The hot July sun blazed down on me as I worked.

I decided to go inside my office to pay some bills. Once there, I kicked off my shoes and sat behind my desk.

I stared at the bags of sand and cement I'd just purchased to start construction on a floor safe in which to keep cash until I could take it to the bank. A machete leaned against the wall beside my office door. I'd programmed my telephone with a one-touch speed dial to the police station.

I had done everything I could think of to protect myself, yet I could not stop my sense of uneasiness.

My best sales often occurred in the late afternoon, when carpenters ended their workdays. So I stayed late into the evening, hoping one or two would come by to purchase lumber. None did.

At the end of the business day, I closed the accounting books. As I put them into a file-cabinet drawer, a slap on the pay window grabbed my attention. I looked through the glass and saw a short young man with fuzzy, twisted hair. He looked like a Rastafarian. His blood-red eyes matched his tank top.

"I have some lumber to sell," he said.

A sense of dread radiated up my spine. "What kind of lumber?"

His eyes darted around the store, taking everything in. He looked like a lion preparing to attack. My body trembled.

His gaze shifted past my head. I turned to look behind me. At the back corner of the building stood a tall man—the one I'd seen on Friday who threatened to come back and take care of me. He nodded to the Rastafarian at the window.

The tall foreman behind me moved toward the front door. I saw a large knife in his fist.

I decided to engage the young Rastafarian in conversation, hoping to distract him. "Did you say you had lumber to sell?"

He smiled an ugly grimace and shook his head.

I inched closer to the entrance, my eyes firmly fixed on the enemy most visible to me. Then I bolted for the door, hoping to

either signal a passing vehicle or catch a curious pedestrian's eye. But both men rushed forward, blocking my exit.

"Get back inside!" Rough, clammy palms pushed me back into the office. The door slammed shut. The foreman pressed his cold knife blade against my throat.

My heart pounded. I had to get away from these men, but I froze, helpless.

Images of my family flashed through my mind. My parents, who'd sacrificed so much to help me succeed in life. My nine-year-old son, Dale, whom I'd always dreamed would soar higher than I did. Would I ever see them again?

Screaming for help would do no good. Thick walls surrounded the building, and the noisy traffic outside would block out any cries.

I prayed for a customer to come in, but no one did.

My assailants forced me into a recliner. They tied my hands behind my back and my feet to the legs of the chair. They stuffed a filthy cloth into my mouth. I gagged from the stench and tried to suppress my breathing.

While the tall foreman held his knife to my throat, the Rastafarian rifled through my desk drawers, taking whatever items he thought valuable and stuffing them into a backpack. He went through my pockets and took all the bills, then removed my ring and wristwatch.

I wanted to shout, "Leave me alone!" But fear and the gag kept me silent.

The shorter man took a small glass jar from an outer pocket of his backpack and pushed my head back against the recliner. He held the jar over my face.

I tried to pull away, but the foreman held my head in a vise grip.

The shorter man's lips curled into an evil grin as he tilted the jar. He poured liquid from it into my right eye.

In scalding pain, my body jerked.

The man swore. "You burned my hand!" He dumped more fluid into my right eye.

I screeched in agony as everything around me turned into a black void.

One of the men yelled, "Hurry up, before someone comes."

Searing fluid splashed over my face and dripped down onto my neck and chest. I could feel it peeling away skin. I felt my nose disintegrate as the liquid consumed it. I could barely breathe. The tiny holes that were left of my nostrils filled with the stench of sizzling human flesh.

Stinging pressure tortured my face. Pulsating fire shot from my sightless eyes. My head seemed to explode.

Between my screams, I heard the door open and the men run out. I writhed and groaned in agonizing pain.

Oh, God, how could You let this happen?

I couldn't stand any more of the intense pain. I felt lightheaded. Each breath shortened. I begged God to let me die.

GLIMPSE INTO THE FUTURE

As the outstretched arms of death beckoned me, a haze fell around me. Through the haze, I saw a vision of myself rising from the recliner, leaving my country, traveling to a land of green hills beside still waters, where men and women were decent and honest, cared deeply about their families, and took to heart the well-being of strangers. I became an eloquent speaker, addressing thousands of people in large auditoriums. I told my story about having lived a life of insignificance and meaninglessness day after day, month after month, year after year.

My audience sat on the edges of their chairs, listening intently to every word I said. When the speech ended, they jumped to their feet, applauding. Their standing ovation filled me with an energy I had never experienced. I perceived friendships developing, along with opportunities to teach and write.

Suddenly, the vision disappeared, and the pain returned. As the mist cleared, I felt a deep loneliness. I saw death coming to get me again. This time I clung to life.

With all my heart and soul, I cried, "Jesus, save me! I don't want to die!"

I heard the sounds of traffic outside my office. I struggled to twist out of the bindings that held me to the chair. Finally the ropes around my hands loosened. I untied my feet and stumbled

out of the office, shouting, "Help me! Somebody have mercy and help me!"

Hands outstretched, I moved toward the sounds of the street. I used my left foot as a guide on the curb so I wouldn't drift into passing vehicles. Blindly I made my way to my landlord's house and workshop. I pounded on his front door. When it opened, I nearly cried out in relief.

"Lord God!" he moaned. "It looks like you got battery acid on you."

I heard him fumble around the yard. Then I made out the sound of a rusty faucet turning, followed by water gushing through a hose. When the stream struck me, I felt like a pillar of living fire. He tried to towel me off, but the cloth felt like sandpaper on an open wound.

I heard voices and recognized them as belonging to the carpenters who worked in my landlord's shop. They gathered around, gasping and whispering.

I imagined what I must look like: the rubble of a face, ragged, broken, blinded—my straight black hair matted with blood. Reality hit like a thunderbolt. I fell to my knees.

Wanting revenge, I hammered my fists on the ground. Just when I thought I could make ends meet with my lumberyard, my plans had exploded in flames. My dreams were shattered. I rolled onto my back; my pain eased somewhat by the soft grass.

My strength and courage fled, leaving a complete emptiness. The light inside me flickered out.

One of my neighbors gingerly helped me into the backseat of a cab, which rushed me to a doctor's office. But the doctor didn't know how to handle such extensive injuries. He covered me with a medical gown and sent me on to the hospital.

The cabbie drove insanely fast. I squeezed my neighbor's hand, even though the contact burned and stung.

She helped me up the walk to the hospital. When we reached the nurses' station, I cried out, "Help me! Please!"

Emergency personnel gathered around me. I heard someone whisper, "Look at her eyes. They've turned white. She's blind."

What little energy I had left disappeared as any semblance of a productive future fell into the cracks of the earth. But even in the midst of this living hell, I sensed God's strength.

Thank You, Lord, I whispered in my soul, *that at least I'm still alive.*

A nurse washed the acid from my eyes and my body, but the burning continued. Ice packs were placed on the open wounds, but nothing stopped the pain.

While a doctor filled out paperwork to transfer me to a larger hospital, policemen came into the examining room and started asking questions. I sat on the edge of the bed, struggling to respond with coherent answers, but all I wanted was for everyone to leave me alone.

When I could no longer continue, the officer said he would get the rest of the report from me another time. He promised to send a message to my brother and mother, informing them of what had happened. The policemen left, and in my utter darkness I had nothing but my thoughts. While I waited for an ambulance, I forced myself to focus on positive things.

• • •

I thought of the beautiful little village of Mount Vernon, in a remote section of Portland, Jamaica, where I grew up. No one there had a good education or a professional job, but there was always enough food to survive.

My parents had struggled to give me a better life than they'd had. Mom worked hard to earn enough money for me to go to school. At the age of seven, shortly after my brother, Dennis, was born, I started to attend school in the city. By God's grace I became the first one in my family to graduate from high school. My success had made my family proud.

Now everything I'd wanted to achieve—all my hopes and dreams—were burnt to ashes under clouds of darkness.

One of the nurses said that my brother had arrived. Footsteps approached.

A warm hand took mine.

"Carol." Although I recognized Dennis's voice, it lacked his usually upbeat tone.

Together we cried wild sobs and moaned in anguish. My tears felt like hot glue on my face.

I could think of nothing to say to my brother. Apparently he was at a loss for words as well.

Finally he let go of my hands. His footsteps paced the floor. In a voice thick with agony, he begged the doctors and nurses to do everything they possibly could to help me.

Four hours later, a doctor announced that the ambulance had arrived. No wheelchairs were available, so I had to walk to the entrance.

Dennis helped me up. I struggled to my feet, feeling lightheaded, breathing heavily. Every step was a trial. I tried not to cry. I attempted to calm the pounding of my heart and the rushing of the blood in my ears, to calm my nerves and my panic, and to wish the hurt away.

Outside, the ambulance driver complained about working all day with no break. He went to get something to eat while the head nurse filled out additional paperwork. I was left waiting once again.

• • •

How could this happen to me? I had a bright future ahead of me. I owned a small business that was successful and my own beautifully decorated apartment. Next year I'd planned to travel to Brazil to buy more lumber. Later, I intended to go to America and purchase cabinetry accessories.

But now…

The ambulance driver finally returned. A nurse accompanied me to the larger hospital. Dennis said he would follow.

Every bump and turn of the twisty road brought agony to my entire body. I felt as if demons were plucking at my face and eyes with hot pincers and were sawing on me with dull knives.

I experienced short intervals of numbness, during which my emotions churned from grief to sadness to despair to anger to regret. Tears flowed, dried, and then flowed again.

Afraid that my eyes were permanently swollen shut, I used my fingers to spread the lids open. To my amazement, I could see a little—vague, foggy shapes, ghostly images. A slight ray of hope shone in my darkness.

HOPELESSNESS
ABOUNDING

The head nurse told me the doctor couldn't see me until Monday, but student doctors would treat me in the meantime. Apparently I was in a teaching hospital.

She flushed my eyes and changed my bandages. I could barely make out her tall stature and long black hair. She asked me to count how many fingers she held up, and I did.

"That's good. But don't get your hopes up. The damage to your eyelids is extensive. You will never see clearly. Most likely you'll lose your eyesight altogether."

Left alone in the crowded ward, I reached up with trembling hands and felt the holes in my face where my eyes and nose should have been. The skin creeping around the edges felt like charred leather.

I cried out to God for healing. I had to believe that if I gave myself to His will, He would provide the power for me to regain my sight and heal from my wounds.

Lord, I prayed, *help me to find the strength to continue on.*

I had no idea what God had in mind for me and my life. My Christian upbringing had taught me that everything works out through prayer. Still, my defeats and losses dominated my thoughts. I felt neither truly alive nor truly dead. I was simply a shadow in the world of light.

Devastated by my sightlessness and tormented with the painful burns, I struggled to keep my faith but met with despair.

The next day, in the early afternoon, a nurse told me that my mother and aunt had arrived. I asked her to help me sit up. The attempt was painful but somewhat successful.

I heard the door to my room open. Then I heard loud gasps of shock and sympathy.

I pictured my mom's eyes widening in horror at the grotesque sight of my disfigured face. I imagined her quickly averting her gaze from the frightening view. I visualized Aunt Pearl slumped beside the door, staring at me in shock and pity.

I heard Mom shout, "My beauty of all beauties? That couldn't be Carol. It isn't her! They must be wrong!" Then I heard steps running away—Mom's hasty departure, no doubt a traumatic reaction to the terror of seeing her daughter looking barely human. Her loud sobs traveled down the hall and into my room. "How could someone do this to my darling child?"

"Mom!" I called out. But her out-of-control weeping continued in the distance.

I heard her anguished voice. "I will never smile again. I am the most miserable woman living. If what I'm feeling were equally distributed to the whole human family, there would not be one happy face on this earth."

My body quaked with sobs.

I heard Aunt Pearl say softly, "Come back, Lea, and comfort your daughter. Hope in God."

A chair scraped beside my bed.

"Sit here," said the nurse on duty.

I heard Mom sink into the chair. I pictured her sitting with her hands over her head, her face with an expression of deepest pain.

For several moments, only Mom's deep, long breaths broke the silence. Finally, through tears, she said, "I'm so glad you're alive."

She explained that the captain of the fire station in the city nearest our village had gone to her home late the night before. "All

he told me was that you'd been badly hurt and had been transported to Kingston Public Hospital. When I asked if you were alive, he couldn't answer me. The police hadn't told him your status."

Mom said she went to the church and begged people to pray for me. Knowing that somewhere saints prayed for me brought a tiny spark of hope to my heart.

"It was the longest night of my life. I believed you were dead, yet I prayed that I would find you alive." Afraid of what she might face, she asked her sister, Pearl, to accompany her to the hospital.

At dawn, she and Aunt Pearl started the forty-five-mile journey to Kingston. First they had to walk two miles to the nearest bus stop. Friday morning rush hour crowds filled the buses, and they couldn't get a ride until almost noon.

"Your father sends his love."

I couldn't begin to imagine how this news was affecting my family. I felt grateful that Donald, my son's father, had taken Dale to visit his grandparents for the summer. I ached to see my child but couldn't bear the thought of searing into his young mind the image of his mother looking like a deformed monster.

"Is there anything I can do for you?" Mom offered.

I asked her to help me take a shower. We performed the painful task in awkward silence, other than each of us occasionally asking if the other was okay.

Out of the bathroom and back in bed, I felt compelled to pray. I grabbed Mom's hands and cried out to the one true God—the only one who could help me. Mom and I took turns praying, sobbing all the while. With each word, I felt my strength rebuilding.

I found the will to accept that perhaps God had a plan for the rest of my life after all. Surely He would give me insight to something better, something that could never be found without experiencing deep sorrow and despair.

When Mom and Aunt Pearl left for home, I lay down to sleep.

Early the next morning, Mom returned to the hospital. Her slow, heavy steps spoke of sadness and a broken spirit. "I brought

you a suitcase full of sleeping clothes, personal hygiene items, and food: fried fish and crackers."

I grabbed the savory feast like an owl snatching up a mouse and gobbled it up. Though the hospital had provided some food, the meals arrived sporadically, and most were unfit for human consumption.

After I ate, I reached out to my mother and put my arms around her. She stood motionless for a moment and then gingerly wrapped her comforting arms around me.

I heard firm footsteps walk into my room. Then I heard a deep intake of breath and recognized it as my boyfriend's.

"News of your attack is spreading through the neighborhood," Carlton said in a soft, choked voice. I felt him approach my bedside. "Oh, Carol, how I wish I could make everything beautiful for you again. Just know I'm here to help in whatever way I can."

I tried to smile, but sorrow brought streams of tears from my eyes.

Carlton told me he had brought clean bed linens for me, something the poverty-stricken hospital did not supply.

The wooden chair at the bedside creaked as he sat down. "Oh, Carol, why didn't God prevent this act against you? Why didn't He strike those horrible men down?"

"I don't know."

He took my hand, and I felt his tenderness and love. We remained that way for several moments, grieving in silence.

He stayed until noon, when the hospital's pitiful lunch was served. "I'm afraid I must leave you for a while. I have some business to take care of. You need to get well. I will pray for a miracle from heaven for you."

After he left, Mom returned. "Your grandmother went through the village and collected money for your hospital bill. She gave fifteen hundred dollars of her own money, and with the other donations, the total is five thousand."

My eyes teared as I pictured the villagers giving of their meager money toward my healing. Love always hopes for the best. Even in spite of the facts.

WILTED ROSE

Every morning, the nurses woke me very early. I opened my eyes and looked about. Over the next few days, my vision gradually decreased. I could see only phantoms of people's figures, unable to distinguish eyes or faces or even arms.

In the shower, I used the water pressure to peel off dead facial tissue—a painful horror. After I dressed, a nurse applied soothing ointment over my face and then covered my head with cloths.

A physical therapist came to exercise my neck and shoulders. I couldn't turn my neck without severe pain. My lungs ached as I fought to breathe through the exertion, but the therapist told me I had to cope with the discomfort or I'd be unable to move my neck and shoulders for the rest of my life.

Although I couldn't see myself, I knew I had become something unimaginably horrifying. The young-looking, attractive me had been ruined beyond repair.

Eating was a torturous ordeal because of my raw, sore mouth and lips. I carefully put small pieces of food into my mouth, opening my lips as wide as I could to avoid touching them. They often split open, flavoring my food with blood.

Anger, depression, and hunger made me miserable. My only source of comfort came from recollections of Bible stories, especially those depicting suffering. I reminded myself daily that Jesus had come into the world doing good, loving everyone, performing miracles for those around Him, yet was persecuted, tortured, and finally crucified.

I compared my sufferings to His. From somewhere deep within, my spirit cried out, "My God, my God, why have You forsaken me?"

No answer came.

"Lord," I bargained, "if You let me live, I will spend the rest of my life telling the world about You."

I wondered if He heard my promise or my pleas.

Day after day, Mom came with freshly laundered clothing, my favorite foods, and impassioned prayers for me. My friends and other family members visited as often as they could. Carlton always came early in the mornings. He traveled over fifty miles to get to the hospital. The nurses told me that sometimes he just stood at the door and looked at me, then went outside to cry.

The police repeatedly asked me to identify the men who did this to me, but because I couldn't see, I was little help to them. I described the woman who had brought me the bad lumber and told the officers that my attackers worked for her. But the police said my description of this woman was too vague.

No witnesses came forth. One man went to the police after hearing about my tragedy and said he had been standing at the edge of the long drive outside my lumberyard that day, waiting for a cab. Two men passed him on their way to my office, but he'd thought they were customers, so had taken little notice.

My pastor, who'd recently lost his wife, came to see me a few times, bringing flowers and gifts.

A pregnant cousin refused to visit me because she believed if she set her eyes upon me, her baby would be born deformed.

A girlfriend came by once and gave me a large rose. I held it in my hand, stroked my fingers along its slender stem, and smelled the sweet fragrance. She put it in a vase on my bed stand, just within my reach. I often stretched over and touched it. A few days later, my rose wilted over the edge of the vase. The bud never opened. It reminded me of my life. I hadn't reached my full bloom of potential and would never release the full fragrance within me to share with others.

One morning, the head plastic surgeon came to my bedside with a nurse and some student doctors. A surge of optimism swept through my spirit. Hoping for a chance to restore my face, I endured his painfully thorough examination.

When he finished, he said, "I've never seen such a severe case."

My expectant spirit crashed.

"I'm afraid the only thing I can do for you is to cover the burnt areas where the tissue has melted down to the facial bones. It won't be a cosmetic improvement; this is only for protection."

I nodded—the only response I could make.

"Nurse, we need to get her into surgery immediately. Schedule her the moment the operating room is available."

I heard people gather in the hall outside my room and speak in hushed tones. I caught only one phrase: "She might live; she might die."

The life I'd lost would never return. I wasn't sure whether I wanted to go on. If I lived, I'd carry my scars with me for the rest of my existence.

The surgical room came available. I didn't die.

• • •

Five weeks after I was admitted to the hospital, my mother told me that Donald was back in Jamaica and would be bringing my son to see me later that afternoon.

Her words opened a fresh well of emotions as I relived the seven years of pain and heartache I'd spent with my husband.

I recalled the first several times he told me I should take Dale to visit my mom for the week or weekend or that I should go visit his mom for an extended trip. When I refused, he instantly became angry, shouting, "Who are you saying no to?" In rapid succession his feet kicked my face, and his fists battered my body until someone who happened to be around begged him to stop or until he was satisfied that he'd given me the punishment I deserved.

In fear I whimpered as I packed to go wherever he wanted me to.

A man known as Public reared goats on the government land Donald and I lived on. Every day, he brought hundreds of animals to feed in the grassy, abandoned playing field next to our house. Oftentimes, when I looked out the window, I caught Public's eyes fixed on me. He'd smile, then turn and walk away.

One day, while Donald was away, Public came to the door. He said to me, "The man you are living with has been fooling around with other women. Whenever you go away, a few hours later one of two women usually comes. They leave just before you return."

I couldn't believe what I was hearing.

"Sometimes I approach the house," he continued, "pretending to need water from the pipe in your backyard, in order to converse with whichever woman is here. One of the girls is named Jennifer. She's a schoolteacher. The other one is Janet. She lives where he comes from."

I recognized both names. Shortly after I graduated from high school, I went to work with the Ministry of Agriculture as a receptionist. A couple of months later, Donald came to work there as an agronomist. A woman name Janet called him there regularly. He told me she was a friend he'd met when he was abroad at a university, and she was just checking to see how he was doing—nothing more.

A few years later Jennifer started calling. Donald told me she was a high school classmate, and they too were just friends. And I believed him.

"Does anyone else know about this?" I asked Public, mortified at my own naïveté.

"Most people in the community are aware of his behavior. But they're afraid to tell you. I don't fear him, though. He treats all three of you like furniture. He has no respect for anyone. Don't be foolish. You deserve better. Leave him. He'll never change." He turned and walked away.

His words devastated me. But I didn't dare say anything to Donald for fear he would accuse me of listening to gossip and

beat me again. He might even take his anger out on our son, and I couldn't risk that. Besides, maybe Public was wrong. I didn't want to accuse my husband falsely.

Soon after, Donald suggested I take Dale to visit my parents for the weekend. Not wanting to make a scene, I left without argument. When I returned home on Monday, the house was a mess. In the bedroom I found some women's clothing that wasn't mine. I also discovered some used condoms and their wrappers between the sheets and on the floor.

As I cleaned up the place, fighting tears, I asked myself, *How can I allow this to continue?*

When Donald returned home from work that day, I said, "I can't stand this any longer. I know you send Dale and me away so you can sneak other women into our home."

"What makes you say such a thing?" he asked.

"Other people have seen you. Everyone in the village knows. It's humiliating. Can't you stop?"

His hands and feet started pounding me, right in front of our son. My mind became dizzy. When he finished, I felt like a rag doll. Knowing my face must look horrendous, I covered the mirror of the dressing table with a sheet so I wouldn't see my face.

The next day, after Donald left for work, I removed the sheet and checked my image in the mirror. My eyes were swollen and bloodshot. I noticed blood spattered on the white walls of the bedroom. With an aching body, I scrubbed the stains away. As I did, my heart beat fast, and my mind told me I needed to get away from this nightmare.

When I'd finally cleaned up the evidence of my latest attack, I started packing.

Before I finished, I heard a vehicle pull up by the gate. Donald walked through the door and saw my suitcases. "What are you doing?"

"I'm going to take Dale and go away. Then I won't be in your way. You can do whatever you want without hurting me anymore."

"If you leave, you will never see Dale again. I'll take him away and hide him so well you'll never find him."

My life wasn't worth living without my son. Convinced Donald would do as he said, I unpacked and stayed. And whenever he told me to go, I went, returning only when he told me to come back. I felt miserable, ashamed, and lonely.

Late one night he came home with a bag of yams, vegetables, and dried salted codfish. He woke me up to prepare his favorite dish.

"It's one o'clock in the morning, and you want me to cook?" I offered to make it the next day in time for lunch.

Again his feet kicked my face, and his fists pounded my body. He beat me until all feeling in my limbs went numb. I begged him to stop. He told me he'd stop when I got up and cooked his food.

My body aching, I prepared the meal the way he liked. When I finished, I went to the bedroom to inform him. I found him fast asleep.

I made myself blind and deaf to his ways, always submissive. I lived like a bird with broken wings in a cage, never dreaming of freedom. But even an injured bird will escape when the cage breaks open.

One Saturday morning, Donald left Dale and me at home so he could visit Janet. Sometime after midnight, I awoke to a loud knock at the front door.

"Open up," said a booming male voice. "It's the police. We're chasing a man, and we saw him run into this yard. He may be inside with you. Half asleep, I stumbled to the front door and opened it. I saw five young men on the veranda with guns in their hands.

Two of the men barreled into the house. The taller one yanked the gold chain from around my neck and said, "This is a robbery. Where is the man who lives here?"

Fearing death, my body trembled uncontrollably. My voice unsteady, I told the leader, "There is no man here. Only my baby and me."

He gestured for the three men in the yard to go around the back and circle the house. They did.

The leader raised his gun to my head. His companion stuck a gun in my back. They took me to every room in the house,

searching for any man who might be there. When the leader was satisfied that no one was in the house with me, he told me to give him all the money I had. I went to Dale's bedroom and pulled out a few hundred dollars from the dresser drawer.

"Is this all you've got?"

I assured him it was.

He ordered me to go to my bedroom, lie face down on the bed, and keep my eyes closed. I obeyed, trembling with fear as the gunmen threatened to kill me.

As I lay there, the men removed all the valuable items they could find, as my son slept soundly in the next bedroom. Each passing moment increased my fear, yet I was desperate to live. I promised God that if I survived, I would leave Donald and return to my parents.

I survived. And I kept the promise I made to God.

AMERICA, THE HOPE

All the burnt skin had fallen off my face, and the raw flesh drained constantly. I longed to see my son, but I didn't want him to see me.

Donald would no doubt try to use my situation to prove to Dale that I could no longer make my way in the world, and he would be better off living with his father.

Maybe he's right.

"Does Dale know what happened to me?" I asked my mom.

"Donald promised me he would talk to him about it."

The television and newspapers had reported my story along with my picture. Dale probably already knew how I looked.

I propped myself up in bed when I heard footsteps coming through the door. Sensing Dale and his father standing at my bedside, I imagined Donald's eyes boring into me, summing me up.

Pain drew every line of my face tight. I forced a casual tone into my voice as I greeted them.

"Say hello to your mom," Donald said.

I reached out my hand. Dale took it. His little fingers felt warm. "Mom?" His voice trembled.

"What did you do over the summer, honey?" I tried to smile, even though he couldn't see my expression under the scary bandages.

"I played with my brothers and grandparents and went to summer school," Dale told me. "Some members of Grandma's Jehovah

Witness church sent gifts for me to give to the kids in our village. And I'm wearing the new clothes Dad bought me in America."

I didn't have the heart to tell him that I couldn't see his new clothes.

"I brought you toothpaste and bath soaps," Donald said, relieving the awkward silence. "If you need anything else, I can go to the store and get whatever you want."

"Thank you. But Mom's already taken care of everything." I wondered if my ex's offer indicated that we might finally have a chance at a decent relationship.

He must have leaned closer, because his scent filtered into my nostrils. My breath nearly stopped. He and I hadn't been so close in five years. He whispered, "Your right breast is burnt off too." His voice sounded almost triumphant.

Even in the worst tragedy of my life, he'd found a way to make me more miserable.

My heart silently cursed him. But I couldn't speak my mind because throwing a stone would glance right off of him and strike my child.

"I'm going to get better, Dale." Tears rolled down my face and into my mouth.

"We have to go," Donald said. "Call me if you need anything."

My soul ripped when my little boy's hand left mine. As I listened to them leave, I tried to forget Donald's cruel remark. I forced myself to focus on rebuilding my life and spending my remaining days in a way worthy of God's grace and mercy.

• • •

In September, when the new school year began, I still lay in the hospital. During the week, Dale lived with Carlton in his four-bedroom house, only a fifteen-minute walk from school. Carlton helped him with his homework in the evenings. On weekends Dale stayed in my apartment with my mom or my brother's girlfriend.

My fear that Donald would take Dale to America to live with him faded when I learned, through bits of innocent conversation

with Dale, that Donald already had two sets of children living with him, some from Janet, and more from his new wife, Jennifer. Apparently he couldn't afford another mouth to feed.

One morning, I awakened early and found that I could sense the dawn and smell the dew on the grass. I envisioned the sun coming up over the mountain back home, and the hills turning pink and lavender, like the inside of the seashells around my garden's edge. Even without eyes, I could picture the village where I was born.

"Thank You, God," I shouted over and over. "Thank You!"

A few days later, Dr. Johnson, a final-year resident who intended to pursue ophthalmology, came to see me. As she examined me, she described the process. "I am shining a light into your eyes. Please tell me if you can see anything, and let me know if I hurt you."

Dr. Johnson gently probed my raw, aching eyes. I appreciated her courage to come so close to such a monstrous-looking person, to look upon a face that I imagined appeared barely human, to stare into grotesquely swollen eyes.

"I can't tell for certain how deep the burns go," she said softly. "Hopefully, only the corneas have been damaged and the iris, pupil, and retina are untouched. If that's the case, a cornea transplant could restore your sight."

Her comments gave me a shred of hope that all was not lost. In a daze, I couldn't speak.

"Unfortunately," Dr. Johnson added, "we don't have the facilities to perform such a procedure here. However, cornea transplants are being widely performed in America. I've seen people who'd been blinded for years have their sight restored by surgery. Maybe it would work for you as well."

In my present state, I was not much use to my family, society, or myself. America held out a glimmer of hope. Could I really go there and regain what I had lost?

She patted my hand. "At least you've healed enough to leave off the painful bandages." After a clacking of heels on the hard

floor of the ward, I heard her speak to a nurse in the corridor. "Make sure you keep all mirrors away from Carol."

Her comment made me go cold with dread. But as Dr. Johnson's words about surgery began to sink in, tenuous dreams of going to a doctor abroad whispered through my mind. Perhaps, somewhere, there might be a surgeon who could work a miracle that would enable me to see clearly again.

I wondered how the six other people in my room felt about having to look at me every day. So I asked my doctor to transfer me to another wing of the hospital—preferably in a private room. He denied my request, afraid I would take my life if left alone. I told him I wanted to live, that I never thought of killing myself. He obviously didn't believe me because he referred me to the hospital's psychiatrist, who gave me pills that made me sleep for long periods of time.

For four long months I wallowed in the filth of that teaching hospital. The facility's conditions were a constant topic of discussion on local radio stations, including reports of corpses littering the floor of the morgue, where mongrel dogs ate the rotting flesh. I even heard rumors of rats eating off the toes of diabetic patients housed within the wards.

The hospital workers served meals in small boxes and warned the patients to eat immediately and not set food on the nightstands, where the roaches would discover it. Patients often flushed uneaten food down the toilets, which then overflowed.

My bed stood so close to the bathroom I heard flies all about. One night, I felt things crawling on my upper body. I tried to brush them off, but they swarmed over me. I heard someone pause close to my bed and say, "Lord God, roaches are eating her face!"

I moved my pillow to the foot of the bed.

I hadn't seen my plastic surgeon in six weeks. I felt myself wasting away. I begged Carlton to get me out of that horrible place.

He picked me up on a Friday afternoon. When he took my clothes out of the drawer of my bedside table and unfolded my

dress, hundreds of roaches scurried all over it. He put it in the garbage. The bugs had also infested an artificial bouquet on the nightstand, my hairbrushes, and numerous personal belongings. All followed the dress into the trash.

I couldn't wait to get home.

SHIMMER OF
DESOLATION

During the long journey on the winding road from the hospital to Ocho Rios, in a cool voice, one without emotion, Carlton described several accidents along the way. Listening to him describing scenes of car accidents to me, I felt loved. Remembering his handsome face that I loved so much, I envied every woman with sight. How I wished I could see!

Although I had traveled those same roads many times and recalled the bothersome traffic, by the time we reached home, fatigue had set in. Carlton parked his van in front of the gate to my apartment. I opened the car door, then waited for Carlton to come around to my side. When he did, I took his hand and clutched it tightly. I held my head down and walked slowly behind him, using his wide shoulders as a shield against the throng of pedestrians.

I had taken only a few steps when folks around me ran off to share the news of my arrival. Several people stood beside the metal gate to my apartment entrance, wanting to get a good look at me. After they had satisfied their curiosity, they stepped back, murmuring.

My inner pain lessened with the joy of arriving home. We walked through the living and dining rooms to the stairs and then up to my bedroom. We sat at the foot of the bed for a few minutes while I caught my breath.

I felt my way into the bathroom, longing to see my face. I had formed a picture of myself from feeling my features with my fingers, from hearing the descriptions by my visitors, and by the way people reacted when they saw me. However, I wanted to see for myself.

I stood close to the mirror, but with my fogged eyes I couldn't see clearly. I moved closer still and pressed my nose against the glass. For the first time since the attack four months ago, I got a glimpse of myself. I did not recognize the person gazing back at me.

Though I knew I would look different, I still held an image of the old me in my mind. Even after the ravages of surgeries, I was unprepared for the macabre face that stared back at me in the mirror—an irregular patchwork of raw flesh, dark strips of skin grafts, and pink dots where hundreds of staples held the pieces together. Thick scars intertwined like fat, ugly worms, in some places almost obliterating the staples.

I stood in front of the mirror, stiff and cold, laden with a fearful dread. A surreal feeling took hold of me, and I seemed to drift off the ground, disconnected from my feet.

An old memory returned of an imaginary creature that had caused me nightmares as a child. Night after night, that strange, torn-flesh demon had tormented my sleep, chasing me around the little house in my village.

In spite of the horror, I pressed my nose even further against the glass to see more clearly. My eyes looked lifeless and dead. My burnt lips colored with the pale pink of new skin.

Weary in spirit, I returned to the bedroom.

Carlton said nothing, but hugged me for several moments. Then he left to go to the grocery store. I sprawled on my bed, too stunned to cry.

The ringing of the telephone interrupted my despair. I hesitated; then I stretched across the bed to answer it.

The female voice that said hello sounded vaguely familiar. With a tremor in her words, she asked, "Is this Carol?" I said yes.

When she asked, "Would you like to buy some lumber?" I realized my caller was the woman who'd brought me the bad lumber four months earlier.

I sat at the edge of my bed and listened to her bitter sobs. I assumed she asked the question so I could identify her. I actually felt sorry for her. Perhaps she'd felt guilty when she heard of the injustice those young men had done to me.

"I don't need any lumber," I said calmly.

She hung up.

I didn't know how she managed to contact me. My home phone number was unlisted, and I hadn't given it to her. The call made me nervous. If she found me, so could those men. Would they come to my house and finish me off?

When Carlton returned with the groceries and dinner, I told him about the disturbing phone call. He seemed as puzzled as I was.

Thoughts of that woman came to me again and again. Fear and guilt dominated each day, and I could not sleep well at night. I prayed desperately for protection. Yet many times my anger erupted toward those around me.

I called the police a few times when I thought I'd heard someone outside my home during the night. They came quickly and made careful searches around the apartment, but never found anyone. Still, I felt insecure.

When I was up to caring for Dale again, Mom prepared him for my appearance. I pictured my son's expression as he looked upon my un-bandaged face.

However, when Dale moved back in with me, he acted as if I were the same normal mom he'd had before the devastation. He asked me to help with his schoolwork, just like before.

I stumbled about my apartment doing household chores, bumping into furniture, trying to be Super Mom, attending to my nine-year-old son's needs: cleaning his room, doing his laundry, preparing dinner. And I did help with his schoolwork.

With my mom's assistance, I taped grains of rice over the control knobs on the washing machine, enabling me to feel the settings with my fingertips.

I learned to find my way outside to the clothesline with the wet laundry and how to gather it after it dried. Every piece of furniture in my home had a fixed spot. Kitchen cupboards were organized by category. I figured out how to cook using my undamaged senses.

A slight amount of vision remained in my right eye. If I held a newspaper close to my face and squinted my eyes, I could read the headlines and anything with extra-large, bold print.

In the mornings I prepared breakfast and helped Dale dress for school. He did his homework every evening, reading aloud so I could guide him. To my pride and relief, he maintained good grades.

I enjoyed cleaning our home and taking care of my son as never before. But regrets terrorized me whenever Dale was absent. In the mornings, after he left for school, I wondered about life outside the walls of the apartment and whether the neighborhood had changed since the last time I had eyes to see it. I longed to gaze at the marvels of creation and the faces of people.

I hated Mondays. On the first workday of the week, the sounds of people moving along with their regular lives reminded me that I had no job to pay the bills.

I listened to the sounds coming from the highway and the chattering of passersby in front of my apartment and pictured the busyness. I heard the clacking heels of ladies and visualized them in their colorful tailored suits. I had been part of that lifestyle only four months ago. I had stayed in shape, waking at the break of dawn to exercise and jog. My accomplishments had made me feel worthy, attractive, and valuable.

Now I hid in my home and dared not even look out the window for fear that someone might see my disgusting face. People gathered outside every day to catch a glimpse of me. News reporters constantly stopped by, curious to find out if I'd survived another day. I spent hours on the floor of my bedroom, crying bitter tears, my wails echoing through the apartment.

My insurance company questioned me for weeks. Over and over, they tried to force me to admit that I could have prevented my tragedy. At one point, I felt as if they were trying to suggest that I'd poured the flesh-eating acid on myself in order to get the disability benefit.

They repeatedly scoured the police report for discrepancies—any reason to deny my claim. Each time they interrogated me, I felt their piercing gazes.

The interviews exhausted me mentally and physically. As they repeatedly asked their grueling questions, my head would ring, the room would turn around me, and I'd feel sick to my stomach. One moment I thought I had the details straight, and the next, a despair of mental knots tried my patience. I knew they wanted to confuse me into a confession of my own negligence in order to cheat me out of the settlement.

Through it all, I prayed and awaited God's will. I thanked Him for the blessings He'd given me: my son, our home, the strength and courage of my mother, and the many people who'd helped me, but I did not find the peace of God that passes all understanding.

THE EVICTION

Whenever friends of my landlady came to visit her, she took them to look at me. After one such visit, my landlady told me I had to move out because she couldn't live beside me anymore.

"Your face looks like spoiled meat. I can't eat meat any longer because of the sight of you. The image gives me nightmares. And you smell like garbage left out in the sun for a month. Besides, I don't want you to die in my house."

Even I felt repulsed.

Her words hurt worse than any stone thrown at me, and I knew the bruises would last longer. But the worst part was that she said all this in front of Dale. I felt a deep pain for my son. Hearing those ugly words had been horrible for me, but how much more so for him?

I wanted to argue with her that she had no right to kick me out, but because I'd had no salary for almost five months, my bills had piled up. My bank balance could not keep a goldfish alive, much less continue to pay my rent. Cab rides to the hospital and back had already added up to about $2,000, and I spent more thousands on medicine.

Since I could no longer run my lumber business, my landlord's wife helped me sell off my stock. The proceeds paid off some of my past-due bills, but it felt like a small drop in a huge bucket.

On various checkout counters, I'd seen money cans for charitable organizations, with a slit cut into the top where customers might

drop their loose change. I decided to start a fundraising project like that to help pay my living expenses and medical bills.

I hired a photographer to come to my home and take pictures of my damaged face to put on the collection cans. He charged hundreds of dollars for his services, which seemed paradoxical. I used the last of the proceeds from the sale of my lumber to pay him.

About a week and a half before my attack, I'd posed for a professional sitting and had kept the proofs. Carlton selected the best picture in the stack. I covered the cans with my "before and after" photographs, then attached a letter appealing to people to help me.

Numerous establishments—department stores, supermarkets, post offices, etc.—agreed to display the cans.

My former schoolmate, Maxine, and her husband, Michael, also got involved in the fundraising. They went to big businesses, such as insurance companies, banks, television stations, and newspapers to seek financial help on my behalf.

I received both small and large donations. One lady called and told me she owned a hotel, and my story had touched her deeply. She sent a check for $1,000.

Individuals and churches collected donations for me. I never met most of the people who extended their loving kindness and generosity, but I knew some probably lived on modest incomes.

Dale and I got by on the contributions of others. But I recalled the words of wisdom my papa had instilled in me when I was a child. He often said, "Money is the most ungrateful thing on earth. If you spend your dollars unwisely today, tomorrow you will need a penny, and no one will give it to you." I spent my money wisely, knowing I had no promise of more to come tomorrow.

A missionary with a prison ministry in New York came to Jamaica and stayed with a deacon friend of mine. Every day after work, the deacon stopped by to check on me. He shared my plight with his guest and provided him with copies of my pictures. The missionary took them to America and told my story to prisoners. I heard through my deacon that when his colleague showed them the photos, the inmates expressed outrage at the men who'd hurt me.

The prisoners worked at various jobs in the correctional facility, earning a small wage for their labor. My plight apparently touched their hearts, for each prisoner pledged to donate a certain amount of their wages. Some months later, they gave the Jamaican Consulate $1,200, along with notes. Their generosity made headline news, and the local television station and newspapers took an interest in my plight. Despite the agony of feeling hot pincers all over my face and chest, I went on television and radio to solicit help. During each interview I struggled to find the right words to convince the public of my needs for highly skilled plastic surgeons and eye specialists to restore my sight and my face. I hoped listeners would perceive me as an intelligent individual, not just a victim.

As the reporters questioned me, I relived my tragedy over and over, and the original horror came rushing back every time. I experienced a chaos of emotions, more anger than sorrow.

Though I received generous donations from my church, my family, and dozens of other people, the total was still pitifully short of my needs. I went to various hospitals and clinics, but the doctors showed no interest in my case. I realized they held no hope for me. I would have to leave Jamaica to find medical help and rehabilitation in another country.

It was a wild dream. But through the grace of God, I had learned to rely on the kindness of others. I knew if I kept seeking, knocking, and asking, He would open wide the doors of possibilities.

• • •

Instead of diminishing, my rage seemed to increase over time. Keeping a fury hot within me created a pressure-cooker personality.

Too embarrassed by my looks, I hadn't dared to venture into either of the two churches close to my home. But on quiet Sundays, if I listened closely, I could hear the music. I strained to catch the sound of the gospel songs and the old hymns, the handcrafted drum and tambourine. The music took me back to the little church of my childhood: that rich, sweet, spiritual world

where people loved Jesus and one another; a time when life held less pain. My toes tapped, and I smiled, then I sang along from a wellspring of joy deep within me.

I recalled Pastor Edwards telling me once, "Men can destroy the body, but they cannot destroy the soul."

And yet the flames of my extreme personal trauma had smothered my enthusiasm for God. I wrestled constantly with the unanswered questions of my life. Daily I asked God, "Why did You create me? Why am I still here? Why do I suffer so much? What is my destiny? What could You possibly accomplish in me?"

I clung to the belief that living with love and goodness in my heart would strengthen me physically and mentally and thereby help me avoid an early death. I had to believe that God had something specific in mind when He created me, some eternal plan and purpose.

• • •

One day, a policeman came to the door and told me my landlady had asked her lawyer to draw up documents to break my rent contract. The officer had come to serve an eviction notice.

I told him about my tragedy and explained that I did not want to go home and let my father and the rest of the village see me this way. His eyes misted, and he sniffled like a person with a cold. But he pushed the papers into my hand and said a quick good-bye.

I panicked. Between the housing shortage and the outrageous expense, finding another place to rent would be almost impossible.

I called my friend Maxine, who had already helped so much. She offered Dale and me shelter. She and Michael had just bought a three-million-dollar home in a gated community in Ocho Rios. It was ready to move into, but the lease had not yet expired on their farm. So they gave their new house to us to live in for a year, rent free. I wept with gratitude.

During those twelve months, I flourished. At night, I took walks and opened my senses to nature's gifts, often looking toward

the moon, picturing its warm glow. Sometimes I strolled along the road, but I turned my face away from passing cars.

In those contemplative moments, my thoughts turned to Bible stories in which people had triumphed over adversity. My only choice lay in trusting God with my future, so I placed my life in His hands. I prayed for a miracle from God, trusting Him to fulfill His promise that He would always take care of me.

Rather than continue to look at the world through the dark glasses of negativity, I resolved to see with clear lenses and celebrate the fact that I could still enjoy life. So I couldn't see— at least I could cook, help my son with his schoolwork, do my laundry, clean house, and do hundreds of things that less fortunate people could not. The tragedy had left me blind and disfigured, but those were conditions I hoped to restore to some semblance of normalcy…someday.

When Maxine traveled to America to purchase merchandise for their stores, she often brought me back wall decorations, housedresses, bed linens, and toys for Dale. Her gifts made me laugh and cry.

She and her husband taught me lessons on life and faith, reminding me constantly that brewing anger taxed my physical and mental well-being. It also hampered my relationships with others and with God. They told me to stop being a victim and to start feeling victorious, with a grateful heart—not grateful for my losses, but grateful that God would heal me.

With my friends' guidance, I learned that I am not on this earth primarily for personal pleasure, although happiness is an important part of God's purpose. I am not here to gain wealth, although substantial rewards may rightfully be mine if I work for them. I *am* here to share my life and love with others.

I also learned that even when I fumble and fall short, my loving Father has a plan for me. He understands what's in my heart. He knows my problems and my possibilities. He surrounds me with the love of many people.

My friends accepted me for myself. Their unselfishness and understanding kept me alive and sane.

LOVE FADES AWAY

When Carlton came to visit me, love songs soared in my veins the moment I sensed his closeness. He sat beside me on the sofa. I inhaled his familiar aroma—like the sun striking the cheek of a ripe red apple. I longed for him to take my horrible face into his hands, look into my sightless eyes, and tell me he still loved me.

As we exchanged the usual pleasantries, his voice sounded sad. For the first time since we met, no electricity leaped across the space between us. I knew we were not going to have the kind of conversation I desired.

I pictured him staring at his hands, folded in his lap, his head lowered as he spoke. "Carol, your tragedy is too much for me. When I look at you, I think of the woman you used to be. The one who knows where to find her smile, the one who can reel me in without even trying. I'm sorry to have to say this, but you're not that person anymore."

"But I am," I scratched out. "I'm the same person I was before."

His voice cracked with emotion. "Being in your presence takes too much out of me. It breaks my heart to see you this way. I just can't deal with it."

I swallowed the lump of fear in my throat.

"I can't come around much more."

Unable to deal with this startling announcement, my mind journeyed back to a time long before my flesh-eating acid attack.

It was one of the happiest moments of my life. I was seated at a table in a yogurt shop in Ocho Rios, enjoying a cup of strawberry yogurt. A handsome young man caught my eye from across the room. Our gazes locked, and I felt such an intense hunger for love, I feared it might devour me.

He came to my table, and I invited him to have a seat. He introduced himself as Carlton.

"I'm Carol," I said a bit shyly.

He asked about my day.

"I'm taking a break to rest my feet. I'm in the process of trying to fix one thing so I can fix another."

Carlton chuckled. "What are you fixing?"

"My own job security. I'm searching for a suitable spot to start my own business."

"That's interesting," he said. "I own my own business myself. I employ twelve workers."

We talked about pleasant things like the weather and my business plans for about an hour. I was carried away with happiness just being in his presence.

He told me he wanted to give me a new name.

"What name would that be?" I asked.

"My new name for you is Moses."

That struck me as extremely odd. "Why Moses?"

"It's like you can see the mountain, and you're ready to grab every opportunity to reach it and turn it into something even bigger."

I laughed. Without even trying, this man had made me feel better about myself. *So that's what love is all about,* I thought: *One person letting out her fears and the other coming closer to soothe the pain.*

We shared many personal things with each other, even secrets we'd been hiding from others: Sorrow, shame, loneliness. Along with tremendous release, joy took over my heart.

I felt lucky to have found this special friend. When the time came for us to part, we exchanged contact information and left the yogurt shop.

Later that day, I found the ideal location for my business. It was everything I had wished for.

When I returned home, I believed I had a perfect life ahead of me, like a fairy tale with a happy ending assured.

Now, as I sat beside Carlton, I traced my fingers along the jagged scars on my face. The cruelty of my fate burned inside, taunting me. I couldn't blame my boyfriend for not loving me anymore. It was true: in body, I was no longer the woman I had been.

But the inner part of me—my mind, will, and emotions—remained the same. And I still had the Spirit of God within me.

"If you need something," Carlton said as he left, "you can still call."

I wondered if he meant it or if he was simply trying to assuage his guilt.

That night, I felt my way upstairs and threw myself onto the bed. I took hope in reciting the age-old philosophy, "What does not kill you can only make you stronger."

Through my unique window on the world, I saw how society loved the lovely—those who looked good, who smelled sweet, who fit in with expectations. I also saw the difficulty in loving people like me whose appearance caused discomfort and whose special needs inconvenienced their lives.

I craved human touch. But my needs and desires went unfulfilled.

• • •

Haunted with loneliness, I took up with strangers. Though I did not always agree with their behavior or morals, I went out of my way to make people happy.

A couple I'd never met showed up at my apartment with a puppy. The woman placed the adorable creature on my lap and urged me to pet it. The man told me they wanted to help with my living expenses.

As the woman engaged me in cheery chitchat, her husband drifted away from the sofa. I heard him prowling around, stopping now and then to search through something.

The woman asked, "How much money did you receive after those heartbreaking appeals for help we read about in the newspapers?"

"Very little," I murmured. "Not enough to pay my bills."

"Do you keep the donations here? We'd be happy to take the money to the bank for you."

Her husband rejoined us on the sofa. Sensing their silent communication, I knew he'd found no cash lying around. Had he taken anything I cared about? Would they beat me because he'd found nothing?

"All the money goes directly to the bank," I said in a calm tone, "and the manager pays what he can on my behalf. I can give you his name, and he'll—"

They stood quickly, snatched the puppy from my arms, and left without saying good-bye.

I yearned for my past life. I became obsessed with food, feeling deprived all the time. I seesawed from hope to despair and back again. Time seemed to crawl.

I thought of all the friends who'd abandoned me. They seemed to have blown out of my life on a strong wind, like so many scraps of paper. Our worlds no longer connected. Many times I caught myself opening my lips to speak to someone, but then closed my mouth again, realizing no one was there.

My son filled some of the gap created by my friends' absence. When he was around, I carefully measured the things I said and did in order to protect him from the blackness of my moods. I spoke to him cheerfully, keeping a smile in my voice.

Each night I prayed that God would give him the strength to lead a more gratifying life than mine. As he slept, I stood over his bed, and in my mind's eye I saw his little chest rise and fall with life's precious breaths.

May you never feel what I feel now. May your eyes never shed scalding, heart-wrung tears. May you never appeal to heaven in prayers as hopeless and agonizing as those that come from my lips.

I could not fool my son. Dale looked right through me and beyond.

He stopped the daily withering of my soul by reading to me. Each day he engaged me with school events and news of the city. Through him I saw nature. He took my hand and led me on walks outside, vividly describing the fields, towns, rivers, sunbeams, and clouds.

Dale never seemed to grow weary of helping me. His kindness filled my soul with delight.

One night, as I lay down to sleep, I determined not to allow grief to overwhelm me. I would pick up the pieces of my life and look to the future. I had suffered too long through disbelief, anger, and denial. At long last I was ready for acceptance.

I began to experience a desire to reconcile with my Maker.

I knew God had not put me in this world to become a poor little blind girl sitting on a street corner crying. He had something more in mind for me. So I faced my situation, realizing that sometimes the universe does not unfold as we expect.

I decided not to run away from blindness; instead, I was determined to learn from it.

Blindness had robbed me of the ability to enjoy the marvels of creation, to assess the faces of people in my presence. I searched for a way around this painful fact. I fixed in my mind the faces of my friends and family, and the familiar images of creation that had given me such peace in my childhood so that I would always remember them. The visions of my heart and mind became more important than what I couldn't see with my eyes.

From a young age, and throughout my life, I'd enjoyed watching birds fly overhead, gathering material in their beaks to make a nest. In awed silence, I had thrilled at the intricate positions they took to retrieve hanging fruits from the branches of trees, and I marveled at their skill.

I'd delighted in seeing the colorful countryside glistening in the sunshine. Spanish needles, with their dainty white and yellow flowers, had grown in wild array along the roadsides, on the estates, and in the private yards of my little village, where worker bees gathered nectar for honey from the flowers, and colorful

butterflies scattered pollen with their delicate wings. Brilliant rainbows had arced overhead.

In the stillness of my blindness, I pictured all the things I had ever seen, things I'd once taken for granted and wished I had stopped longer to enjoy. At night my dreams kept all the lovely images alive and fresh.

People blind since birth had never seen faces, colors, animals, or the beauty of creation. I counted myself fortunate to have had some of those experiences. There were others better off than I, but many were worse.

I focused on gratitude. I thanked God for the life He had given me. I praised Him for the blessings of inner strength and vision.

Most of the blind people I'd known in the past had been poor and dirty, dressed in shabby clothing and living in deplorable houses, forced to beg on street corners with a tin can in their hands. With pity in my heart, I'd given them money and wished I could take away all the diseases, wickedness, and darkness from the world. Never in my darkest dreams could I have imagined that one day I too would be sightless.

I yearned for an active life with the exciting toil of a career—perhaps as an author or an artist or a nurse or a cleaning woman—anything other than that of a beggar. But losing my sight did not have to mean the end of the world. I could still go on to become the best I could be. I'd heard of blind people becoming as successful as the sighted, although most had to work three times as hard. But I was convinced that modern technology could help me find a fulfilled life.

I tried to do everything I used to do before I lost my vision. Blindness had not rendered me stupid or helpless. I couldn't see through my eyes, but my heart and mind were still clear. And my other senses had sharpened—a surprising compensation. I began to consider my blindness an inconvenience, not a handicap. I put an end to wallowing in self-pity and determined to do my best to create a new beginning for myself.

A JOURNEY BACK

Six months after the day of my tragedy, I went back to the hospital as an outpatient for eye care. Still ashamed to show my face in public, I wrapped my head in a large white towel and created a small opening to breathe through.

At the hospital, Maxine's sister took my arm to escort me. She said that every head turned to stare at me, and she felt ashamed to be with me. It took all of my strength of will not to turn and run.

When I arrived in the waiting room, someone pulled the towel from my face and exposed my physical disaster for all to see. My heart seemed to stop, and my brain felt like it would burst.

I heard a cold female voice say, "You look like as though all the evil of humanity has been revealed to you. Where is your God? Has He abandoned you? If I looked like you, I would have killed myself!"

Her words sapped my strength.

I sensed a large crowd gathering around me, and many voices asked Maxine's sister, "What happened to her?"

As the story tumbled from her lips, I knew their hearts were filled with joy that this tragedy hadn't happened to them. I cried with rage, despair, and fatigue.

One raspy voice said to me, "You are beautiful...in an ugly sort of way."

Finally, the nurse called my name. As I stood, some people said solemn farewells to me, saying such things as "We will meet again in a better world," as if in expectation of my death.

I will prove them all wrong, I affirmed to myself.

The nurse took me to an examining room, where a student doctor examined me under a microscope and checked my eye pressure. Sounding tired and hopeless, he gave me prescriptions and told me to come back in a few weeks.

The next five visits were no better. Four more times, other patients pulled the towel away from my face. I felt shame and humiliation, then anger. At the end of each visit, tears poured down my face.

The clinic did nothing to restore my sight. I would have to pursue other avenues. I prayed for deliverance from my third world country that had few resources for rehabilitation.

On my seventh visit to the clinic, I asked the doctor for a referral letter so I could go abroad. But hospital policy prohibited him from accommodating my request.

I found out that a group of eye doctors from America would be visiting in a couple of weeks, giving free eye care from their ship. Excitement replaced despair.

The night before their arrival, I prepared Dale's breakfast for the next morning, laid out his school clothing and lunch money, and reminded him to brush his teeth before leaving for school. Then I took a cab to the ship. But upon arrival, my driver told me that an outpouring of people prohibited our reaching the doctors.

"I will do whatever it takes," I told him, determined to push through the crowd.

He refused to venture forward another foot, afraid we'd be trampled to death. I begged, but he wouldn't change his mind.

I let loose of him and tried to find the doctors on my own. I walked in the direction of the noise for a while, then stopped. I couldn't find my way without assistance.

I retreated in shame. I wanted to be strong, but instead felt cold, nervous, and shaky. I could think of nothing but getting out of there and hurrying home.

For the next several days, I cried myself to sleep.

A week later, I visited the head doctor of the hospital in his private practice. His office smelled fresh and felt pleasant and comfortable—far different from the hospital clinic. As I entered, I felt the eyes of people seated in the waiting room looking curiously at me. But no one asked any questions or invaded my privacy.

After a short wait, Dr. Kalda briefly examined my eyes and handed me a prescription. I left the office feeling helpless. In spite of the much-improved conditions, the attention I'd received was no better than at the clinic.

• • •

I heard that an organization called the Lion's Club was known for helping people with sight problems. I contacted the chapter in my area and told them my story. They seemed very sympathetic.

One of the members told me about a doctor who would soon visit Jamaica from the Bahamas. I obtained the address and made plans to meet him.

Being an entrepreneur, Carlton had business that took him to the capital of Jamaica one day of every week. Swallowing my pride, I called and asked if he would take me with him, drop me off at the doctor's office, and pick me up after he finished his work. In spite of the awkwardness of our last conversation, he agreed.

After the long journey to Kingston, Carlton got out of the van and walked around to my side of the car. He took my hand in his. I felt his firm strength as his fingers locked with mine. Something passed between us as fresh and light as the breeze over the Caribbean Sea. The current—aching and strong—flowed up my arms and filled my body with desire.

I felt a smile play over my face. Joy dawned inside my head and opened a well of forgotten emotion in my heart. I thought of how good he had been to me and how lost I felt without him. I loved him for his strength and kindness.

A person without sight can't walk hand in hand gracefully. So we changed positions, and I held him by the arm, following the

motions of his body as we entered the doctor's office. I inhaled Carlton's fragrance as he led me to a chair. He signed me in and left for his business meeting, leaving me to my chaotic thoughts.

The clock ticked away the minutes. Finally, with the help of a nurse, I saw the doctor.

He said I needed continual care, but he visited Jamaica only once a year. So he referred me to another specialist, Dr. Meyer, stressing, "She is very good."

His referral revived hope.

After learning my history and giving me an examination, Dr. Meyer told me she worked with other physicians in Canada, where I might regain my sight with a cornea transplant, which would treat the affected area and create an environment where cells could regenerate. But we both knew I could not afford the trip.

I went home to ponder my next step.

As I sat on the sofa, my face cupped in my hands and elbows resting on my thighs, wondering how I would go about finding rehabilitation, Dale burst through the door. He raced over and sat beside me.

"Mom," he said, his voice stricken, "why are you so sad?

"Life is hard, son. It's even harder with blindness, because I can't always do everything I want exactly the way I want to."

I took his hand in mine. "I need a sense of purpose. Everything in my life that had meaning depended on my being able to see. Blindness took all that away."

"I am so sorry, Mom. I'm sorry for everything that has happened to you. I wish I could somehow take the pain away."

"I appreciate that," I said, squeezing his hand. "But there may be a way for life to become better for us. Unfortunately, it would mean having to leave you and go abroad."

His hand tightened on mine. "Could I go with you?"

"I'm afraid not. It would be a difficult journey. I'd spend most of my time at a hospital, undergoing painful surgeries on my eyes and face. I wouldn't be able to parent you properly. You'd need to stay here in Jamaica and keep up with your schooling."

"That's so unfair," he complained. "First Dad went away, and now you're planning to go away."

"You could go live in the village with Grandma and Grandpa," I suggested. "You'd have several relatives there to love you in my absence."

That idea seemed to appeal to him.

"Mom, what happened to you is like a terrible dream, the kind you never forget parts of. I remember going to see you in the hospital. How scary you looked. My friends asked endless questions about you. But then people started talking about you the way they would mention the weather…something that happened and was over now. Only for me it's not over. Every day I think about you constantly. I can't concentrate at school. I just want to go back in time to before you got attacked."

I couldn't count the number of times I'd wished that myself.

"When I think about what happened that day, I imagine being able to save you. If I'd been there, I would've been your bodyguard!"

"I'm sure you would have." I ruffled his hair and laughed. "But now I need to go to America, and you won't be able to serve as my bodyguard there either. Still, I don't want you to worry. I'll be away from you in body, but I will always be with you in spirit."

That seemed to comfort him, and after a big hug, he scurried to his room to start on his homework.

Leaving my son behind while I traveled to America would be heartbreaking for both of us. But by doing so, I might be giving him the greatest gift of all—returning to him a better mother, with eyes and face restored.

During the weeks that followed, many people told me the United States was a better possibility than Canada. The technology there was so highly developed, they said, it was like the doctors could work miracles.

The struggle to restore my sight in Jamaica had turned into a rollercoaster. Each rising sense of hope had fallen back to where I started. But I found comfort in the idea of going abroad and having a cornea transplant.

Mom had relatives in Florida—the nearest point to Jamaica. I called and asked them to look for doctors nearby who might be able to help me. Their answer came a few days later: "We don't know of any doctor like that." They talked about my devastation as if I had the plague. I realized that they had not even tried to contact any doctors or hospitals because they feared having me around.

I focused on getting to Florida, praying each night for the journey into the unknown. I dreamed of being in the United States, of seeing clearly with my face restored.

I felt confident that there was a cure for me and that I would find it in America. I vowed never to give up.

THE CHOICE
IS MINE

My mom, always a woman with hope for a brighter future, ever vibrant and alive, changed after my tragedy. She used to rock and twist to the rhythm of the reggae beat. But music no longer dried her tears. She focused on what the power of darkness had done to me and its evil influence rather than on the blessings God had given us.

Her negativity and worry sometimes caused my heart to wander off course, and I lost my willpower. I prayed to God for courage—the antidote for fear.

I told her to be thankful I was still alive and that we could talk and share things with each other. I reminded her that we had to choose good feelings over bad, positive attitudes over negative, gratitude over grief. But Mom had become stuck in all the pain, injustice, and tragedy of my life.

Mom's hair began to turn white, years before her time. Hatred for those who'd hurt me consumed her. I sensed her terrible emptiness and knew she wept bitter tears in the lonely hours of the night.

She spent few daytime hours at home.

"When I'm alone, my thoughts center on the bad things that have happened to you. I want to be with family and friends all the time. They give me other things to think about."

Still, my mother's love gave me the will to defy death.

"As long as you have breath," she often encouraged me, "keep going, even when it looks as if there is no way out and you are hanging on by a toenail."

During one of Mom's visits, I felt very tired, so I went to bed and fell asleep. When I awoke, I found Mom at my bedside, bent over me, looking into my eyes with a loving smile. She put her arms around me and held me close. Pressed to the soft firmness of her bosom, I felt the touch of her mouth against my forehead. Her tears dripped onto my face.

I determined to cling to the will to live for the sake of my family.

• • •

On one of her visits, Mom told me that my father and a friend had read the evening newspaper, and when Dad realized that the horrible photographs of a mutilated woman were of his own daughter, he collapsed, heartbroken.

The shock of my fate jolted him into a long, dismal decline that eventually led to a mild case of dementia.

Before the tragedy, I had been the apple of his eye. My arriving home always brought festivity. No joy would greet any homecoming now. I couldn't let anyone in my village see my changed appearance. Embarrassment and shame kept me away.

Still, I felt a deep desire to see my father again, to share in the simple things we used to do. I missed the food my dad cooked for me as a child—the most delicious meals I'd ever eaten.

I longed to go home and shine in the hearts of my people again.

• • •

A woman named Andrea called me after reading my story in the papers. "Carol, I'm thinking you must need someone to run errands and help you in your home. Would you allow me to visit you and speak to you?"

I hesitated, but hearing the honest caring in her voice, I agreed to a meeting.

When Andrea arrived and introduced herself, I immediately felt at ease with her. We chatted about many things, not just my difficulties, and a comfortable rapport blossomed between us.

"I live in Oracabessa," she told me, "and I'm the president of the youth club there. Our organization supports both the military and the police. I want you to share your plight with members of the police club at our next meeting."

I was deeply touched by her offer, but I wasn't sure I wanted to speak to a bunch of policemen. A past experience had given me a negative view of people in that profession.

Three years after I graduated from high school, Mom had scraped together enough money to pay for my first semester at college. At the end of the semester, I boarded a bus to journey home. I disembarked at the nearest bridge to home. In the blackness of the night, laden with luggage like a pack mule, I commenced walking.

About a block from the bridge, I heard footsteps. Fear gripped me.

When I reached the junction, I turned onto the dirt road that led to my village. The man who'd been following me sprang onto my back. His arms wrapped tightly across my shoulders, pinning me. He placed a knife at my throat and said, "Give me everything you've got."

Remembering a self-defense technique I'd heard women in the village talk about, I slid my left hand in front of my neck to protect my throat from his knife blade. With the other hand I grabbed his crotch in a vise grip. I clenched my teeth and twisted my hand.

He squealed like an injured pig. He pulled the knife as if to slash my throat. The blade sliced the palm of my hand instead. Amid stinging pain and flowing blood, I felt him loosen his grip on me. I ran straight home.

When I told my parents what had happened, Papa hopped on his motorbike and took me to the police. I explained every detail of my attack to the officers, but they said there was nothing they

could do. Their impotence allowed my attacker to remain free to harm others. The experience left a sour taste in my mouth for law enforcement.

Not wanting to appear ungrateful to Andrea, I said, "I appreciate that you want others to hear about me. But I don't understand why God would want me to keep reliving my pain and disappointment and heartaches."

With a sweet voice she said, "Carol, before your tragedy, did anyone ever ask you to share your story with any youth clubs? God is going to use your blindness and disfigurement to make you more powerful, more impacting, more productive, and more fruitful for His kingdom. That's the kind of God He is."

Andrea was right. I had to figure out who I was without sight. Frequently, the affliction we seek to avoid is the very door of our deliverance. You have a mountain of work ahead of you, and there's no way you can get out of it. This circumstance in your life will lead you through a chain of people all the way to the end of time."

Andrea's words provided a unique revelation to explain what I'd been struggling with. In order to help heal myself, I had to look beyond the embarrassment and shame and focus on what I could share with these young people. My story would be a preview of what they would likely encounter in the world—how cruel mankind can be, but how amazing God could be.

I doubted that anyone would want to hear what I had to say. But perhaps my physical damage might give my words credibility. A long-lost sense of self-worth shivered through me. Maybe I could make a difference—a positive, desperately-needed difference.

Her visit redirected my thoughts for a short time, and for that I felt deeply grateful.

A few days later, Andrea returned with a request. "I've arranged for you to speak at a banquet to be held next Saturday at the military base in Port Maria."

I knew the location of that base. Only a chain-link fence had separated it from my high school. The banquet would be held in

the recreation room, which I'd visited on several occasions during my school years for various functions.

"Don't worry about a thing," Andrea said. "I'll have a police vehicle come pick you up, and I will be with you the whole way."

"I'll do it!"

We clasped hands, and Andrea promised to call me with details within the next few days. I waved good-bye to her on my front doorstep, eager for my future.

Never before had I spoken to a formal group. But God had given me an important story to tell. Through me, He would open the eyes of the police, the military, and the community to the devastation of my tragedy and the awareness of taking preventative measures.

"My life still matters," I said out loud.

I picked up the phone and called my mom at her workplace. "I've been invited to speak to police and military men at a banquet," I told her. "Something good may come from this blindness and disfigurement after all."

"I like your resolve and your will," Mom said. "If anyone is qualified to speak to the police regarding violence, it's you. I wish you the best."

Dale needed a sitter for Saturday. I asked Mom if she could watch him for the weekend.

"If you want me, I'll be there."

On Saturday night, Andrea arrived early to help me dress. The short, bumpy drive to the military base brought jitters of stage fright.

Andrea introduced me to the superintendent of police, Mr. Waite, and a group of his colleagues. She told me that a quite a few young officers of the police force, as well as a large number of military men, were in attendance.

Once everyone settled, I walked to the podium with Andrea's help and then stood in front of the audience alone. "It is a privilege to be here in your midst tonight."

I felt all eyes upon me in the silence of the room. I imagined their expressions of revulsion and curiosity for this horribly damaged

woman. Dread froze me. I took a deep breath and reminded myself that I had been given this opportunity to make a difference.

"I stand before you as a victim of a horrible crime, and I want to speak boldly about violence in today's society."

As the words flowed from my mouth, energy rushed into me. With surprising ease I shared my plight.

Tears streamed down my face as I said in conclusion, "My future is up to me. I can look for life, or I can see only death. God has called me to live, albeit not like normal people, but I trust He will lead me."

After a round of applause, people gathered around, shaking my hand, hugging me, telling me how touched they were by my story of pain and fear and loss. Many promised to take up my cause and do their share to help end the senseless violence spreading through our communities.

Their best wishes bolstered my courage and uplifted me. I realized that deep in the recesses of my soul was the potential to make other people listen.

When I returned home I found Mom waiting up for me. "How was it?" she asked.

"In front of an audience, I didn't feel so ashamed. When I talked, it didn't even sound like my own voice. And when I thought about what to say, it seemed like somebody else was thinking for me. I felt deep compassion from everyone."

"Carol," she said, "you were born with the will to persist."

The next week, Chris Blackwell, founder of Island Records, one of the most successful entrepreneurs in the Jamaican music industry, sent me a check via a messenger. His generous donation helped me pay my bills and buy food, medication, and a few other necessities that I had been forced to go without.

God had shown me my path. I had become a talented fundraiser and a riveting storyteller. Both gifts would enable me to survive.

But I still had to get away from Jamaica in order to find the medical treatment I needed to improve my life. I longed for my darkness to turn into light, and to see the light in myself.

THE OPEN DOOR

July meant a year had gone by since my attack. The anniversary brought a long night of hard thoughts, tears, and anguish. *I have to do something. I have to at least get started on something!* I had lost Carlton, the love of my life. I had loved him for his strong, passionate, earthy nature, so like mine. I missed laying my tired head on his broad shoulders. I had loved him as tenderly as a woman could ever love a man, and I wept for the life we would never share and the children we would never have. I lived on his memories until they wore thin; then I suffered alone.

One summer night, I switched on the radio to a late-night talk show program. The topic pertained to medical need. I listened eagerly.

A young lady said she had to go to Cuba, where her sister would donate one of her kidneys for a transplant. They had inner strength, but no funds.

Generous donations came in from all across the country. At the end of the program, they had more money than they required for the trip and surgeries.

Their story of courage inspired me. Maybe I could call in to this radio program and receive enough money to go to America for surgery to restore my sight.

After rolling over the idea in my head, I decided not to call the radio station, but to go there in person. If the host of the show saw how horrible I looked, maybe he would be moved to help.

I went to bed that night so weary I couldn't even pray. In a dream, God appeared as my Father and stared deep into my eyes.

My blindness vanished, and I could see again. His compassionate gaze drew from my heart all pain, bitterness, and disappointments.

"These are my burdens now," He said. "They are no longer yours."

I awoke in the middle of the night to total peace and calmness. I could not see how everything was going to work out, but I desperately wanted my dream to become reality. I fell on my knees and cried out to God to bring that about.

In the morning I dressed, wrapped my head in the white towel, and took a cab to the studio. I met the host of the talk show and found him as warm-natured as I had anticipated. I felt the same generous spirit that came across the radio waves at night. After we shook hands, I sat in a comfortable chair in front of him, and my story tumbled out. He told me he'd heard about my tale from some of his listeners who'd called in at the time of my assault. Unfortunately, he couldn't help me. The show focused on appeals for poor people whose lives depended on receiving special medical care to stay alive. Although he appreciated the horror of my situation, I could technically go on living.

Pain and bitterness roughened my voice as I thanked him for his time.

Sitting in the back of a cab on the way home, the flush of anger slowly faded, and I regained my calm acceptance.

The collection cans that displayed my story and my picture brought in a minimal income of donations. I resolved to double my efforts, bring further attention to my plight, and hope more people would find it in their hearts to send generosity my way.

One Friday morning, the bank manager who kept one of my collection cans in the lobby called and said a Jamaican woman who'd traveled from America wanted to meet me. I told him to send her over. I lived less than a block from the bank.

I waited nervously, uncertain of what to expect from this stranger.

The woman arrived and introduced herself as Paulette Allen. She'd brought her teenage son and daughter with her. I greeted

them and offered them a seat. The room fell silent. I felt Paulette studying me and sensed her pity.

She asked permission to take my picture and share my story with her pastor and church members in Connecticut. I told her she could do so and handed her one of the extra fundraising packets I kept on hand for such purposes. I expressed my sincere gratitude for her efforts on my behalf. She wished I thanked God for putting this generous woman in my life.

Please let her church reach out to me in a positive way.

• • •

That Friday night Michael and Maxine stopped at the house. Michael said, "When we picked up the mail today, there was a check for the full amount of your life-insurance disability benefit. We deposited it into your bank account." He handed me the deposit receipt and the letter from the insurance company.

I felt like dancing! The check represented new hope. I could finally leave my country and get help in America.

After Maxine and Michael departed, I began making plans in my mind. I saw America as a land of miracles, filled with good doctors, excellent hospitals, and people who would give me the assistance I needed.

For several months, I thought of little else than the great land of America. From the many movies and television shows I had watched, I pictured what America must be like. I especially wanted to go to the place where the movie stars lived. I thought, *If they are as beautiful on the inside as they are on the outside, I know one will have pity on me and help me.*

I dreamed of living in America, seeing beauty and majesty that could not compare with the world in which I existed. I knew I would go there and my wishes would come true.

I would acquire a new circle of friends, with whom I'd start a new life and develop new attitudes and habits. I would become the person I wanted to be and cultivate the attributes I wanted to have, go where I wanted to go and do what I wanted to accomplish.

. . .

One day my pastor called and asked if he could come over with some church members who wanted to bring me food and the Word of God. I hadn't seen these people since the Sunday before my tragedy. My nerves tightened. I did not want them to see me in my present condition, but I agreed to the visit.

I knew by the tension I felt when they walked through my door that they were in a mild state of shock. I was a totally different person from the one they saw at church a year before. Despite my internal struggles, I tried to sound pleasant as I expressed my gratitude to them for coming to visit me.

When we prayed together, I heard quiet sobbing, and I imagined tears of sympathy trickling down their cheeks. After the prayer, my visitors wrapped their arms around me like the tendrils of a vine. One said, "Carol, as much as you may be tempted to hold on to bitter thoughts because of your blindness and disfigurement, you have to go on living. One day, perhaps a long time from now, you will realize how much the pain has eroded."

Their confidence infused me with hope. I told them I had suffered devastating misfortunes, but I refused to stay crushed. My tragedy had not broken my faith—I would find triumph. I shared my desire to go abroad to seek care that might restore my sight.

They mentioned other members of the church who sent their regards but were unable to come. They promised that their prayers on my behalf would increase throughout the community. The joy of that revelation led me to believe I could achieve what I desired—the restoration of my sight and my face.

My strength grew each day, not from any special wisdom or stamina, but because I had plunged into the water of the Great Sustainer. Once I found the humility to look to God, He blessed me with a belief in others and in life.

• • •

Mom sent messages to relatives living in America to find doctors who might help me. Weeks later, she called me, sobbing. "I've received replies from three family members in America. They all say they do not know of any doctors who can help."

I read the underlying truth beneath her words: they felt apprehension about what the future might hold for me. Perhaps they were afraid of me coming to live with them and having to support me while I received medical attention. Maybe I would have done the same thing in their position.

A member of my church, Mrs. Dunn, brought dinner to me and visited a while. As we conversed, I told her I desperately needed to get in touch with a hospital in America that might help me regain my sight. She promised to help me find a good doctor.

That night, she contacted her family in Florida. They gave her the telephone number for the head cornea specialist at Jackson Memorial Hospital. Her news soothed my fear and sadness.

The following day I called the hospital and made an appointment to see the doctor. The receptionist suggested hotels near the hospital that offered special rates to patients. I called the Crown Plaza and made a reservation. Mom and I would share a room.

I next made an appointment for an interview at the American embassy to obtain a visa to visit the United States for health reasons. Anticipation brought hope for a future. The days passed quickly and peacefully.

On the day of my appointment at the embassy, Mom and I awoke early and gathered the documents we needed. Walking from the house to the waiting cab, I felt the warm sun on my skin. The beautiful morning empowered me.

When we arrived at the embassy, the sun shone bright, and the air felt fresh and crisp. Uplifted and hopeful, I prayed for the embassy personnel to grant me a visa.

Mom and I approached the window for our interview. I stood straight and tall, without the towel over my head, allowing everyone to view my face.

As we handed our documents to the customs clerk, I felt his gaze on me. His voice held compassion.

After Mom and I answered his questions, he left to consult with some of the other embassy personnel. Mom fidgeted beside me as we waited.

The man returned to ask more questions, then checked our documents.

I felt the prayers of my church family and found the strength to remain calm and continue the lengthy interview.

The man told us to come back at three o'clock that afternoon for our visas.

God had granted His grace to accomplish a miracle. In that glorious moment, a door opened, offering me freedom from my horrific life, an escape from the numb misery that had held me in its grip for over a year.

At three o'clock, Mom and I gathered with others waiting to obtain visas. When our names were called, we proudly walked up to the window. I had never felt so elated.

Joy spread through me. With visa in hand, I cried out to the Lord in thanksgiving.

Excitement carried me through the weeks of preparation for my departure.

Two days later my pastor gave me two airline tickets donated by American Airlines. I rejoiced.

I arranged for my son to return to the village, where relatives would take care of him until my mother returned in three weeks.

A few days before my departure, I sat at my desk and stuck my nose down close to a pad of wide-lined paper. I could not see the lines on the paper, but using a wooden ruler and thick markers I scribbled a farewell note to Dale. It said, *I will return home with my sight and a better-looking face. Life is full of uncertainties. But*

America is alluring, even intriguing, to me. It could mean a future that Jamaica could never give me. I placed it in his luggage.

As Mom and I rode to the airport, I fretted over living without Dale for a time. But I felt excited over the prospects of returning whole.

In order to check in for processing by immigration to embark on my flight, I had to remove my protective towel. The airline attendant gasped loudly and then bid me good luck. As I moved through the different checkpoints, every attendant expressed positive wishes for me.

I had never traveled by plane, and I felt both anxious and excited.

My burdens lifted with each mile we drew closer to America.

NEW CREATION

Faith and hope burst in my heart as the plane taxied down the Florida runway on September 18, 1995. For fourteen months, my soul had slowly withered. Now it blossomed forth, more fulfilled from the bearing of sorrow.

When the plane doors opened, Mom and I remained onboard, awaiting a wheelchair. As the other passengers disembarked, I sat in my seat with a feeling of supreme happiness, even while wondering how Dale was doing. I longed to wrap my arms around him and tell him I loved him.

Once we were off the plane, Mom maneuvered me through immigration, then outside to a cab. She handed the driver a piece of paper with the name and address of our hotel.

A warm afternoon breeze funneled through the driver's window and blew on my face, fluttering my curls. A wisp of hair fell over my forehead. My face felt radiant underneath the jagged keloid scars.

Mom spoke to me on the ride, but I heard little as I pictured the scene along the road in my mind.

We checked into the hotel and prepaid the bill, received the keys, and went up to our room. When I entered, I set down the luggage and fell to my knees, praising God for bringing me to America.

Mom and I were hungry after our long journey, so I suggested we treat ourselves to a meal at the hotel's restaurant, but because we were so tired, we decided to order room service instead.

For the first time in months, I slept the heavy, dreamless sleep of exhaustion. It refreshed, renewed, and rejuvenated me.

I woke late for my hospital appointment, but nothing could destroy my enthusiasm at experiencing my first daybreak in the United States. As I dressed to meet the doctors, excitement and anticipation replaced the dreary months of horror and grief.

Mom and I took a cab to the hospital. As always, I hid my face beneath a towel.

When we entered the hospital, Mom whispered, "Everyone is looking at us."

I felt mortified but stayed on course and registered to see the doctor. My mother sat next to me in the waiting area.

Some people near us struck up a conversation with Mom. They spoke in friendly and caring tones. After a few minutes of polite chatter, one of them asked in a low voice, "What happened to her?"

I pictured Mom biting her lower lip, as she usually did when she prepared herself to talk. She recounted my acid attack. At the end she said, "When your daughter is hurt like Carol has been, you can't just start over. It hurts so much to see her like this. I wish it had happened to me instead of her."

One lady said, "Such cruelty seems impossible. How could anyone purposely use flesh-eating acid against a defenseless woman?"

"People who are backed into a corner will do anything to fight their way to the center again. That's why we're here at this hospital: to fight our way out of this blindness."

A woman's voice called my name from the hallway.

"That's your nurse," Mom said.

She guided us into an examination room where we met the pleasant and knowledgeable cornea specialist. He sent me for tests and a physical and then scheduled my surgery for the following morning.

Mom and I set off to find the cashier's office. In my purse I held the insurance disability disbursement I had exchanged into

American currency. I handed over the thick stack of US dollars. Mom and I had counted it several times.

The hospital's cashier accepted the money and thumbed through it. After a pause, she told me some of the hundred-dollar bills were counterfeit—a thousand dollars worth. Shock gave way to seething anger.

In Jamaica, one had to make an appointment to procure foreign currency, and a limited amount was allowed to each purchaser. Since the money necessary for my surgery exceeded the bank's allotment, I had to purchase the difference from the black market. The person who had bought the American currency for me had known I needed the money to pay for surgery, yet he had deliberately deceived me.

Sensing the eyes of the cashier upon me, I took a deep breath. Did she think I was trying to defraud the hospital? Would she call the police?

The cashier pushed the bad money toward me on the counter. I collected it and exchanged it for different bills, saying, "I didn't know. I'm so sorry."

Mom suggested we have dinner at a Chinese restaurant she'd seen about a block away from the hospital. As we were crossing the wide and busy street, Mom stopped in the center of the road and cried out, "A speeding car is coming right at us!"

We ran toward the curb. My foot twisted, and I stumbled. Mom pulled away from me. My legs crumbled, and I collapsed onto the asphalt like a drunk. I heard screeching brakes. In that split second, I thought of two things: Dale and death.

My trembling body felt around and touched a car. I lay almost directly under the front bumper.

Strong arms lifted me, and I leaned heavily against the person who helped me to the sidewalk. A deep male voice said, "I'm so sorry."

When I asked about my mom, he told me she had safely reached the other side of the road.

I ran my hands over my body to see if I was still in one piece. Then I wiggled my feet. There were no broken bones, though I felt weak and dizzy.

I did not want to cry, but stupid tears trickled down my nose.

Away from the road and in a safe spot out of the way of traffic, I thanked the gentleman who'd helped me. After I assured him I was all right, he went on his way.

Mom helped me clean up. Her voice cracked as she tried to cheer me up.

Once we'd calmed down, we completed our walk to the restaurant. Mom purchased dinner to go, and we took a cab back to the hotel to eat in the privacy of our room.

That close call brought back memories of a near-fatal car accident I'd had at age twenty-three. I was being driven to the airport. The car windows were rolled down, and I was enjoying the freshness of the evening breeze. As the utility vehicle approached a bridge, it suddenly swerved to the left, flipped over, rolled three times, and settled upside down in the river. Water instantly flooded the car. The driver lay unconscious next to me. My head pounded, and my heart throbbed, but at least I was alive. I forced myself to ignore the dark whispers in my mind telling me, "You're not going to make it. There's no way out."

With shaking hands I frantically felt for a way to exit the vehicle. When I found the latch of the vehicle, hope came to me. I pulled it down, and with all my strength, I pushed forward, and the rear door opened. Tumbling out of the vehicle I fell into the water. Voices in my head repeated the phrase, "You are not going to make it; at this hour you will die in this river." I contradicted those voices, affirming aloud, "I *will* survive." I started to swim.

At the river's bank I heard vehicles passing on the bridge and voices of people coming down from the road to the river below. With my body shaking like a leaf in the wind, I crawled up the river's bank. I felt sick to my stomach. The voices in my head continued to whisper, "You are not going to make it!" Wanting to live and fearing death. I reasoned that I should be standing upon my feet. I looked around me, and there was a tree. I knew the tree was strong. On my knees I crawled to the tree. I reached out and

grabbed hold of the trunk of the tree, and pulled myself to my feet. I heard excited voices down at the wreckage. I knew people had come to rescue the driver.

"Carol," my mother said, "I can't believe a car accident almost took your life the day after our arrival in America. Do you think it happened because we have weak faith?"

"No," I said. "I just think life doesn't always go the way we want it to. Things happen that we don't like because we're not in control. I believe that if something bad happens, we need to do something good to turn things around. If we focus on the positive future that will start for me tomorrow, we can reclaim our happiness."

• • •

On the morning of September 20, 1995, I woke early to prepare for surgery.

Under local anesthesia, I lay on the surgery bed, listening to the doctors perform the procedure on my right eye.

A couple of hours after the surgery, Mom and I caught a cab back to the hotel. I took my pain pills and went straight to bed. I awoke in pain and took more pills, then went back to sleep. Throughout the night I took pills to offset the pain, but neither food nor drink entered my mouth.

The next morning we returned to the hospital to have the bandages removed and to discover the result of the surgery. I prayed silently as the doctor lifted the thick dressing.

My right eye filled with light. I blinked a few times and saw—in detail—the doctors, nurses, diplomas, and equipment in the examination room. I read letters on the eye chart like a school child.

My heart leapt for joy. The past year of pain and suffering and failure vanished in an instant. I felt born into the world anew, my life of blindness nothing but a troubled dream. In that splendid moment, I loved everything. America was the only place in the world I ever wanted to live.

I put aside my towel and laughed, danced, and sang in the room, then down the hallways of the hospital.

The doctor gave me medicine to use in the eye. He instructed me to check in at regular intervals.

As we left the hospital, I walked free of holding on to Mom for guidance.

I knew Dale would want to know everything as soon as possible. I couldn't wait to call Jamaica and tell him that I could see!

I looked up at the clear blue sky and then gazed around Miami for the first time. That bright, sunny morning seemed to bring me back from the grave, and every green thing gave off dazzling living energy.

I marveled at the wonders of creation. The birds poured forth their songs clearly and joyously, it seemed, just for me.

I felt like someone drunk with wine. I thanked God for the mellow September air, for the chance of seeing the blue sky again. I thanked Him for the rising and setting sun. God's glory filled my soul with intense delight. I felt like a rose blooming in a country garden.

As I strolled through the hotel grounds, I studied its architecture and artwork. I gazed at the manicured gardens surrounding a bubbling fountain. The sight of fresh flowers filled me with delight.

Over the next several days, the world enthralled me. I watched the sun rise over the forest and set over the palm-lined shore. I viewed distant mountains by day, and at night the stars and moon in the heavens. I saw trees, animals, clouds, rainbows, rocks, flowers, lakes and rivers, birds and bees and butterflies, the sparkle of dew on bushes in the mornings.

The rivers had always flowed, the sun and the moon had always shone, and the bees had always hummed, but all this had been covered by an elusive veil before my eyes. Now, with new sight, my gaze lingered on every beautiful snippet of life.

Back in my hotel room, I took from my suitcase a small album containing photographs of Dale. Sitting on the side of the bed,

I went through the pages. I had not seen my son's face for more than a year. The images brought laughter to my heart.

I held the album close to my chest and imagined my son with me. I wanted to protect him from pain and loss, but I also wanted to teach him how to face life—to strive for happiness even when things turned cloudy and gray. I prayed he would have an easy life, but knew that was unrealistic.

"Lord, help him to draw strength from You, the eternal God, so that when the winds of fate blow, he will not be swept away."

After promising myself that I would get a phone card to call Dale on my next trip to the pharmacy, I felt rested and at peace.

• • •

With the last of my non-counterfeit money, I purchased a supply of eye medication and paid for another week's accommodation at the hotel. This brought me face-to-face with the reality that I had no additional resources.

Refusing to give in to panic, I listened to my heart and waited for God's voice. Either He would miraculously intervene on my behalf, or I would have to practice self-denial to survive.

In the midst of this crisis, God's words reached my consciousness. From the Christian teachings I'd received throughout my childhood, I remembered songs telling of how God would take care of His children. As the lyrics played repeatedly in my head, I felt renewed.

That evening, I stepped out onto the balcony, where Mom sat reading the newspaper. She had two more weeks to spend with me in Miami before she went back home to Jamaica. I would miss her presence sorely, but I knew she was the ideal person to care for my son in my absence. The air tasted fresh. The softness of evening dropped over the city, blurring the sharp edges of daytime. I watched the sweep of headlights from cars on the road, under the city lights.

People strolled. Lovers walked hand in hand. The night sky lent some of its peace to me. A lively wind blew a mild chill over my body, stealing the warmth of the heated room behind me.

The heavens and stars did not primarily invoke thoughts of God. I thought instead of the challenge facing me. My mind swung erratically from thought to thought, finally resting upon Dale. I knew he would want me to stay optimistic. Confidence flowed back into me like a turning tide.

EXPRESSIONS
OF LOVE

Rain fell in the half-light of the early dawn. I listened to the comforting steadiness of the downpour and let the sound carry me back to cool, damp mornings in my village in Jamaica, when I stayed snuggled under my blanket, not wanting to awaken.

Mom called from the bathroom, "Another visit to the doctor today."

I stretched as I swung out of bed. As soon as my feet touched the floor, I picked up the phone on the night table and called for a cab. Remembering that I was now penniless, I took in a deep breath. I hoped Mom had enough money to pay him.

Fortunately, she did.

At the hospital, the doctor expressed concern that my eyelids did not close entirely. I wondered if this was a warning sign that the cornea wasn't thriving, but I couldn't find the courage to ask the question. I reasoned that if something were wrong with my eye, and my doctor was concerned about it, he would inform me. Since he gave me no further details, I assumed I should continue caring for the eye as he had originally instructed.

"Because of the extent of the burns you suffered," the doctor said, "I need to monitor your progress closely for the next six months."

"That's a lot longer than I requested a visa for," I said.

"I'll write a letter to the INS, requesting an extension."

I thanked him for his kindness and then left the office wondering how I could be apart from my son for such a long time, yet wanting to do whatever was necessary to ensure my healing.

Back at the hotel, Mom received a call from the front desk announcing that I had a visitor. I knew no one in Miami. I asked that my guest be directed to my room.

I gasped when I saw my dear friend Jasmine. A strikingly attractive woman, I'd met her eighteen years before, when she'd come to Jamaica on vacation.

Her eyes held mine without blinking. I sensed no reaction whatsoever to my disfigurement.

I ran to her and hugged her. We jumped up and down like children given an unexpected gift.

"I heard about your story shortly after it happened," Jasmine told me. "But when I went to Jamaica last year for my summer vacation, I couldn't find you. None of our mutual acquaintances knew of your whereabouts. When I discovered that you were in Miami, I tracked you down. I'm living here now—I moved to Miami from Boston a year ago."

Jasmine introduced me to her two sons—Dennis, a teenager, and Seth, a toddler—and her boyfriend, Nimrod, the baby's father. They watched TV with my mom as my friend and I chatted.

Jasmine held my cheeks. Her hands cupping my face drove strength back into me. We stood nose-to-nose, eyes locked. Her expression radiated love and serenity, understanding and knowledge.

"Carol," she said, "your face bears only traces of the face I remember, but I see beyond that. Your beauty shines through the scars, and your sweetness is enough to mask the sorrow."

"Jasmine, I am a woman in mourning. My eyes and face are gone; I go about blind with my head wrapped in a towel. I want my old self back. I want to walk the street like a normal person, with poise and elegance, seeing creation and creative things. In

my heart there is a little room, and in that room is a young woman age thirty-two years old. She is waiting and hoping beyond reason for healing to be found here in America; the pain in my heart distantly gone, and the old self restored. That's why I'm here. America is my hope."

By the time we finished talking, night had fallen.

When it came time for her to leave, she paused at the doorway and blew me a kiss. Nimrod shouted, "We all love you, Carol."

A couple of days later, Jasmine and her family visited again. She brought a home-cooked dinner that reminded me of the special Sunday meals back home. Brown stewed chicken simmered in tomato sauce. Rice and beans cooked with ham and coconut cream, spiced with scallion and thyme. Delicious!

At the end of the visit, Jasmine invited Mom and me to stay with her as long as we needed to. We joyously accepted her generous offer. Having a home to live in, even for a little while, seemed a miracle.

That evening we drove to Jasmine's house over a well-kept, wide road. I read the billboards and advertisements on passing trucks and vans. Shops painted in bright colors, enticing people to come and purchase, tantalized my vision. I peeked into cars and studied their drivers and passengers. People scurried about on foot. The whole world seemed wonderful. Again I thanked God for my sight.

As we drove into Jasmine's driveway, the warm scents of rich soil, flowers, and hedges filled the air. Somehow she and her family made room for us in their two-bedroom, one-bath house.

Living with Jasmine's family, watching her sons running and playing and shouting, I felt Dale's absence sharply. I remembered when he was a toddler, and we planted flowers together. He would lie on the beds of soft ferns that laced the garden and roll around in the fresh dirt. What I had scolded him for back then was now a treasured memory.

After graduating, Jasmine had become a secretary, but she found office life boring. So she went to vocational school and received training in carpentry. For many years she'd worked as a carpenter, but when she was diagnosed with breast cancer, she quit the carpentry business.

She needed to work part time to provide for her family, so she now drove a school bus. She came home about 11:00 each morning and left again at 2:00 p.m. to collect the schoolchildren. Her schedule allowed her to spend time with me, pick up my medicine from the pharmacy, and drive me to my doctor's appointments. Jasmine did her best to love, encourage, comfort, and motivate me to do my best. She prayed for me, accepted me, and stimulated my creativity.

When the time came for my mother to go back home to Jamaica, we both found it hard to say good-bye.

"Departures have never been easy for me," she said, "but I'm glad you have Jasmine to take care of you."

I didn't think I could have let my mom go if it hadn't been for my generous friend.

"I'm going to start crying again if I say much more," Mom said, "so just let me hug you."

She and I embraced.

"Tell Dale and Papa I send my love."

"I will. Day and night I'll pray for God to help you achieve what you came here to accomplish."

I thanked my mom and tearfully watched the cab take her away.

• • •

After a checkup with the eye doctor, as I waited in the hospital lobby for Jasmine to pick me up after work, two doctors dressed in white lab coats walked past. From their conversation, I gathered they were surgeons. A thought struck me: maybe my face could be restored with plastic surgery.

The next day I called the hospital and made an appointment to see the head plastic surgeon. Two weeks later, I went in for an interview.

The nurses listened to my story in silence, their expressions revealing horror, rage, sympathy, and compassion. The staff spoke to me politely and kindly and offered refreshments.

While I waited to meet with the surgeon, I considered how I might get assistance from individuals, groups, and organizations to raise the funds necessary to attain my new goal.

When I returned to Jasmine's place, I told her about my ideas. After agreeing to help me write fundraising letters, she pulled out an old typewriter from her closet, set it on the dining table, and cleaned it.

"I love the feel of a typewriter. Nothing makes me feel so in touch with myself."

Her enthusiasm filled me with a desire to write to my family. It took approximately two weeks to exchange letters with people in Jamaica, but lots of mail could be sent back and forth within my six months of recovery and follow-up. Letters would be cheaper than the phone calls I'd been making. In writing I could tell my family how I was doing in more detail and find out about the lives of everyone else in the village.

When I shared my idea with Jasmine, she replied, "I hope you find as much fulfillment in writing as I have."

We went to the stationery store and purchased supplies.

I gave Jasmine the fundraising letters I had used in Jamaica. She read them aloud, and we made some changes. Jasmine typed the new letters for me, and I searched telephone directories for the addresses of local churches, civic clubs, radio and television stations, and charitable foundations. We sent out twenty-five letters with pictures, telling my story and appealing for help.

With that accomplished, I gathered a writing pad, pen, and stamps for mailing my personal letters. I placed photographs of Dale on the dining-room table, determined to have his image in

front of me while writing to him. I put Jasmine's address at the top of the paper and then wrote, *Hi, Dale.*

I paused. Over a year had passed since I last wrote a letter. Tears came to my eyes and fell onto the paper. If I'd stayed in Jamaica, I would still be blind. I wouldn't be able to write.

In my letter to Dale, I expressed my love for him and my sorrow for the pain and anguish he had to suffer because of my afflictions. I shared my faith with him so he too would remain hopeful for a full recovery. I told him how much I missed his physical presence, but how I enjoyed thinking about the fun we had cooking, having meals together, hiking in the hills, and witnessing the marvels of nature.

I encouraged Dale to listen to the news and read the newspapers. He needed to know that he lived in a world full of brutality, where life is a cheap commodity, but I urged him to always have faith and to know that in spite of the ugliness, he could persevere.

I next wrote to Mom. I told her and Papa that I was thankful for America, and doctors, and the sight I had to write them a letter. *I am taking the best care I can to keep my sight going, and I am also trying to get surgery done on my face. Since I do not have enough money to pay the hospital and doctors for their services, my healing will take both time and opportunity. I am grateful to have you as my parents and to be alive. I pray God will yet make something beautiful of my life.*

A few days after I mailed my letters, the head of a television station called and said they wanted to interview my doctor and me. When I called the doctor and told him about my attempts to raise funds for the surgery, he said he did not want to be caught up in public affairs—he would not grant an interview.

Refusing to let his reaction daunt me, I called one of the radio personalities I had solicited. He referred me to a publicist who had connections with radio stations, saying she might be able to get me radio interviews. However, each time I scheduled an appointment with her, something came up, and she canceled.

I called another plastic surgeon and made an appointment, but when the day came, I felt so afraid that he would turn me down like the others had, I canceled the appointment.

It took me a long time to pluck up the courage to reschedule the visit.

Finally the day came. The doctor and his staff seemed pleasant. I told him my story as he examined my injuries. He offered his services for free but said he'd need to find a hospital willing to offer their facility for the surgery. He promised to contact some hospitals on my behalf.

I left the office hopeful.

GYPSY WOMAN

On the way home from my new doctor's office, Jasmine stopped at the market to buy groceries. I don't know why, but for some reason I decided not to wear the towel on my head. I pulled it off my face and threw it into the backseat of the car.

In the store, I noticed several shoppers rubber-necking at me. Most turned away if I looked in their direction, but some just stood and stared.

As I walked down the aisles beside Jasmine, pushing the cart, I gawked in amazement at all the overwhelming choices on the crowded shelves. This land of abundance, I felt, was where I wanted to be, a land of plenty in which everybody has a chance for success.

The colorful seafood in the display cases brought back pleasant memories of the seashore back home, with the fishermen in their boats and the fish-mongers carrying their catch in large pans on their heads to sell on the street corners.

While Jasmine and I stood in line at the cashier's station, a lady came over and pulled my friend aside. When Jasmine returned, she told me the lady said she wanted to help. Jasmine gave me her business card.

A few days later I called and made an appointment to see the woman. She told me she was a gypsy and that she could help me.

One sunny afternoon, Jasmine took me to this lady's place of business—a cottage by the beach. The ocean breeze fanned over

me. A parrot squawked at me. Scattered vendors tried to sell their arts and crafts to the tourists.

We knocked on the woman's door. She opened it promptly and invited me into her parlor. She asked Jasmine to wait outside.

My eyes darted around the small living room that also served as an office. A small wooden desk sat in the middle of the room, with two chairs, one on either side. A telephone, reading lamp, stationery, and assorted trinkets sat on the desk. The crowded room also contained a sofa, end tables, cushioned chairs, lamps, a TV on a stand, and baskets filled with magazines. Artwork and a clock cluttered the walls, each of which was painted a different color: green, red, yellow, and white. Scented candles perfumed the room.

The gypsy woman gestured for me to take the chair nearest the door. She sat across the desk from me. I felt strange and uneasy, but I couldn't put my discomfort into words.

I sat on the chair offered to me and studied the gypsy's thin face. Her smile seemed slow and lazy. She took my hands and caressed them, telling me she could help me heal.

She turned my hands over and looked at my palms. In a gentle, soothing voice, she said, "I will give you ten special stones. Keep them hidden on your body at all times. Do not let anyone see them. If you follow my instructions, you will get better." The way she spoke sounded very convincing. My mind soaked up her promises.

She told me I had to pay $500 for the stones and the first part of the treatment. If I'd had the money with me, I would have given it to her. But since I didn't, I told her I would return whenever my friend could bring me.

As Jasmine and I drove home, I thought about my experience with the gypsy. Something felt wrong. I knew that what she said wasn't true.

I told Jasmine what the woman had told me. Then I said, "This is the work of the Devil. How could stones hidden on my body possibly heal me? Anyone with common sense would know I need doctors and surgery to restore my face. That woman is a con artist."

"Many years ago," Jasmine said as she drove, "I went to a fortune teller. I paid her twenty dollars to read my palm. She told me I would always have bad luck, but she had remedies to change my bad luck to fantastic luck. Wanting to believe her, I went back to see her several times. I ended up paying her a thousand dollars, but I don't believe she changed my luck at all."

"The gypsy said she could help me, and I do so want help. But I'm not sure that's the kind of help I need. I told her I'd come back. I hate to break promises, but I am never going to that place again."

· · ·

At home, after Jasmine went through the mail, she announced, "There's a letter for you." It was from my mom. I ripped open the envelope and read the letter aloud. She wrote, "The family is doing well. Life in the village is the same as always. The people of Mount Vernon just live their lives day to day. Dale is doing well in school, and he is a semi-finalist in the spelling bee competition. I urge him to do his best in school, and I let him know every day that he is our hope."

Before my tragedy, I had been my mother's hope. She'd worked tirelessly so I could get through school. However, life didn't turn out the way Mom and I wanted. Now the focus was on Dale to do well and make the family proud.

The second half of Mom's letter had a different tone to it. "I have never known pain like this. The images of you in my head have burdened me. I am living in my own private hell. I am surrounded by family and friends here, yet loneliness washes over me in waves that make me weak."

I used to think that bitterness and happiness were choices we make, but as I saw how angry my mom was because of what had happened to me, I realized that emotions often fall upon us regardless of our faith.

I thought carefully about what I could say in my next letter that might lift my mother's spirits.

. . .

Three weeks passed, and I had not heard back from the doctor on the progress of finding a hospital for my surgery. I phoned his office but got his answering machine. I hung up without leaving a message.

The next day the plastic surgeon called. In a somber voice, he told me he'd had no success with any of the prospective hospitals. He said he was very sorry and wished me better luck as I moved on. My eyes filled with helpless tears.

I called a local church I'd written to appealing for assistance. Though they had not replied to my request, I asked to meet with the pastor. He arranged for me to visit the church.

The people there stared at me, obviously appalled at my appearance. My tongue refused to utter the request I had prepared. I retreated in shame.

I trudged back to Jasmine's house, cowered in my bedroom, and wept until nightfall.

When I came out for dinner, Jasmine said, "A letter came from Jamaica for you today. It's from Dale."

With his envelope in my trembling hand, I settled on the sofa near the window and imagined my son with me. Just holding his letter—something he had recently touched—brought joy to my aching heart.

Dale wrote that he wanted me to get better quickly and return home to him; he couldn't wait to be with me again.

I want the same thing, too, my son, I thought.

A sliver of light shone through the darkness and a gentle, ethereal voice whispered, "This is not the end, Carol. You are still young, and you have a brain. Keep using it. Never give up on life."

I wrote back to my son, *Dale, I love you with all my heart. Your grandma and grandpa love you too. I expect you to be obedient to them. Do well in school. And always remember, I have confidence in you for everything.*

Writing to my family became my nourishment, my life, my being.

• • •

My seeing eye began to feel uncomfortable. On Monday morning, when I went to the hospital for one of my regular post-surgery visits, I told the doctor about the change in my condition.

He sat me down before a microscope. At the end of the examination, he told me my eyelids were so badly damaged from the acid burn that the muscle elasticity had dissipated. My eyes were not closing well enough to protect the new cornea.

He gave me a new prescription and increased the dosages of the anti-rejection drug and the antibiotics. I would have to visit him more frequently—every other day.

I left the room, my heart filled with anxiety, anger, fear, and sorrow. I almost fell as I entered the elevator to descend to the lobby. I dreaded the long hours waiting for Jasmine to finish work and come get me.

I willed myself to close my eyes most of my waking hours. Just before I retired to bed, I put a piece of non-stick tape on each of my lids to keep them from opening at night. During the day, I used eye drops and artificial tears to create moisture in my chronically dry eyes. I took all the prescribed meds as ordered.

I refused to believe that God had brought me this far only to let me fail.

SACRED WORDS

Nimrod's mood shifted toward me. I became acutely aware of his eyes following me. When we happened to pass in the small house, he lowered his head and then glared up at me from the corner of his eye. I got the feeling Jasmine's husband didn't want me in his home anymore.

Fighting and cursing became a way of life in that house. Seth, the toddler, cried constantly. Dennis, the teenager, rarely said a word. Sometimes neighbors overheard screaming at night and called the police.

Yet Jasmine seemed downright gleeful. She took special care to make herself pretty, and she spent more and more time away from home.

One day, in an animated voice, she told me she'd met a handsome, athletic man who was "vibrant and full of promise— the exact opposite of Nimrod. Whenever he looks at me, the hairs at the nape of my neck stir. Every morning, when I drive into the schoolyard, he's there with a cheerful greeting. He brightens my day." Her face and eyes showed all the signs of a woman in love.

Jasmine confessed that she and this man had slept together a few times. A warning bell went off in my brain. I had a feeling we were all heading for disaster.

Though I cautioned my friend about this man, their courtship grew stronger. Jasmine spent even more time away from home, occasionally taking lovingly prepared meals with her.

One morning Nimrod appeared at the breakfast table, haggard and unshaven. Beads of sweat stood on his forehead, and suspicion lurked in his eyes. "Jasmine is having an affair," he growled. Rage and indignation tainted his voice.

"Did she tell you that?" I asked cautiously.

"She doesn't have to. I'm not an idiot. I also know she told you all about it."

I refused to either confirm or deny his suspicions.

After he left the house, I sat alone for a long time, staring at the wood-grain patterns in the tabletop and wondering what I should do. Part of me wanted to stay rooted because I had no money. Another part of me wanted to flee. But where would I go?

I walked out of the house to breathe some fresh air and to think. Hunger for my mother, father, son, and Carlton welled up within me. My neck and shoulders felt tight. Fear squeezed my heart. I tried to calm myself, to find some bulwark against the rising tide of panic.

Dinnertime came and went. Finally, I returned to the house, scurried to my room, and went to bed. As I waited for sleep to take over, one thought spun round and round: *Oh, God, let me live in America long enough to finish what I have started.*

Early the next morning, while I was in the bedroom applying medicine to my eye, I heard Jasmine come home. Nimrod stormed out to meet her. He broke out in furious bursts of rage, the tone of his voice cruel and cutting. The tirade was interrupted by Seth's cry.

Jasmine told her husband to go away and leave her alone. Then she left the house again.

Moments later, Nimrod yanked open my bedroom door and stomped in. "You mangy slut! This is your fault. I hope you die and burn in hell."

"How can this be my fault?"

"Since the day you came here, Jasmine has spent more time with you than me. You must have put the idea into her head of having another man. I wish those men had killed you!"

Fear ripped through me as he spat out the cruel words. I sensed violence fighting its way to the surface.

Nimrod called the police. We stared at each other in brittle silence until a loud knock came at the door. Nimrod opened it. Two policemen cautiously entered the house.

Jasmine's husband pointed at me with his calloused index finger. "I want this woman to leave my house. Look how ugly she is. And her visa has expired, so she's here illegally. Get her out of here. Deport her back to Jamaica!"

The policemen looked intently at me. I read pity in their eyes.

Ashamed of my ugliness, I kept my face averted as I explained that the Immigration Department had given me a visa extension for six more months. I had received the official documents from the INS weeks before.

The policemen didn't ask to see my papers, but one of them gave a stern warning: "The next time we come here, one or more of you will be going to jail." Then they left the house.

Nimrod started up on me again, accusing me of going into his closet and taking money. When I didn't respond, he packed up his belongings and drove away.

Jasmine, her two sons, and I remained in the house, but by the end of January, we didn't have enough money to pay the rent.

By divine intervention, just before the end of the month, Michael and Maxine sent me a bank transfer of money donated to me from well-wishers in Jamaica. The amount was more than enough to make the rent that month. Jasmine and I praised God, but we wondered how we'd pay the bill the following month.

One evening, Jasmine told me I'd received another letter from Dale. It read, "Mom, life seems unfair. But I want you to know that you have touched many lives with your dignity and personal integrity. You must fight to be the person you were. Fight against the fate that has disabled you and taken you away from me. Please don't let them win."

Don't worry, son, I wrote back. *I won't let them win. I am committed and determined to get my face restored. My courage will enable me to make the right choices. I will persist and persevere.*

• • •

Later that week I received a phone call from the pastor of a church in Connecticut that Paulette Allen had mentioned to me when she visited my home in Jamaica.

"Carol," Pastor Milhaus said, "your suffering has touched hearts here in Hartford. My entire church body has agreed to help you. It took a long time for me to find a doctor who could help you, but I finally did. He is in Orange County, California, and he's a member of our church organization. He'd like to meet with you to see for himself the extent of your injury. His name is Dr. Robinson. I sent him copies of your photographs, along with a brief description of what happened to you so he and his staff can prepare themselves."

Pastor Milhaus's words warmed my heart.

"I also gave a brief description of you to a friend of mine who is an elder within my church organization in Los Angeles. I asked him to find someone from the church in Orange County to arrange for a motel for you to stay in and to help you upon your arrival."

I rejoiced in gratitude and again envisioned my goal of restoring my face.

"If you can be ready to leave Florida in two weeks, I'll send you a plane ticket," Pastor Milhaus said.

Without hesitation I said yes and thanked this generous man.

With good news to share with my family, I sat at the dining table and wrote letters to Mom and Dale, informing them about the new opportunity.

Three days later I received the plane ticket, courtesy of American Airlines. I waited with much anticipation for my travel date, daydreaming of California and the promise of a better life.

Happiness penetrated me deeper than any sorrow I had ever felt. In my mind's eye I saw sunlight kiss the roses and morning glories.

As I counted down the days, my thoughts turned to the future. I believed that God was going to work in my life while I was in California. After my face was restored, I would return to my Jamaican village with my head held high, feeling as proud as a peacock. Papa would see no trace of the ugly images he saw in the newspaper.

My spirits lifted. I prayed God would make something beautiful out of my life.

IN CALIFORNIA

On the long flight from Florida to California, my thoughts raced wildly. Soon my ruined face, frozen with scars, would thaw, and I would be able to look decent, if not beautiful, in the eyes of society. I could walk with my head held high. In California I would make a new life and a new name for myself.

My heart swelled with gratitude to the beneficent God of this earth.

A welcome party of three met me at the airport. They walked toward me with smiling faces.

The man introduced himself as a friend of Pastor Milhaus and the two women with him as his sister-in-law, Candace Bell, and one of Candace's friends. Candace volunteered to transport me to doctors' appointments, the market, and church. I thanked her effusively.

As we journeyed from the airport to the motel that would be my home for three months, I felt as if I had landed on another planet. A constantly moving stream of cars and trucks zoomed by, dense and fast. Sidewalks were jammed with people—businessmen and women, shoppers, tourists. The driving energy seemed huge, deafening, and frantic.

I felt overwhelmed. I wondered how I could ever fit in.

The motel sprawled in two-story structures surrounded by colorful gardens. My escorts led me to a lower-level room next to

a swimming pool. I set down my luggage and glanced around the room. It looked more like a studio apartment than a motel room. It contained a king-sized bed, a television set, a dressing table, a small fridge, a microwave, a dining table, and an easy chair. Thick floral drapery covered the large glass window and sliding back door.

"Do you like it?" Mrs. Bell asked.

I grinned. "Oh, I definitely think I will enjoy living here!"

"We need to go shopping for food, but I'd like to encourage you to remove the towel over your face."

I hesitated, but the others agreed with her, so I took it off.

From the parking lot to the market, and then to a restaurant, I witnessed various expressions on the faces of strangers. Some shrieked at the sight of me. Others stared in horror, then pity. I flushed deeply. My body tensed. I felt inadequate. I did not belong.

Then I thought of the exciting step I was taking to what might be the start of a great life.

When I returned from shopping, I lay in my king-sized motel bed and slept soundly.

The next morning, Mrs. Bell stopped by to check on me. We enjoyed a long, leisurely conversation. We broke through the barrier of strangeness to a place where we felt familiar with each other and began to use the kind of conversational shorthand that long-time friends employed.

"A terrible thing happened to you," Candace said, "but you don't pull it around you like a shroud. I like that about you. I can see that you want to move away from it. If there is anything special you want me to help you with, please let me know."

Fundraising came to mind. Pastor Milhaus had assured me his church would pay my motel bill for three months, but they would not leave me in the cold if I needed to stay in California longer. I'd arrived with $300 in my wallet, needing medicine, food, and personal hygiene items. With no health insurance, I couldn't afford to buy a month's supply of medicine. I knew the church could not offer lasting support.

"Could you help me raise funds for living expenses and medical needs?" I explained what I'd done in Jamaica and Florida and showed her my letters and pictures. She asked to take them home to consult with her family.

A couple of days later, Candace visited again. "Carol, my family has agreed to let me help you with the fundraising project. I promise you I will help raise funds in the best way I know how."

We shook hands and then went to the bank to open a joint account to receive the funds, using one hundred dollars from the three hundred I had left.

On her next visit, Candace brought her husband and her daughter, Cynthia, to meet me. I found her family warm, loving, and understanding.

Cynthia, a psychologist, offered her services to me. Once a week I met with her in my motel room for counseling. At each session, she brought me gifts of candy or pies.

• • •

I made an appointment with Dr. Robinson for 4:30 p.m. on Monday. I would be the last patient of the day.

I felt a surge of anticipation as I traveled to the doctor's office. I was moving straight toward my goal.

Outside the office I took a deep breath, sensing victory within my grasp. As I reached for the knob and pushed open the door, tears of happiness formed in my eyes. I took a seat, smiling and crying at the same time.

Dr. Robinson and a staff dermatologist greeted me with warm handshakes and then ushered me into a plush office suite.

At a large desk, Dr. Robinson spread out the pictures Pastor Milhaus had sent him. There were two sets: the last portraits taken before my tragedy, and ones taken four months after it.

I pointed at the before photos. "That's me, Carol Guscott." My fingers shook as I indicated the other set of pictures. "These show only a shadow of Carol."

Dr. Robinson nodded in understanding. "Your case is the most poignant I have studied in my many years of surgery, and the one most deserving of fulfillment. I'd like to see you rise up and face the world again."

He tapped his fingers on his desk, as if keeping time with his own thoughts. "I hope I can work a miracle for you." He examined my face, gently tracing the scars. The touch of his cool fingers felt good.

He scheduled the surgery for April 10, almost two months later.

Back in my motel room, I wrote letters to Mom and Dale. I told them I had arrived safely in California, and I'd met the doctor who would perform my facial reconstruction surgery.

That night, after the ritual of taping my eyelids shut, I lay in bed, too excited to sleep, feeling exhilaration and triumph. I turned on the radio and counted the passing hours.

At about two o'clock, sleep overcame me. I dreamed my face was smooth and pretty, just like before.

When I awoke, I felt so happy, I tried to go to sleep again so the dream would return, but it didn't. The rest of the early morning I lay awake, remembering the sweetness of the dream.

The motel offered a free breakfast at the restaurant across the courtyard. I wanted to partake but didn't feel up to being stared at. I feared people might not be able to eat after seeing me. So I fixed something for myself, and from then on prepared meals in the seclusion of my room.

Knowing I would soon be having surgery made me want to do things. In the late mornings, when most of the guests in the motel had left for the day, I slipped from my room, face uncovered, and walked about the yard. I loved the tightly pruned hedges that surrounded the motel complex and the sweet-scented spring wildflowers that grew along the fences. Flowers, especially roses, had always brought me great pleasure. Their fragrant blooms reminded me that even though skies got cloudy, gloomy, and gray,

they always came back to life. I hoped I was in the process of coming back too.

While walking around the complex, I discovered a gym a few doors down from my room. I went in and looked about, deciding to use the facility to prepare myself physically for the surgery. I thought of the likely reactions of the other patrons and quickly pushed vanity to the back of my mind. I had to be bold if I didn't want to be crushed.

My first day in the gym, I received mixed reactions. Some of the men talked with me cheerfully, as if they did not see my disfigurement. The women left when I entered, and children cried at my approach. People came out of the restaurant and stood at the door of the gym to stare at me. Instead of covering my disfigurement with the towel and walking with my face to the ground, I stared back and giggled, inspired by the knowledge that I would soon have a nicer face.

Every morning, I spent at least two hours exercising. I worked out hard and felt good from it. At times I pretended I still had the healthy body and beauty I'd once possessed.

The reactions of the people I met around the motel complex changed. The more they got to know me, the less important my disfigurement seemed. I came to realize that people cared more about the way I saw the world, the way my spirit soared, the way my face transformed when I smiled and laughed.

One bright mid-morning, the sunlight stabbed into my eyes, causing a sharp pain. I hurried back to my room and prayed while applying medicine to soothe the discomfort.

Upon awaking the following morning, my sight had decreased, and the eye still hurt.

Oh, God, please don't let me go blind again!

I asked Dr. Robinson to recommend a good eye doctor. He called Dr. Sampson, an ophthalmologist, and asked if he could see me. He got me in right away.

Dr. Sampson discovered I had an infection. A bad one. He applied different eye drops. "Come back to see me every other day. I need to monitor your progress."

With new prescriptions in hand, I stumbled out of his office in a daze of pain and worry.

Back in my motel room, though the day had turned hot, I felt cold. I did not sleep peacefully through the night.

Every other day I religiously visited the doctor. I gradually noticed an improvement in my sight, but it didn't seem as clear as when I'd arrived from Florida.

Two weeks later, after an examination, Dr. Sampson reported that the infection was healing beautifully. His words gave me strength and a renewed sense of hope.

• • •

Candace went to a friend of hers named Barbara Allen and told her about me and the fundraising project. Barbara asked to meet with me, saying she wanted to help me raise funds. She said she was an expert fundraiser, equipped with a post office box and a toll-free telephone number.

One sunshiny morning, Barbara and Candace, along with their husbands, visited me in my motel room. They drafted letters and mailed fundraising packets to businesses, organizations, and groups across the state.

As donations started pouring in, Barbara said we needed to get a charity tax-deduction number and have the donations deposited into a trust fund rather than into my personal checking account. Barbara recommended a lawyer, who was a family friend, to do the legal work and govern the trust fund.

Barbara, Candace, and their husbands went to this attorney and set up the trust fund to accept donations on my behalf. The four of them appointed themselves as board members of the trust fund.

One of Candace's fundraising letters went to a Jamaican man she knew named Collin. After receiving her letter, Collin told Candace he wanted to meet me.

He called my motel one Sunday. We talked about the places and people we both knew in Jamaica. It felt wonderful to talk with someone who had been born and lived in the same country as I and had been to many of the places I had visited.

He mentioned other Jamaicans he knew who were living in various parts of California. He said that a Jamaican friend of his named Leonie lived close to my motel. He offered to give her my number and ask her to call on me.

Collin told me that he sold ideas to businesses for a living. He promised to take some of my fundraising letters to the small companies he serviced and ask the owners to donate to Candace's account for me.

"People need each other," I said to Collin, "especially when we're not well. To have someone like you asking others to reach out and help me is an act of kindness that brings beauty in the midst of pain."

• • •

Reporters from the *Orange County Register* and the *Los Angeles Times* interviewed me and printed my story. A television reporter from NBC came to my motel room with her cameraman and interviewed Dr. Robinson and me. They broadcast my story on prime-time news. Readers of the newspapers and viewers of the television program donated money.

Fundraising hadn't worked for me in Florida, but it did amazingly well in California.

This is definitely the place for me, I thought.

Candace told her pastor my story, and he invited me to attend his church. He said he wanted the congregation to know about me and to help.

I had not stepped foot in a church for more than eighteen months. Being back in a house of God felt refreshing, like a rebirth. I sat with the Bell and Allen families.

At the end of the sermon, the pastor asked me to come to the front. Candace and Dr. Robinson went up with me.

The pastor spoke of the good work their sister church in Connecticut had started for me, the act of humanity Dr. Robinson had undertaken, and the role that the Bells and Allens, members of their church, were playing in my life. He made an appeal, and offering baskets were passed throughout the congregation. People donated money to my trust fund. I marveled at the goodness of God and the generosity of my fellow human beings.

Afterward, Barbara invited the Bell family, some church members, and me to her home for dinner. As we mingled in the living room, the spiritual company soothed and consoled me. Dinner covered two tables spread with white linens, overflowing with vegetables, fruits, and meats. I had never seen so much food served in a home before. The leftovers could have fed an army. Everyone ate and talked cheerfully, and I felt the richness and beauty of life surround me. The following week, I received a large box from Candace's daughter, Cynthia, who taught Sunday school. It contained hundreds of cards and letters created for me by the children of the church. I pictured the many little hands that had worked hard to create beautiful cards and write sentimental notes. Tears came to my eyes; I felt truly loved.

One morning in March, five weeks after I arrived in California, Candace handed me a new pair of pants and a coordinating blouse. I wondered if she was telling me what I had been wearing wasn't good enough. She told me to expect a surprise visit.

For a brief, fanciful moment I wondered if the surprise visitor might be my ex-boyfriend, Carlton. I pictured him searching the world for me and finally finding me, waiting in a nearby hotel to surprise me. I smiled at the ridiculous notion. I knew it wasn't him. But I couldn't think of anyone who would contact Candace to get her approval to surprise me with a visit.

I showered and put on my new clothes. For the first time in a long while, I actually felt beautiful.

THE CHOSEN SHELTER

I sat in my motel room, watching TV, when a knock at the door interrupted my evening. When I opened the door, Candace and a tall, handsome, athletically built man smiled warmly at me. He hugged me tightly and then said in a strong voice, "I am Pastor Milhaus."

I stood in the doorway in disbelief. Though we'd spoken on the phone, I had never met the man from Connecticut who'd arranged for my flight from Florida to California and my appointment with the doctor in Orange County. I gladly invited them in. After a few moments, Candace left.

Pastor Milhaus and I strolled around the motel complex, getting to know each other. He periodically stooped to inhale the fragrances and to admire the beauty of the blooms. He delighted me with unexpected phrases from the Bible. As we walked, I gazed up at his handsome face. He did not seem to care much about how I looked.

My heart sang with joy, excitement, and hope. For a while, I forgot the haunting disfigurement of my face.

He offered me a ride in his red convertible. I sat in the passenger seat, and he spirited me away, pouring vigor into my stale life.

Pastor Milhaus was scheduled to preach at a church in Los Angeles the following day, and he invited me to attend with Candace, her husband, and her friend from the airport. The man

who'd accompanied Candace, her brother-in-law, served as head elder of that church. I would be a special guest.

During Pastor Milhaus's sermon, I stood next to him in front of the congregation as he told my story. Then he proclaimed the words of God over me. Tears poured from my eyes, and amens fell from my lips. I repented of my sins. He appealed to God for people to help me, and the congregation donated money.

After the church service, people swarmed about me, expressing their best wishes for the future. Their outpouring of love and support overwhelmed me.

From the crowd, a Jamaican woman came up to me and introduced herself as Phyllis.

"Is that your natural hair?" she asked.

I assured her it was.

"It's lustrous! I had heard the acid burnt all your hair off."

Her words stung my heart, and I flinched. Then I realized how fortunate I was to still have my hair.

Two weeks later, Paulette Allen called me. "Pastor Milhaus announced in church this morning that Candace's fundraising has collected more than twenty-two thousand dollars in donations for you!"

I was astounded. That money would enable me to stay in California while I healed from my upcoming surgery.

• • •

On Monday morning Candace came to my motel room and told me she wanted me to go with her to see a shelter she thought I should move into.

"All the women and children living there either go to training or to work or to school in the daytime to improve their lives so they can take care of themselves in the future. No electronics are allowed: no radio, television, or fridge. But it's a nice place. I've toured the buildings with the suite manager, and I shared your

story with her. She keeps the place very clean. I'm sure you'd like it there."

My body tightened as I listened to the details. "I don't want to live in a shelter," I blurted out. Sharing a tight space with several women and children would not be ideal with the massive surgery I had coming up. I feared infection in my wounds. I needed a quiet, peaceful environment where I would not be vulnerable to other people's germs or infectious diseases.

Besides, I couldn't imagine being cooped up in a shelter day after day without the sound of a radio or TV to get my mind off my sorrowful life. I was sure living at a shelter would bring down my hope to rise up again.

"I heard that over twenty-two thousand dollars was donated for my living expenses. That should get me a little apartment, don't you think?"

She waved aside my rejection. "Just have a look. It's a nice place."

A couple of days later Candace came to my motel room with a friend named Ann, who had taken a tour of the shelter with her before coming to see me. She gave a good report and said I should go live there.

A few days later Candace came by with another friend, Ms. Bessie. She encouraged me to take Candace's advice too, claiming the shelter would be good for me.

I appreciated Candace's help and wanted to be loyal and honorable. She was my connection to the world. How could I explain to her my fear of becoming a nobody?

I stared at my hands, clenched tightly in my lap. I pleaded with her to understand my perspective. She refused to see my point of view.

• • •

I met Dr. Robinson at his office for an overview of the upcoming surgery, and he performed a physical. All indications showed that I

was in good health and ready for the surgery. He told me someone had called him to get more details about my tragedy, the upcoming surgery, and the expenses. This potential benefactor had promised to send money for my fund. My spirit exulted in the news.

A week later, I received a call from the lawyer of the trust fund. He asked if he could come see me about an important matter. I told him yes.

Less than half an hour later, he arrived at my motel dressed in a tie, coat, and white shirt, briefcase in hand. I opened the door, waved him inside, and offered him a chair. I took the seat opposite him.

"For a couple of weeks now," he said, "Mrs. Bell has been pressuring me to turn the money in your trust fund over to her daughter's account. I've refused. But she keeps calling, demanding the money. First thing this morning, she burst into my private chamber, grabbed me by the collar, and demanded the money. She actually pushed me so hard I fell backward into my chair. I was fearful of her, but I still refused."

I sat there in shock, stunned at the actions of the Christian woman I'd considered my friend.

"Carol, I was contracted to manage and protect the trust fund for you. That money was donated to help you, and you are the only person to whom I will ever hand any of it. Tell me what you want me to do."

I had no idea what to tell him.

I felt as though I was at a fork in the road of my life. Whichever path I chose, I would always wonder if I'd made a mistake.

TRUST FUND CHAOS

Barbara Allen and her husband came to see me at my motel. I invited them in. They sat on the edge of my bed.

"Carol," Barbara said, "I'm not supposed to tell you this—I was sworn to secrecy. But I know why Candace is demanding that the lawyer release the money in your trust fund."

I asked her to explain.

"Pastor Milhaus told her a wealthy New York businessman has promised to send two hundred and fifty thousand dollars to your trust fund. It should arrive in the next three days."

I asked her why a New York businessman would send me such a generous donation.

"He has specified that the money is to be used for your surgeries, health care, and rehabilitation. After your face is restored and you are well, he wants you to use whatever money is left over to go to college and get into a good profession."

For a moment I basked in the dream of getting a college education. I pictured myself on graduation day, dressed in cap and gown, with a diploma in my hand. This seemed too good to be true. I could get all the surgeries for my eyes and face and also have money for college?

"The problem is," Barbara said, "Candace wants to dissolve the trust fund and have all the money transferred to the joint checking account you have with her so she can access it. When the two-hundred-fifty-thousand-dollar donation comes in, she plans

to transfer it all to her daughter's business account. That money would be under their sole control. There would be no oversight by me, my husband, or the lawyer."

"Why would she do that?" I asked.

"She wants her family to have total control of the money donated to you. However, I'm afraid that if this large sum isn't kept in the trust fund, it will disappear. The lawyer's sole priority is to protect the money in your trust fund—to make sure it's spent on you for the reasons it was intended when it was given, but I'm not convinced that Candace has your best interests in mind."

When the trust fund was originally created, there had been harmony between all these fine people who cared about me. I recalled the day we opened the account—five people in a cheerful mood, sitting around a table. We read the legal documents, the lawyer explained it all, and we signed where we were supposed to. Then the lawyer filed the paperwork with the authorities.

From that time on, no one had sought my opinion or included me in any decision-making regarding the use of the money that had been donated to me. I had trusted my friends to do what they thought best. I saw this as the ideal way to keep that money secure for my future.

Now one individual wanted the trust fund done away with because she thought the funds would be safer in her daughter's business account.

"It seems to me," I said, "that Candace must expect to personally benefit from this in some way." I called the lawyer immediately and asked him to keep the money in my trust fund.

After Barbara and her husband left, I went to the gym to rid myself of stress. While I was running on the treadmill, Candace walked in, dark glasses covering her eyes. Her daughter, Cynthia, followed.

"Carol," Candace said, "I need you to tell that lawyer to turn the money from the trust fund over to me. I've asked him for it time and time again, but he keeps refusing."

"Why do you want him to transfer the money?" I asked.

"I don't trust him anymore. He's friends with Barbara Allen and her husband. They recommended him to me and told me he was an excellent lawyer. Now I believe otherwise."

I asked her what had caused her to change her mind, but she wouldn't say.

"Carol," Cynthia said, "Mom and I only want what's best for you. We're trying to protect your money. It would be much safer in my account than in that man's grasp." Her mouth tightened.

"The lawyer said he wouldn't give the money to anyone but you," Candace said, "so I want you to get it from him and then give it to me."

I bit back the accusations that sat on the tip of my tongue. I could not confront Candace with what Barbara had told me in confidence.

"I'm not going to give you that money."

Without another word, Candace and Cynthia stalked out of the gym.

I pedaled the exercise bike for a long time. Then I took a deep breath and slowly let the muscles in my neck and stomach relax.

Not half an hour later, Barbara and her husband returned. Not wanting Candace or her daughter to see them at the motel, Barbara invited me to go for a ride with her and her husband. I gladly agreed. I wanted to get away from the motel compound for a while to ease my mind anyway.

She stopped the car at a quiet spot in a park. We talked about the fund. She suggested I take away Candace's authority and appoint her in Candace's place. She assured me that she and the lawyer would always be there to help me and that I could trust them.

I wanted to please everybody. Candace and the pastor were the ones who'd brought me to California. They would be unhappy if I dumped them and embraced Barbara. On the other hand, I didn't want to disappoint Barbara, her husband, and the lawyer.

Barbara asked me what I wanted to do. I told her I hadn't made up my mind yet, and that I tried never to make important

decisions when I was angry or sad. I agreed to weigh the pros and cons and then let her know what I'd decided after I'd had some time to think things over.

"I don't want to rush you," she said when she brought me back home, "but you need to make up your mind soon. That large sum of money is scheduled to arrive in a few days."

That evening, I sat at my back door and watched the sun ease out of the day. Children frolicked in the pool. I wondered if Dale was playing happily in the river behind our house. My tension eased.

When I returned to my living room, the front desk called. Candace had left a message saying she would not be taking me to my next doctor's visit.

Later that night, Pastor Milhaus phoned. Irritation laced his voice as he said that Candace had told him I was refusing to transfer the money from the lawyer to her. "You came to America to get well. Concentrate on that, and leave the money matters alone."

His words filled me with an aching sadness.

I didn't sleep well that night. I wished that everyone concerned could gather together and talk openly about the money in the fund and the money to come, but apparently that was not to be.

The next morning, in a state of sad acquiescence, I called the lawyer and instructed him to transfer the trust fund money into the joint checking account I had with Candace.

During the pregnant pause that followed, I knew he was trying to comprehend my change of heart. Just the day before I had told him I wanted the money to remain in the trust fund.

"You're a fool," he finally said. "But if that's what you want, I'll arrange it."

The money that had made me so happy now made me sad.

THE MEETING PLACE

Barbara and her husband took me to my next eye doctor's appointment. On the journey home afterward, she drove me to the bank, expecting me to add her name to the joint bank account that I share with anger.

The rest of the way back to the motel, neither she nor her husband spoke to me. As soon as I got out of the car, they sped away, the tires kicking up dust.

I called their house many times to explain, but they refused to talk with me.

Pastor Milhaus phoned to let me know a meeting had been scheduled for me in Dr. Robinson's office with the lawyer, the Allen family, the Bell family, and himself. The meeting was scheduled for five o'clock the following afternoon.

Pastor Milhaus picked me up in his rental car. Along the way, he said, "Don't say anything during the meeting. Gentleness is stronger than severity. Just listen."

This money had been donated to me, and I was supposed to say nothing about how I felt? Obviously Pastor Milhaus was on the Bells' side and wanted to protect them. I hated the feelings of distrust I had for the people who'd been helping me. Fear of their motives mixed with fear of missing out on the money that was rightfully due me.

I was also afraid of what would happen to me if I no longer had access to the money in the trust fund. I wouldn't be able to pay

my bills and would likely end up having to live in a shelter. The thought made me shudder.

We all gathered in Dr. Robinson's large office. I sat stiffly next to the pastor. The Bell family walked in an hour late.

The air filled with a clamor of unresolved questions. The Bell and Allen families did not make eye contact with each other.

Dr. Robinson spoke of the surgery he would be performing on me. Then he said, "I have a condominium Carol can use. It was my first home after I finished medical school, and I've been renting it out. However, my tenants are currently in jail, and they won't be coming out anytime soon."

I couldn't believe this kind man was offering to let me live in a real house.

Dr. Robinson turned to Candace. "I'll have to get someone to remove the previous tenants' furniture and put it into storage before Carol's surgery date. If you would be willing to clean the condominium and use the money in Carol's trust fund to pay the bills the last tenants left, she could live there rent free."

Everyone agreed. I heartily expressed my humble gratitude for the doctor's generosity.

Then an awkward silence stretched out. No one seemed to want to discuss the anticipated large donation from the New York businessman, or why the trust fund should be dissolved and the money deposited into Cynthia's business account.

Finally, Dr. Robinson said, "I need to get home. I've been here since early this morning, and I'm really tired."

The meeting ended, and everyone left without saying another word. Apart from Dr. Robinson announcing that I could live at his condominium, the meeting hadn't resolved anything.

Pastor Milhaus took me back to the motel. The next morning he flew home to Connecticut.

The convivial relationship I'd had with these people for two and a half months had passed. I wished there was something I could do to change the circumstances, but I couldn't think of any way to mend the broken friendships. I felt an aching sadness.

• • •

Dr. Robinson advised me to check out of my motel room the morning of the surgery. Since I would need someone to look after me for a few weeks, he asked a retired nurse named Barbara if she would take me in until I had recovered sufficiently to live on my own. She agreed to do so for a few weeks at a minimal cost.

I spent the evening before the surgery packing my feeble belongings into bags. Then I wrote letters to Mom and Dale. I told them that in the morning I would be having the facial surgery, and the doctor would make me beautiful again. I also informed them that I would be moving to a new place after the surgery and would write from there when I was able.

I placed the letters in the mailbox and then walked back to my room, remembering what Jasmine had said to me about how writing made her feel more alive and in touch. I felt exactly the same way.

Early the next morning, I went to the motel office, closed my account, and returned the key. When I asked for a cab, the manager offered me a ride and drove me to the doctor's office for my surgery.

As I rode the elevator up, I realized that if I had not left Jamaica, my life would probably have ended by now. Or I might have lived in sorrow and anger for many more years, finishing my days in the humble house of my father in the primitive village. I would never have been at peace. The people who'd known me from childhood would know how I suffered, and how I had failed.

But now, I was hours away from being a totally different person. After this procedure, I would be proud to return to my village one day, and to go about society free from the mask, holding my head high.

The surgery would focus on my burnt-away nose and collapsed cheeks, seamed with deep scars. Dr. Robinson planned to use tissue from my lower abdomen to replace that on my face.

The pastor of the Los Angeles church visited the surgery room. He prayed with me and the doctors and nurses. Many people who'd read my story or had watched me on television or listened to me on the radio had sent notes, promising to pray for me. The church body in Connecticut prayed; churches in Jamaica prayed; churches across California prayed. With all these people around the world praying for me, and with the presence of newspaper reporters and a TV cameraman waiting to update their audiences, how could God ignore me?

With confidence that I would survive the surgery and find healing, I changed into sterile garments and then declared, "I'm ready."

DOCTOR'S CONDOMINIUM

I lay on the operating table, doctors all around me. Outside, a world of challenges, troubles, and triumphs awaited me.

When I woke, I heard soothing, gentle voices but could not make out the words.

On my second awakening, I made out blurred figures. When I woke again, the blurring began to take shape. Most of the figures seemed to be dressed in white.

The next time, a faint voice said my name. I felt weak and limp and tried to remember where I was.

With the fifth awakening, a nurse told me my surgery had lasted more than thirteen hours.

When I woke up again, I felt the brutal effect of the surgeon's knives all over my body. In intense pain, I sobbed, "Dr. Robinson, help me! I'm dying!"

The nurse responded, "Dr. Robinson is in his office, finalizing travel arrangements for a San Francisco seminar he'll be attending in the morning. While he's away, the doctor who helped him with the surgery will see you."

Barbara assisted me into a wheelchair. Accompanied by another nurse, she wheeled me to the elevator and down to the lobby, my head covered in bandages with small cracks in the wrappings for my lips and nostrils. I felt drowsy, half asleep.

I heard rain falling heavily outside. From behind my wheelchair, the other nurse said, "This rain isn't going to stop anytime soon. I'll go get an umbrella to cover her."

They wheeled me to the curb where Barbara's car awaited. Both nurses helped me from the wheelchair into the front seat. Barbara fastened my seat belt and then took the wheel. She drove at a sedate pace. My excruciating pain increased with every movement of the car. I groaned repeatedly.

The rain was still coming down when we reached Barbara's place. We waited in the car a while to see if it would let up, but the storm continued. Finally Barbara slipped out of the car and went into her house. She returned with another wheelchair. After opening the passenger-side door, she touched my shoulder. "Carol, turn your feet toward me. Push your body forward, and give me your arm."

Still partially drugged, I followed her instructions as well as I could, but it felt as if we were participating in the sport of alligator wrestling, with me as the alligator.

When I finally worked myself out of the car, I stood rigidly, breathing heavily, my body crouched a little. I gasped deep breaths; I could not seem to get enough air. Barbara eased me into the wheelchair as rain poured down on us.

My wounds throbbed as Barbara helped me undress. "We need to get you into this bed. The lever to raise and lower it is broken, so we'll have to work together."

After many painful attempts at climbing the stepladder, I successfully got into bed. I turned several times, trying to find a comfortable position, but my body was wracked with pain throughout the night.

Every morning for a week and a half, after much struggle to get my sore body up and about, Barbara took me to the doctor to clean my wounds. As he redressed the surgery site, I flinched at the severe pain his touch caused me.

On returning to the little sick room at Barbara's home, I felt isolated—imprisoned in a world of pain and sorrow.

A week and a half after I moved in with Barbara, she told me she had some unexpected family commitments to attend to and I could no longer stay at her house. "But Candace and I have been talking by telephone," she told me, "and she says Dr. Robinson's condominium is ready for you to move into."

With Barbara's help, I called Leonie, the Jamaican lady Collin had told me about, and asked if she could take me to my new home. She came right away.

Moving clumsily, I got into the front seat of Leonie's car. She drove me to Dr. Robinson's condo at the top of Anaheim Hills. On the journey up the winding street, I gaped in amazement at the tall houses, enhanced with expansive gardens and lawns that seemed bright and welcoming.

When we reached the condominium, I struggled to my feet, slightly crouched over, waiting for enough blood to circulate through my brain to keep me standing. I took an awkward step, then another, gaining confidence as I moved up the sidewalk. The cool evening air felt like a caress against my face. Leonie walked close beside me, carrying my luggage.

My new friend led me across the green lawn beside the house to the back. She headed for an awkward-looking rock next to a concrete flowerpot, lifted it easily, and pulled out a hidden key.

Leonie opened the back door and entered the condominium. I stood at the threshold amidst hanging patio plants, a Jacuzzi murmuring beside me. Everything I saw was amazingly beautiful.

I hoped I was finally leaving the ugliness of my life behind.

BEHOLDING THE
IMPERFECTIONS

After Leonie left me at Dr. Robinson's condo, I painstakingly climbed the long flight of stairs to the bedroom. I immediately went to the bathroom to look at my new face, eager to see the beauty that had once been mine.

What I saw in the mirror shocked me. My bruised face was swollen like a giant soccer ball. Deep lines flanked a small mouth. My lips were an uneven pale pink. My skin, once dark and smooth, now looked like a husk, both black and pasty. Hair tangled on my head, exposing my burnt neck. The eyelids were flipped inside out. The inner pink tissues turned to the surface of my eyelids, constantly exposing my bloodshot eyes. Like a snake, my eyelids could not close.

No! my mind screamed.

My fingers roamed over my face, registering every imperfection.

I stood numb in front of the mirror. After all the years of anticipating this moment, I felt completely at a loss. No words could describe my grief. Disappointment surged through me, cold as ice. Shock and sadness sizzled in my heart. Contempt flooded my soul. Pain radiated throughout my body. I crawled into bed and cried myself to sleep.

Every morning, my sight seemed less clear than the day before. I did not want to return to life without sight. I called Dr. Sampson. After examining my eyes, he said in a concerned voice, "This can't

be true." His expression softened into pity as he ushered me down the hallway to the examination room.

He sat on his stool for a couple of minutes, fingers laced in his lap, looking at me with a mixture of sympathy and anger. He handed me prescriptions and recommended specialists in the reconstruction of eyelids.

"You'll need to see one of these doctors rather quickly to reset your eyelids in order to save what's left of your eyesight."

I prayed for the strength to stand under the weight of my shock, then journeyed home, bitter resentment burning inside me.

Back at the condominium, feeling weak and helpless and plagued by fear, I called my mom at her workplace and told her what had happened. My grandmother was there, visiting. She asked to speak with me.

"You'll probably have to go through another round of surgeries," she said.

Tears gathered in my eyes. "Grandma, I don't have the strength to do that. The operation was hellish. And now I'm worse off than before."

In a calm voice, she said, "Carol, you are just getting a taste of what some people go through every day, those who have experienced more difficulties than you have. Some are paraplegics—they can't move a muscle in their bodies. Others have lost limbs and are unable to take care of themselves. Eventually they accept their fate and do the best they can with what they have. Life is what you make it."

"Grandma," I whispered, "are you saying it's possible God doesn't want to heal me?"

"Of course He does," Grandma said sharply.

"But I've been praying for healing from the first moment of my tragedy, and nothing grand has happened yet."

"It could be you aren't doing your fair share."

"What do you mean?"

"If you want healing bad enough, you'll get it, but you have to meet Him halfway."

I felt confused and frustrated with my lack of understanding for my grandmother's homespun wisdom. But in the long hours of solitude that followed, I thought about what she had said. I wondered what she meant by meeting God halfway.

Later than night, like a prophetic wind, the revelation of my grandmother's words came to me. My share was to endure the surgeries; God's share was to give me the courage and determination to go on.

As I lay on my bed thinking over Grandma's words of wisdom, my heart soared with the anticipation of seeing again...and of looking beautiful again.

The donation from the New York business man popped into my mind. I called Pastor Milhaus. We exchanged greetings, and Pastor Milhaus inquired of my health. I informed him the surgery with Dr. Robinson didn't turn out well, and I needed corrective surgery. "I am calling to get money from the sum the New York businessman promised to donate," I said.

"Carol," Pastor Milhaus said, "it was a phantom."

I went numb and felt paralyzed for a few minutes, seeing my college plans and other hopes dashed. I felt deceived and wondered what next.

• • •

Though Leonie occasionally went to the grocery store and the pharmacy for me, I resorted to public transportation to travel to my doctor's visits.

On my way home from one appointment, the bus driver shouted, "Fire! Get out!"

I smelled smoke. The driver and I were the only people aboard. He opened his door and dashed out. I desperately tried to unfasten my seat belt, but it wouldn't unclasp. My body shook with fear.

The driver came around to my door. He took off the seat belt, grabbed my hand, and helped me out of the burning bus. I half-

walked, half-ran about twenty feet. Even with my dim sight, I saw the big ball of fire as the bus engulfed in flames.

Grateful that I had escaped, tears of relief flooded my eyes.

Another bus came and took me home.

The moment I walked through the door, I prayed fervently and sang old hymns I had forgotten I knew. One played repeatedly in my head: "God Will Take Care of You."

. . .

In my state of helplessness, longing, boredom, and sickness, I had a strong desire to write to Dale. I could not see well enough to write neatly on the white lined paper. I feared that Dale would realize I was no longer seeing as before and would know that the surgery had not had the anticipated results.

I didn't mind so much telling Mama and Papa that the surgery went badly. They were adults who had suffered setbacks and frustrations of their own. They knew life is hard and full of disappointment. But I wondered how the news would affect my son's young mind.

I wanted to dump the stationery in the trash and forget about writing. But something held me to the chair. I sat at the table, letting my thoughts run wild.

I felt the smoothness of the pen between my fingers. Finally I concluded that there was no sense prolonging the inevitable. I couldn't hide my blindness forever; I had to come clean, for my family would find out eventually.

My nose literally touched the pages in my attempt to see the lines on the paper. I had to squeeze the pen between my nose and the paper in order to write. I wrote letters in different sizes, and the spaces between the words were uneven. I crumbled paper after paper until I was reasonably satisfied with my final draft.

In my letter to Dale, I told him that expectation is sometimes different from realization. *My surgery has failed, and I am discouraged. The immense failure makes me want to sit down and cry—and give*

up. But whenever I feel I cannot go on, I remember you and Mama and Papa and all the people living in our little village. Their love for me is helping me to go on with the fight.

I concluded my letter by telling Dale that life is full of challenges. *But in every challenge, there is something positive to be thankful for, and I'm thankful that I am in America. I will continue to seek beauty, and I shall not be dismayed.*

In my mind's eye I pictured Dale trying to figure what to make of the news.

MELTING CANDLE

The next morning, cramps ravaged my face, shoulders, neck, and stomach. I got out of bed with great effort of will.

I swallowed the prescribed medicine and applied the special cream, hoping for a miracle. I stood in front of the mirror and bent forward to get a good look. My jaw dropped open in astonishment. My face had worsened. It looked like a melting candle. The newly transplanted tissue was peeling off, and ulcers had formed around it, draining pus.

I felt sick and weary. My body seemed under attack, relieved only for short intervals. The recurrent waves of pain drained my strength.

I went straight back to bed.

The next day, I took my medication as ordered. Suddenly, I became weak and dizzy. I lay down for hours until I felt my senses return. When I could muster enough courage to pick up the phone, I dialed Dr. Robinson's number. When he answered, I described what I had experienced.

After a pause, he said, "You just want me to come over there, don't you?"

His words lashed my soul.

I hung up.

In my exhaustion, I drifted off to sleep.

Every day I went through the same drama, with minor variations. I accepted the unusual reactions at my body's response

to the surgery. I learned to adjust, fearing swift and terrible death if I didn't.

Part of me wanted to go to sleep forever. I fought the urge to give in, afraid to be found dead on the floor, weeks or months later, my body decayed.

I did not call Dr. Robinson again. The thought of his harsh response stung my mind like salt on a cut.

My face looked worse each day. I applied an increased amount of medicated face cream, hoping to stop the deterioration.

During the third week living at Dr. Robinson's condominium, as I moved away from the bathroom mirror one morning, I felt as if I had the flu. My body weakened, and I shook with fever. I felt dizzier with each passing second. In my mind I cried out, *Help!* But no sound came from my mouth, so my neighbors would not hear.

I grasped the faucets and basin. I knew if I lost my grip and fell to the floor, it would be the end. I seemed to drift in and out of consciousness.

Holding onto the walls, I stepped into the hallway and clung to the rail at the top of the steps. I intended to walk downstairs and go outside to find someone to help me, but I didn't have the strength to do so.

With both hands tight on the rail, I trembled so hard I feared my bones would break.

Finally, I decided to go back to the bedroom and call my doctor again. I shuffled along the corridor, hoping that he would grasp the urgency of my situation. Shaking from fear and fever, I braced myself against the walls and felt my way to the bedroom. My eyelids became heavy, wanting to close. I struggled to keep them open and to stay upright on my wobbly legs.

Jesus, my heart and soul cried, *help me!*

I collapsed across the end of the bed; my body went limp. I couldn't even grasp the telephone receiver.

For a paralyzing moment, the room swam around me. Then I lost consciousness.

I don't know how much time passed before I woke up. When my senses came back, I struggled to open my eyes. They were thick with pus. My face oozed. I felt as if I were breathing through a dirty dishrag.

When I sat up, liquid waste poured from the area of my abdomen where tissue had been taken. The excretions streamed across my body, continued down my legs, and coated my toes. I lay on the soaked bed linens in dripping nightclothes.

Not knowing where else to turn, I poured my heart and soul out before God.

THE VISITS

Candace stopped by the following afternoon. Though we'd had our differences over the business dispute with the lawyer, I was grateful she'd decided to check in on me. I barely made it to the door.

When she saw me, she gasped and then helped me to a chair. As I told her what had happened to me, she was distant and polite.

She called Dr. Robinson and described my condition. He prescribed a strong antibiotic to help with the infection. Candace went out and got the medicine for me, dropped it off, and wished me well.

The next day, Candace came by again. She told me she'd asked representatives from two nurses' registries to meet her at my place. The nurses arrived shortly. At their recommendations, both registries told Candace that because of my intensive surgery, I needed experts to provide the proper health care. Candace refused to hire either registry on the grounds that they wanted too much money to care for me.

One of the nurses, Angela, recommended a young lady living in her home who had no nursing skills but needed employment and could at least keep me company.

A few days later, Angela brought the girl over to meet me. She became so unnerved upon seeing me, she cried out and ran from my bedroom. Angela followed her outside, where I heard

her appeal to the young woman to have mercy and stay with me. Hesitantly, she agreed.

For the next few days, the girl lived with me, but she kept her distance. Whenever I spoke, she seemed to shrink with fear and then choked out a one- or two-word response. She talked on the telephone every waking minute. After a couple of weeks, she left and never returned.

I began to cry. Once I started, I couldn't stop.

I had to hold on to God or let go and die. I told the Lord I wanted to live.

Angela went to her church and shared my plight with an associate pastor. He and another pastor came to visit me.

"Carol," Pastor Weaver said, "you've done everything you can do. Now let God do His thing. Rest in God's words and His truth, and allow that to heal you."

"Pastor," I said, "I know God is sovereign. I've been praying, hoping He would heal me, but He hasn't."

For the next few weeks, both pastors brought me food baskets. Ms. Bessie, the woman who had urged me to go live at the shelter Candace picked out for me, was a member of their church. She accompanied Pastor Weaver with a cooked meal once. They all grieved over the waste of my life and wondered at the ways of God.

Candace hired a Mexican woman to help me, but she couldn't read or speak English, and my Spanish wasn't fluent enough to communicate with her. On the third day, she mixed up my medicines and gave me the wrong dosages. That ended her short stay.

I had no desire for food. For days at a time, I wouldn't eat. I just lay in bed, weak and ill.

When hunger pains made my stomach growl, I finally rose from the bed. Crunched over, holding on to the wall, furniture, or railing for support, I made my way to the kitchen. Once there, I prepared whatever food I could find, just enough to sustain life. As I stumbled about in the kitchen, I felt the sun's warmth penetrating through the glass door.

Then my dim sight traveled to the floor. A dark object, about eighteen inches wide, lay halfway between the glass door and the wall of the house. I didn't remember placing anything at that particular spot. I wondered if a piece of clothing or a dishcloth had landed there.

I gazed long and hard at the object but could not tell what it was. I bent down to pick it up. As my hand reached out, my fingers made contact with a large, curled-up snake.

I released the snake as if I had been burnt. I jumped backward. With strength beyond the natural, I whirled around and sprang atop the kitchen counter. The fingers that had touched the snake tingled. I wondered why the creature hadn't attacked me.

The snake didn't feel fat and round, like pictures of snakes I had seen. Perhaps it was malnourished or sick and was dying. I felt lucky to have been spared.

I stayed on the kitchen counter, sweating profusely, my body trembling with fear. Sounds of the gardener cleaning the yard got my attention. I gingerly climbed down from the counter, made my way through the living room to the side door, and went outside. I told the gardener about the snake in the kitchen. He called for his partner to take it away.

When the danger was past, I realized that God had chosen to show me favor, in spite of the unfavorable things that had happened. I wondered what His purpose was for my life, and when He would reveal it to me. Perhaps He already had, and I'd ignored it.

MIRACLE CURES

One weekend, I experienced the recurring horror of dizziness and nausea. I slipped in and out of consciousness. My head throbbed. I cried out in torment as I went through the motions of getting dressed and in preparing a meal for myself.

I recalled television preachers who claimed that the power of positive thinking could work like magic. I forced my mind to think about happy things, such as finding a husband who would love me in spite of my imperfections. I imagined what it would be like to live in a house with fine furniture and paintings hanging from the walls, or having a well-kept vegetable garden growing in my backyard amidst assorted fruit trees.

In spite of my positive thoughts, I continued to shiver from fever. Medicine and blood drained from the large wound on my face and from the skin-donor site of my lower abdomen. When Monday morning came I called Dr. Robinson. "I need help."

"I'm coming," he said and hung up.

He arrived quickly and rushed to my side. He checked my pulse, then felt my forehead.

He took me back to his office. All the way there, I gasped for breath.

When we neared the office, he called his assistant and asked her to meet us in the lobby with a wheelchair.

The assistant and a nurse met me in the lobby. I clutched their hands. They gave me a brown paper bag to breathe into and then

helped me into the wheelchair. We took the elevator up to the office where they gave me oxygen.

My tests showed a blood count of 3.4 when it should have been at least 12.8. Dr. Robinson recommended immediate hospitalization and a blood transfusion.

Without health insurance I knew I could not afford the hospital bill. In addition, back in Jamaica, I'd read stories of people who had come down with AIDS after receiving blood transfusions in America. The procedure seemed more dangerous than my condition.

I told Dr. Robinson, "My body has been through a lot of stress. Maybe if I add more nutritious food to my diet, and take an extra supply of iron and vitamins every day, my health will improve. Perhaps my immune system has been so weakened that the medication can't cure the infection without my body's natural support."

Dr. Robinson did not agree with my assessment. Against his better judgment, but unable to force the issue, he took me home that evening. As he drove, he promised to send someone to cook for me.

No one ever came.

I hoped that feeding my body the healthiest foods I could afford would help the medicine and ointment do their jobs better. I called Leonie and asked her to help me go grocery shopping. With her help, I ate liver, chicken, and fish several times a week. She brought me a juicer so I could make fresh juices from fruits and vegetables.

But my efforts didn't help.

When Leonie visited next, she saw wet clothes hanging about the condo and asked why. I told her I had no washing machine, so I did my laundry by hand with a scrub brush in the bathtub. Then I hung them on the doors, over the shower enclosure, and on furniture to dry. Leonie offered to take my laundry home and do it for me. I greatly appreciated her sacrifice, especially considering that she had a full-time job and attended school after work.

She noticed my unmade bed and offered to make it. When she saw the linens were soiled since the infection in my face and abdomen continued to soak my bedding, she asked for clean sheets.

"I only have two sets. The other one is hanging on the door to dry."

Leonie called a friend and told her about my situation. The friend purchased a new set of sheets and brought it over. They split the cost.

One evening, after preparing and serving me supper, Leonie hesitated as she washed her juicer. "Carol," she said in a strained tone, "I have to tell you the truth. I'm experiencing discomfort being around you. I feel your torture and misery, but I'm afraid I can't go on seeing you—it's just too much for me."

"I understand," I choked out.

Leonie took my hand in hers. "I wouldn't have the stomach to go through everything you're enduring, but you're a strong woman. You have amazing hope. You always find the strength to bounce back from anything. Nothing seems to keep you down. You are a woman of courage, resiliency, intuition, and creativity, with a deep passion for life. You're going to do fine. You're a survivor."

I appreciated her honesty, but I didn't share her confidence in myself.

Upon Leonie's departure, I called Dr. Robinson. He again contacted the woman he knew who might cook for me, but since she would receive no payment for her services, she decided not to give of her time. Dr. Robinson couldn't find anyone else, so I went back to doing my own cooking.

Day by day, my health decreased. I started to feel much like I had during my childhood years of illness.

Shortly after my birth, my mother learned I had asthma. I suffered severe attacks throughout the first seven years of my life. Along with the conventional medicine from doctors, Mom tried many home remedies. She grated coconut to extract its cream, boiled the cream until it became oil, then sautéed garlic in the oil.

Mom gave me the garlic oil by the teaspoon. She also juiced the buds of the cotton plant and gave me the juice to drink. She even made a tea from a plant called spirit weed.

A neighbor told her to put a snail in my mouth and hold my nose until I swallowed it. When I vomited it out, all the impurities in my respiratory system would also leave, supposedly curing me of my asthma forever. This sounded rather extreme, so instead Mom made me snail soup.

Several times the doctor told my parents I would not make it through the night. Yet each time, I was revived.

I wondered what miracle cure my mom and the villagers would come up with to cure me of my present affliction.

Too weak and weary to get out of bed and walk to the bathroom to take my prescribed medicine, I put the bottles and a glass of water on my bedside table. I continued to apply the medicated cream to my face, took the drugs, and prayed for healing.

Whenever I applied the cream to the open wounds, I felt sick again. Cold sweat poured off my body. One night, I stumbled to the bathroom door, holding desperately to the knob. I attempted to go downstairs, hoping to make it outside to neighbors I'd never met, but strength leached from my body.

I wondered if God would ever come through for me. Then my heart said, "If you don't trust Him, you'll never know."

In my spirit, I heard, *Go wash your face now.*

With shaking hands, I felt my way back to the bathroom, found the faucets, and hurriedly washed my face. I felt my senses gradually returning. I continued to scrub and rinse until all the medicated cream had gone down the drain. When it did, I felt better. The cream had been causing my awful symptoms!

I breathed a sigh of relief and stumbled to my room where I called my doctor and told him what I had experienced.

Both doctors who had performed the surgery came to see me. They hung on my every word and then asked to examine my medication. I heard gasps when they studied the cream and some of my oral medications.

In a low voice, Dr. Robinson said, "This cream was to be used only during the surgery." He took the tube and changed my prescription.

I sat, dumbfounded, as they drove away.

Alone again, I felt immeasurable relief at the realization that there would be no reoccurrence.

And yet the sickness lingered. For weeks I lay in bed like a starving person.

In my lonesome world, radio and TV consumed me. On Sundays, I watched nothing but preachers. I listened intently as they assured me that my faith could heal me if I only believed.

In my dreams I could see clearly, but in the real world I could barely make out even large pieces of furniture. I needed to hold small objects close to my face. I developed astigmatism in my partially sighted eye, which blurred all images. When I ventured outside, I had to shut my eyes for the first few minutes to get used to the sunshine. Once accustomed, I could see a little by screwing up my eyes and blinking.

A large stack of mail accumulated. Most of it was junk mail, but I received a few small envelopes from Jamaica. Unable to read the letters, I set them aside with the intention of asking my next visitor to read them to me.

To fill the endless void of long, boring days, I occupied my hands and mind by immersing myself in domestic tasks. The physical activity proved a comforting therapy. I enjoyed cleaning the house, washing laundry by hand, and weeding the garden.

One night, as I lay in bed asleep, I awoke and sensed something strange near me. My heart pounded, and my flesh shivered. I listened attentively, but all I heard was a dog barking furiously outside.

A surge of fear swept through me. I took a deep breath and let it go, then listened again.

This time I heard the crackling movements of patio chairs in the backyard, followed by a long pause, then someone splashing

about in the Jacuzzi. I suddenly remembered that the lock on the kitchen door was broken. Fear gripped me. In my dark bedroom, I lay still, wondering if whoever was in the yard would eventually walk through the door and up the stairs.

I eased out of bed and tiptoed, crouching, to the window. I parted the drapes slightly, squinted and screwed up my eyes, but could not see anything.

I refrained from calling the police or Dr. Robinson, who owned the condo. I feared that if I voiced any complaint after so much time and money had been spent on me, Candace would use my insecurity against me and force me to move to a shelter. I dreaded that more than a nighttime trespasser.

For more than two hours, I stood frozen in fear and apprehension, until the sounds outside stopped. I guessed the trespasser had left, as I heard nothing more.

The following night the visitor came back. As he or she splashed about in the Jacuzzi, I lay on my back, unable to sleep for fear of the terrifying unknown.

For two weeks this person came at the same time every night. Wakefulness left me fatigued, but I could not call for help without risking being sent to a shelter.

By day, the sun bleached away my fears, and I resolved to set aside my insecurities and think positively. I vowed that if God spared me, I would go through life devoted to knowledge, not emotion. I would learn how to do things, even with blindness.

One evening Dr. Robinson and his wife came to visit. Remembering Mrs. Robinson's elegant beauty, I mentally contrasted my appearance against hers. Envy tore me up inside, but I determined not to show my true emotions. Embarrassment washed over me as I waved them in. I offered them seats, but they refused, saying they had other places to go.

Standing in the dining room, Dr. Robinson said, "Someone has purchased the condo. You need to leave. We would like you to be moved out by tomorrow."

I didn't know how to respond.

Dr. Robinson and his wife said good-bye and left.

Alone, I thought of all I had been through living there. Moving would get me away from the late-night unknown visitor. Was this a blessing in disguise? Although the move would be difficult, I felt God had allowed this to protect me from whatever He saw coming.

But where would I go? How would I survive? How could I go into the world and face people with my severe disfigurement?

FEELING LIKE
A LEPER

D r. Robinson and his wife contacted Candace and asked her to help me find a place to live. I felt like a stray puppy, ready to wag my tail at the sound of a kind word.

Candace located an apartment, but because I had no credit history, nine month's rent had to be paid in advance before I could move in. The large withdrawal almost emptied my pitiful savings.

When I arrived at my new home, I stood away from the movers as they unloaded the truck. The air smelled clean and fresh. The flowing water of a creek gurgled behind me, birds sang gaily, and I imagined trees and flowering plants all around.

Then I heard human screams and sobbing nearby. I asked one of the movers what had happened.

In a scornful tone of voice, the young man said, "The people in the complex are screaming at the sight of you."

I felt hundreds of eyes focused on my disfigured face. The need to get away sparked along my spine, but I could not escape.

Since I had no idea what lay around me, I had to walk by touch. With arms outstretched, I entered my new home without responding to the heartbreaking cries of my new neighbors.

A few days later, one of the apartment managers knocked at my door. She told me the people living there were afraid of me. Some of the tenants had complained of nightmares brought on by the sight of my face.

From then on I went back to covering my face with a big white towel whenever I ventured outdoors.

I lived in constant apprehension for what might happen next. Grief and remorse caused me to foster a grudge against humanity.

I settled into my new apartment and eased into a semblance of a comfortable existence. I kept the curtains drawn, feeling separated from people and society. However, I liked the isolation—at least I wasn't offending anybody.

In the quietness of my new home, I learned to live with blindness once again. My apartment was filled with gifts I'd received that had outlived their uses to their givers. I thanked God for them, but I hated knowing I was destitute.

Still, I believed my life could be meaningful and filled with goodness. I just needed to make the most of what I had. I determined to find ways to shape a life for myself, to find purpose in my days.

I grew flowers, made telephone calls to my son, listened to radio and television, and learned as much as I could about California. I found pleasure in the different accents of the American language and the intriguing names of places. The new sounds rolled off my tongue like poetry.

At times I was happy, in my way; but at other times my mind raced in circles. I had to do something to erase the awful memories of my past. If I didn't take any chances, I would not get anywhere. Moving on with life became my focus.

Some money remained in the joint account with Candace. I had never withdrawn anything from it, for she had forbidden me to do so. However, that money rightfully belonged to me, and my health had to be my first priority. I decided to use those funds to correct my faulty eyelids.

I consulted with the plastic surgeon Dr. Sampson had recommended. He agreed to perform the intricate surgery under local anesthetics in the hospital.

That Saturday night I telephoned Leonie. I told her I would be undergoing surgery the following Monday morning to correct the faults of my eyelids.

"Where did you get the money for the surgery?" she asked.

"From the joint account with Candace. I went to the bank yesterday and made the withdrawal."

"When Candace finds out, she's going to be angry."

"What would you have done if you were in my position?"

"I'm not saying you're wrong. You have just as much right to that money as Candace does. Just be prepared for her reaction."

Candace had been my guardian angel when I came to California. She had faith in me, even when I lost the courage to believe in myself. I clung to the hope that she and I would get along again. I hoped she would not be too upset about my accessing the money in our joint account.

The following Monday morning I went into surgery to correct the faulty eyelids. Hours later, my eyelids had reversed back to God's original design. While I anxiously waited for full healing, I searched my heart and concluded that I would have more surgeries until I recaptured as much of my old self as possible. This would take me to the limits of my faith. I promised myself I would never stop trying.

One morning, Leonie called. "I told my friend Phyllis what you shared with me the other day. She called Candace and told her what you told me. Candace said you shouldn't have withdrawn money from that account on your own. She told Phyllis she wants nothing more to do with you."

I called Candace to talk over the matter. She refused to talk with me.

A few days later, the apartment manager knocked on my door. She said that Candace had come to her and told her she'd closed the bank account we shared. She gave her all the money from the account and asked her to give it to me. The manager handed me

an envelope containing less than four hundred dollars. I couldn't believe the account had dwindled to such a small balance.

Through the months that followed, I listened to the radio with the sole purpose of finding charitable organizations, foundations, and nonprofit groups that might help me. I reasoned, *If they really follow the words of God, they will have compassion for me.*

Each broadcast ended by giving out telephone numbers and addresses. I recorded their contact information onto a cassette tape, then called and begged for food. For some time, I lived on stale bread and canned goods from food banks.

Later, Meals on Wheels began showing up. Volunteers arrived each day with a cheerful greeting and inquired about my health. As they left, they waved good-bye, wishing me well and saying they hoped I enjoyed the food.

Though I was grateful for the sustenance, I felt unsettled when I thought about my neighbors seeing the Meals on Wheels vehicle parked in front of my door. I felt the service carried a type of stigma with it. I had to find a more dignified way of taking care of myself.

I considered what I could do. Perhaps some hobby that might give me pleasure—like painting, writing, or speaking—could be a source of income for me.

Show me the right path, Lord, I entreated.

I reasoned that if I went out and met people, I would have a better chance of getting help. I called churches and asked if someone could give me a ride to attend their services.

A couple of days later, two ladies from different churches responded to my call. Betty took me to her church on Saturdays, Marney to hers on Sundays. I kept my head wrapped in the white towel during the services and the drive there and back.

After a few weeks of attending church together, Marney took me to lunch. She said she wanted to know more about me. She told me her father was the president of the local chapter of the

Lions Club, a charitable organization committed to eye care. Marney suggested I contact them for help.

The following day, I called the Lions Club. The president and vice president, Robert and David, visited me, bringing oranges and canned food. I shared my story with them. They invited me to attend the Lions Club meetings. I accepted their offer.

AMBASSADOR
AT WORK

All of the Lions Club members treated me like a valuable human being. The tone of their voices inspired proud feelings within me, and a loving relationship developed among us.

David Crawford, acting as my ambassador, introduced me to the governing body of the Lions Club International. He got their approval to help me, and the Lions Club took up my cause. I became an honorary member.

A couple of weeks later, David approached the editor of the local newspaper, showed her my pictures, and asked her to write a story about me.

The interview took place at my home. After I poured out my tale, the reporter said, "Carol, you've inspired me. You have courage, perseverance, personality, a sense of humor, and intelligence. Basically, everything about you is great."

My heart swelled at her words.

People read my story in the newspaper and sent donations to the Lions Club on my behalf—along with letters of sympathy, often sharing their own adversities.

The Lions Club referred me to an eye clinic in Santa Monica. I met with the head physician, Dr. Assile, for a consultation. He examined me and told me that my eyelids needed more reconstructive surgery. They had drooped since the last procedure.

The cut skin had healed time and time again, almost closing my eyes. And yet, they were not closing properly.

Two months later, I underwent another eyelid surgery. Dr. Assile seemed satisfied with the closure of the eye and told me he believed another cornea transplant could give me some sight. I rejoiced at his words.

The morning of the surgery, David Crawford drove me to the clinic. With warm blankets over me, my head resting on a soft pillow and another pillow under my legs, I lay on the surgical bed with doctors and nurses all around me. Lovely music played in the background.

Under local anesthetic, I listened dreamily to my doctor and followed his instructions as he removed the cornea. "Look down to your toes, and keep looking down. Don't move your head, just your eyes."

As he stitched the new cornea to my eyeball, I cried out in misery for more medicine to numb the pain. The anesthesiologist released medicine into my vein.

"Now, look up at the light."

I gazed at the large, round fixture above me with great anticipation. The surgical light looked like a kaleidoscope of rainbow colors. I also saw shadows of the doctors and nurses in their green surgical gowns. I was willing to endure much more pain without complaint after that first glimpse of hazy sight.

Two hours later, David drove me home. The following day I returned to the doctor's office to have the bandage removed. I sat in the waiting room and prayed to God for success.

When Dr. Assile removed the dressing, I saw his smiling face and bright eyes for the first time. I looked about me and saw David clearly as well. His eyes peeked at me through prescription glasses. I gazed at his beaming white face, deep wrinkles, gray hair, and stooped shoulders. I beheld the faces of the clinic staff, and the diplomas and certificates that covered the walls, and cried out, "Praise the Lord!"

The doctor and staff expressed their pleasure for me.

As David drove me from Santa Monica back to Orange County, the mountaintops glowed golden and the sky shone pale blue. My heart overflowed with thanks.

At home, I took in each detail of my apartment, eager to see colors and patterns I'd only guessed at. The sofa had a yellow and brown design intertwined with a green background. End tables held vases filled with artificial flowers in brilliant colors. A wide-leafed green plant sat in a white pot on the coffee table. The dining table's top had been stained a smoky gray, and the round metal chairs were painted white, with cushions to match the sofa. Stains covered most of the carpet, but I reveled even in seeing that.

Bookshelves lined the stark white walls, stocked with telephone directories, religious books people had sent me, and other gifts. On one shelf lay a large Oxford dictionary, a bit worn, and my King James Bible and hymnbooks that I'd brought with me from Jamaica, determined that I would read again.

The television sat on its stand, waiting for me to turn it on and actually see what I'd only heard. A cobweb high in the corner above the TV made me smile. It wouldn't escape my next cleaning frenzy.

I opened the front door and looked outside. Rust had deteriorated parts of the metal railing on the porch. In my backyard neighbor's garden, an orange tree sagged under the weight of ripe fruit. My mouth watered with a sudden craving for a big, juicy orange.

A crow cawed noisily, and I shielded my eyes, searching for him. A flutter of wings brought my gaze to a telephone pole a house over. The rascal shouted its taunts for the whole neighborhood to hear. A couple of magpies dove at him, trying to chase him away. I watched the three combatants with a lump in my throat. How I had missed this ordinary, everyday occurrence. I vowed to never take anything for granted as long as I lived.

That evening, I sat on my porch and stared into the night, watching the stars—brilliant and sharp—wink across the sky, filling the darkness.

My success thrilled me so much that I didn't sleep much that night.

At four o'clock the next morning, I arose and got dressed. As I waited for daylight, I wrote letters to Mom and Dale and shared my latest success. *I can see again, and I love you!*

Envelopes in hand, I stepped outside, wearing a baseball hat pulled low over my face to disguise my disfigurement. The sun rose and sparkled on rain-wet flowers. The air smelled cool and fresh as I dropped my letters in the mailbox, then strolled the acreage of the apartment complex. My heart sang.

Now I could refocus on my goals and lay plans for reaching them. There among those plants, trees, flowers, and singing birds, I could make clear, rational decisions. I lost myself in the incredible lushness of it all, letting myself absorb the aura of living things.

I hiked along the bubbling creek I had heard upon my arrival months earlier. It ran sweetly in the early-morning sun. I sank to my knees in the silky grass and gave thanks to God. I felt supremely blessed because I could witness, once again, the wonders and marvels of creation.

A week later, on my third visit to see Dr. Assile for a checkup, he discovered that my eye had started leaking. Holes had appeared between the stitches of the newly transplanted cornea. The problem needed prompt attention.

David Crawford, who'd driven me to my appointment, gasped when he heard the news.

"The cornea is in deep trouble," Dr. Assile said. Then he strode off to order a surgery room made ready.

As I waited, I assured myself that God was in control. He loved me unconditionally. He would show me what to do if I obeyed and listened. He would bring good out of my trials.

With a prayer in my heart, I endured another painful procedure. The doctor seemed satisfied that he had stopped the leakage, but told me he wanted to see me the following day. He needed to keep a close watch on the newly transplanted cornea.

When I returned the next day, the doctor examined me and then gave a long sigh. The cornea still leaked.

I endured the corrective surgical procedure a third time.

On the way home, my eyesight was murky, and I felt miserable. I told David, "It feels like nothing is going right for me. Life is full of disappointments, and I'm afraid of the future."

"I'm so sorry things have turned out so badly for you," he said with compassion.

I thanked him for being at my side and for giving the best of himself to me.

The following morning, I returned to the clinic. The cornea still leaked. My courage drained too, and fear settled over me like a dark cloud.

Every day for a month, I rode with David to the clinic. On each visit, Dr. Assile found another hole. I endured one or two surgical procedures every day in attempts to fix the problem. Every time, I lay numbly on the surgery table, feeling Dr. Assile probing my eye with needles and sewing the cornea onto my eyeball.

By the end of the month, I had undergone twenty-two operations; still my brief period of sight had not been restored.

Dr. Assile handed me prescriptions and talked about caring for the eye. Exhausted, I walked out of the office with David beside me.

On the journey home, traffic slowed to a crawl.

"Carol," David asked, "can you see the beautiful mountain range ahead?"

Biting my lips, I whispered no. Feeling the heaviness of tears coming on, I said, "I will undergo as many painful procedures as it takes for my eyes to get better. As long as there is life, there is hope. I will not rest until I get my sight back."

He played the radio the rest of the way home, undoubtedly too choked up to speak anymore.

Alone at home, I tried to think of happier days. Nevertheless, my troubled mind focused on my difficulties, health and financial problems, discouragement, and dissatisfaction. I felt as if God had abandoned me. I cried out to Him day and night, yet it seemed He didn't hear me. I wondered if He cared whether I ever saw again with my own eyes.

Waking up every day without my eyesight, I began to believe that nothing would ever work for me. I was a complete failure. I would always need someone to help me.

The words of the Bible assured me, "You are not alone. God is with you. He suffers for you. But He is all powerful" (Matthew 28:20, Joshua 1:9, Philippians 4:13, paraphrase).

Like a soldier trusts his leader through the contradictions of war, I determined to trust God, no matter what. One day, my nightmare would end, and I would look back at this time in my life like a distant dream. I simply needed to believe in God and await His will. In the meantime, I would find ways of coping. I refused to admit defeat.

I forced myself to imagine what it would be like to have eyesight that would never fail. That way, I figured, when it really happened, I would be ready. I kept at it for months. But I found it increasingly difficult to keep myself focused on the future when my eyes were sick and blind.

PAPA'S IMPARTED WISDOM

One of the apartment managers notified me that my lease had expired. A new lease would require a raise in the rent, which I could not afford.

Through long, sleepless nights, I reviewed my plight. I could not solve this problem by myself. God would have to open doors for me.

Betty and I attended church on Saturday every week, and we went to lunch after the service. I told her about my urgent situation as she drove from lunch to my apartment. She listened with concern and promised to do what she could to help me.

The following Saturday Betty gave me a telephone number from an advertisement she had seen in one of the newspapers. "There's a one-room apartment available, but it's in a very low-class area."

"All I'm looking for is a roof over my head," I assured her.

She drove me to see the apartment and meet with the landlord. As we crossed a set of train tracks, Betty described the place. "This is a really bad neighborhood. There's graffiti all around, and the apartment is near the railroad track. You'll definitely hear the trains day and night."

In spite of the conditions, I had no choice. This was the only place I could afford.

The landlord explained that his apartments all had two bedrooms and two bathrooms. But he had divided each apartment into two dwellings. That meant I would have one bedroom and bathroom, and another tenant would have the other bedroom and bathroom. My roommate and I would share the common areas of the living room and kitchen and split the utility bills. It would not be up to me to choose my roommate—the landlord would decide that.

I figured the landlord had divided his apartments this way because it was difficult for him to get one person or family to rent a two-bedroom apartment in this neighborhood.

I didn't know where the money would come from to pay for my upcoming month's rent. I would have to live one day at a time, trusting my future to God.

The landlord agreed to rent to me. When I told him I had no financial security, he said he trusted me to find the money to pay him each month. He allowed me to spread the security deposit over a few months rather than come up with it all at once.

Though Betty continued to warn me about the roughness of the neighborhood, I couldn't afford to pass it up. The apartment would keep me off the street and provide me with privacy. At least I wouldn't be homeless or have to live in a shelter.

Once I'd signed the rental contract, the landlord cautioned me to stay away from the alley on the far side of the building. Ladies of the night offered their services there, and in the wee hours, gang members congregated; the police had broken up a gunfight only a few days before.

Betty gasped but said nothing.

All the money I had to my name had come from donations that trickled into my mailbox. I had just enough to pay a month's rent and hire movers.

On moving day, David Crawford of the Lions Club came to my rescue once more. He watched the movers like a hawk, so they worked steadily—no slacking off to unnecessarily increase the bill.

Once I'd settled into my new home, I realized I had to start making some practical plans for my future. I had failed to find any dignified way to earn my keep. Repeatedly begging through letters to individuals and charitable organizations brought a distressing shadow over me.

My inner voice inspired me to reach out to my friend Leonie. I called and asked her to visit. The following evening, as we sat around the dining-room table, I asked her to read my mail, and then I would dictate a letter for her to type for me at work. She graciously agreed.

Among the stack of letters were two from home. Both Dale and Mom had written to me. I asked Leonie to read Dale's first. He wrote, "I want to see you—the real you, not the picture of you in my head when we talk on the phone or I read your letters."

Mom wrote, "I wish I didn't have to share this news with you. You are going through so much of your own, I didn't want to add to your heavy burden. But you need to know that your papa's health is steadily declining. He had a major stroke last Monday night, causing damage to the left side of his body that has resulted in slurred speech. Taking care of him is difficult for me, especially since I still work outside the home to support the family. Nevertheless, it is my duty, and I will carry it through to the end."

I recalled my dad taking me to town on his bicycle my first day at primary school. As we passed the rows of colorful concrete houses with beautiful awnings at the windows and doors, I asked Papa to buy one of those pretty houses. He immediately said yes, even though he knew he couldn't afford it.

I then thought of some things he'd told me as a young lady: "Carol, extraordinary experiences will come your way when you are an adult. If you learn from them, you will become a better person. Obey God, and leave the consequences to Him. Do your best, give your best, be your best, look your best, and never stop trying."

After telling Leonie what I wanted to write to my family, I dictated another letter to solicit donations. Searching the telephone directory and addressing envelopes took a great deal of time, and Leonie was preparing for finals at school, so she couldn't help with this task. She recommended Ruby, another Jamaican she knew.

In addition to helping with envelopes, Ruby clipped coupons and purchased groceries for me. I passed my days stuffing envelopes, licking stamps, and mailing hundreds of letters with my pictures, appealing for help. I constantly listened to the radio and television, looking for more organizations, clubs, and churches. I sent letters to anyone I thought might help me survive.

At the end of the first month in my new home, I did not have the money to pay the rent. It was due at 5:55 p.m. on the first. I prayed as I went to the mailbox at three o'clock that day. When I opened the letters, I found that they contained just enough money to take care of one month's rent. I thanked God for His provision. Since I had nothing left over for groceries, I went to food banks and church pantries and got enough rations to last me through the month.

My day-to-day struggle to survive affected me mentally and physically. Through it all, I felt the Holy Spirit urging me to keep trusting God and to continue letting Him have control of my life.

At the end of the second month in my new home, I again did not have the money to pay the landlord.

I found letters with checks in them, just enough to take care of the current bills. I thanked God for His blessings. In a world full of sin and heartache, selfishness and cruelty, my heavenly Father would always come through.

TICKLE MY FANCY

One afternoon, David Crawford came to see me. He said, "The Lions Club wants to try to arrange for your son to visit you for the summer."

I sat in stunned silence, unable to believe my ears.

"Some of our members shared your story with prominent people in the community. The person in charge of a chain restaurant called Boston Market decided to use his power and influence to help you. Their PR person is organizing a press conference so your story can reach a wider range of people across the country."

With the help of members of the Lions Club, that Boston Market executive, the Jamaican ambassador in Washington DC, executives of Air Jamaica Airlines, and the American ambassador in Jamaica, my son would fly to America—first class.

Gratitude welled up in my heart for everyone who had made this possible. That night I felt like the richest woman in the world.

Dale's arrival at the Los Angeles International Airport was met with colorful balloons, banners, and welcome signs. A group of children sang welcoming songs. Television production crews crowded around the terminal with their cameras as reporters hosted a live broadcast. I pictured my son all dressed up, with the knobby knees and thick fingers and cheekbones of the little boy I remembered.

Air Jamaica officials processed Dale's documents quickly, and he passed through customs in record time. When an airline

official gave the signal, Dale walked down the aisle, escorted by a flight attendant. A song of rejoicing burst through the terminal. People of all ages surged forward to greet him. Strangers stopped and stared in amazement.

I had watched scenes like this on TV when important people arrived in the country. Now my son, a simple boy from a small village in a third world country, was receiving an astonishing display of the glimmer and splendor of America.

He presented me with flowers that Air Jamaica executives had given him for me.

"I love you, Mom." I could hear the smile in his voice.

I buried my face in the bouquet as tears of joy found their way through the scars on my face. His presence eased the longing in my heart. I hugged him close and said, "Thank you, my son," then gave him a big squeeze.

Air Jamaica presented us with more gifts. Then we went to supper with those who had made this occasion possible. All along the way, we gave television interviews.

Tiredness crept into our bodies by the time we returned home. While getting ready for bed, I asked Dale, "How is Papa doing?"

"He's sick. He lies in bed all the time."

My father had always been a strong man. I hated the thought of illness making him so weak. I fell asleep with memories of Papa in my head.

The ringing phone woke me. I answered in a daze.

David Crawford told me that he and Robert were coming to get Dale and me and would arrive in fifteen minutes. He hung up before I could ask what was going on.

I woke Dale. Half asleep he asked, "Where are we going?"

"I don't know. But David's picking us up, and he's a prompt man. Hurry and get ready. I don't want him to have to wait for us."

Dale and I dressed quickly and hurried down to the gate of my apartment complex.

Robert and David greeted us with cheery faces. "What's going on?" I asked.

"We can't tell you," David said. "It's a surprise, but our destination is ten minutes away, and people are waiting for you."

Dale and I climbed into the back of Robert's minibus.

When we pulled up to the restaurant, Dale said, "Mom, there are a lot of people here. Some of them have cameras, and some are just standing around. We're surrounded!"

David explained that many broadcast vans with television news crews had parked along the street, and the cameramen had positioned themselves hours ago.

"Is this a press conference?" I asked.

"I always knew you were smart," David said. "Members of the Lions Club and Boston Market's public-relations people gathered here early this morning. As soon as the restaurant opened, the press started to arrive. That's when I called you."

"Why didn't you give me some warning?" I asked, wondering about my hastily put-together wardrobe.

"This isn't the Academy Awards. We want people to see you at your worst so they'll be eager to help you."

I laughed. "Well, they certainly will see me at my worst this morning. You guys did a good job of ensuring that."

Though I couldn't see their faces, I heard the voices of the eager group outside the car. Feeling a bit overwhelmed, I squeezed Dale's hand and assured him that everything was okay.

Through my scarred eyes, I caught the flash of cameras and felt the warmth of their lights across my face. My heart pounded as I climbed out of the minibus and stood on shaky feet before the crowd.

Cameras flashed repeatedly. The reporters' questions came all at once, making them hard to decipher. I answered as best I could, feeling like a celebrity.

David and my son described to me the beautifully decorated restaurant and the tables set with white tablecloths and fresh

flowers. Many years had passed since I'd enjoyed such a delightful spread. I appreciated the outpouring of interest in my story and the love so many strangers had shown Dale and me. Never in my wildest dreams could I have imagined this happening to us.

The restaurant manager invited Dale into the kitchen to don an apron and cap and help fill trays with corn bread. The restaurant served lunch to everyone, even the reporters.

The meeting and interviews lasted throughout the morning. Between breaks, I made a lot of new friends. Members of the Lions Club cheered me on after each interview. The restaurant manager took Dale to Toys 'R' Us and bought him his first basketball, courtesy of the Associated Press and the Orange County Cable Channel.

After the story broke, telephone calls poured in from people of all walks of life, eager to help or to learn more about me. Every morning another member of the Lions Club showed up at my apartment and saw to it that Dale would experience all the fun places such as Disneyland, Knotts Berry Farm, and swimming at the city's pool. He returned home filled with happiness for the pleasure he experienced. In the evenings we went to Blockbuster to rent movies. For two weeks we dazzled in the company of each other. The two weeks came to an end far too soon; Dale returned to Jamaica.

The OCC station fed my story to CBS television in Los Angeles. Linda Alvarez, the news anchor for CBS, contacted the Lions Club and said my story had touched her heart. She asked for an interview. We met at my home "Carol," Linda said, "when I heard your story, I knew I had to do an in-depth interview with you for our community segment on prime-time news."

We had a pleasant conversation. She asked me to describe what had happened to me in Jamaica and explain why I had to come to America for help. Everything seemed of interest to her, even how I marked the different vials of eye medication to keep them separate and to remember which were to be taken and at what time, and how this odyssey of surgeries and suffering had affected my family. She

asked when was the last time I'd seen my son and how I planned to pay my bills and purchase the necessary medicines.

At the end of her visit, I felt I'd found a new friend. She seemed warm and kind and genuinely caring about my situation. As she left, Linda said she wished to visit me periodically, to report updates on my condition to her audience.

A few days later my story started appearing on television as a special feature.

I received almost fifteen thousand dollars in contributions, and the Boston Market restaurant donated a year of food. I felt stunned beyond words.

As my friends read the cards and letters people wrote to me, I learned that many of the senders were also injured in body and spirit. They told me about the horrors in their lives and even, in some instances, the hurtful things they'd done to others.

As I corresponded with many of my benefactors, several lovely friendships developed.

A man named Tom, who'd seen my story on the evening news, contacted me by phone. He said my plight had touched him deeply. He told me that his youngest daughter, on her way home from school one day, had accepted a ride from a stranger who had later murdered her. Though the culprit now resided in prison, nothing could compensate for Tom's loss.

"Carol," Tom told me on the phone, "your life is like a mirror to help show people what patience and faith and hope and love are all about."

"I don't know about that," I said. I couldn't see my situation from other people's points of view. "However, I do have faith. I certainly don't have the material success that some people use as a measure of personal success, but I find love and hope in ways that I can only call living in the spirit. I don't pretend to fully understand it, but I know that I will never give up."

HOLLYWOOD'S GIFTS

A woman named Dalena[1] called me and said, "When I saw you on the news, I was so touched by your strength and bravery, I told my daughter about you. She's an actress, and she wants me to visit you to see how we can be of help."

Dalena came to see me early on a Sunday morning. I met her at the gate. We embraced as if we were sisters.

"Oh, my dear," she said, "I am so happy to meet you."

She'd brought a carload of gift baskets containing scented oils, bath toiletries, hair accessories, and food. The driver shook my hand and introduced himself as David Easter. He took the packages into my apartment.

Dalena spent most of the day with me. We conversed as if we'd known each other for years. I told her about my village, my family, my old job, and how much I wanted to get on with my life. As I poured my heart out to her, tears streaked down my face.

Dalena gently wiped them away. In a soft, comforting voice she said, "Your wounds will heal. Time erases many things."

When Dalena left, she promised to report my living situation to her daughter, the acclaimed actress Tamela Johnson.[2]

Back in the apartment, I dug into the gifts she'd brought me. Sweet fragrances filled my nostrils. I drifted through the day in

1 Name changed at individual's request.

2 Name changed to protect the individual's identity.

a cloud of fantasy, floating first to Hollywood, then to the top of Beverly Hills to a private estate, and even on to movie studios.

I had never heard of Tamela Johnson, so as soon as I recovered from the giddiness of her gifts, I asked my friends to tell me about her. When I learned that she starred in a sitcom, I turned on the television and found the show. I pressed my nose against the screen, trying to see a little of what she looked like, but everything was dark and blurry.

Tamela contacted me and gave me her home and office telephone numbers. She told me I could call anytime.

Courier services arrived bearing presents from Tamela: a vacuum cleaner, CD player, gift baskets, a television set, gift cards to music stores and department stores, and an exercise machine. Tamela not only gave me large checks and sympathy cards, she called me from planes when she went to different countries, on the set of her show, and from movie locations.

Tamela's love made me feel like I had swallowed sunlight. She treated me like a sister—seeing me at my worst, yet accepting me for who I was.

Within a week of the press conference, four doctors had called the Lions Club offering their services to restore my disfigured face to one with some semblance of normalcy. All four doctors expressed confidence and caring—a combination I had found rare in medical professionals. Choosing one of them would be a difficult task. I asked Dalena to help me conduct a background check on each of them.

A few weeks later, she gave me her report. All four doctors had excellent skills and humanitarian natures. I made an appointment with each one to learn more about their plans.

Dr. Kinney, the first of the four doctors, generated a peace of mind in me that I had forgotten existed. When I asked how he learned of me, he replied, "A friend of mine, Katy Powell, saw your story on television. She's an actress on the soap opera *General*

Hospital. She asked if I would help you for her. I immediately agreed to do all I can."

I smiled in gratitude, touched to the core.

Each doctor showed me love and compassion. But I felt drawn most to Dr. Kinney. I called to tell him I would put my trust in him to perform my next surgery and that I expected nothing but his best. He promised just that, and offered realistic hope.

Because of the past failures, pessimism filled me. What if I'd chosen the wrong doctor?

I wanted other people to hear my plans so I could get their insight and opinions. I asked Dalena and David Crawford from the Lions Club to accompany me to my first appointment. They both agreed to stay at my side. David brought Robert as well.

The three of them sat on a couch in Dr. Kinney's office. I sat in front of the doctor, next to Tamela. We held each other's hands as the doctor described, in graphic detail, his proposed outline for the upcoming surgery. Deep inside, I felt I'd made the right choice.

Dr. Kinney offered his services free of charge. He promised to ask the management of Century City Hospital to donate their facility as well.

A couple of days later, I received a call from the hospital PR person. He and the administrator wanted to meet with Dr. Kinney and me, along with my representatives, to discuss the surgery and the extent of the help they would provide.

The hospital administrator promised me free use of their facility if I would grant a press conference before the surgery. I agreed.

Dr. Kinney convinced his mentor, a USC medical professor named Dr. Brody, to assist. They set the date for my operation, and I walked across the hall to undergo a physical examination. There I received the green light to proceed.

At home, I exercised for hours every day on the machine Tamela had given me. My body, mind, and soul eagerly awaited the big day.

HOSPITAL'S PRESS CONFERENCES

As promised, I held a press conference the evening before my surgery. The hospital's conference room filled with a swarm of television and newspaper journalists. I felt the heat of the cameras around me as I stood behind a podium, fully aware of the eyes of the world upon me. I told my story passionately, then expressed gratitude for the generosity of my doctors and the Century City Hospital.

A man approached the podium and introduced himself to me as Pastor Robinson, from a Baptist church in Santa Ana. He said that God had led him to be by my side at the hospital. I was grateful for his presence.

After praying for the success of my surgery, he told me he had a special message for me. "Carol, God guarantees grace for every trial. We live in a sinful world, and sometimes things don't go right. But when a righteous man falls, he doesn't get bitter at God or at people. He realizes that God sees the end from the beginning, and the end will be good for those who don't quit."

As I shook his hand, a calm sensation of acceptance swept through me.

After the press conference, as I stood next to Dr. Kinney, a colleague came up to him and said, "Brian, I think Carol's story is worthy of a book."

"There's definitely a possibility of that," Dr. Kinney said. "I'm sure she could share a lot with the world."

I wondered for a moment if writing might be my destiny in life, but I quickly dismissed the notion. I had never read a book for pleasure in my entire life. I'd read *Jane Eyre* and Charles Dickens and William Shakespeare in English literature classes in high school. However, I could never write like they did. I didn't have the education or training to be an author, and I knew nothing about the intricacies of grammar. I also knew that transforming an idea into a book was a long and complicated process.

I met with the hospital CEO, the public relations manager, and other people in management positions. They gave me a large suite, described to me as well decorated and filled with soft sofas, matching drapes, portraits on the walls, colorful flowers, and snacks. Normally, only rich people and celebrities stayed in rooms like this.

A nurse told me that a Saudi prince had the suite next to mine. I never met him, but I felt very important having a prince as my hospital neighbor.

A couple of hours after my press conference, the nurse in charge of the ward knocked at the door and entered. With a warm smile in her voice, she took my hand and placed an envelope in it. I asked her to open it and tell me who sent it, and to read the note or card.

She explained that she'd not asked the name of the man who gave it to her, but he had told her that after watching me on the news, he'd immediately switched off the TV, gone to the mall, and purchased a gift certificate in the amount of $1,500.

She read the note attached to the certificate: "This is just for you, to go shopping at Nordstrom when you're feeling better. I am a retired police officer, and during the many years I spent on the force, I have never seen such courage."

I turned to Dalena, seated in an armchair in the corner, and beseeched her aid in tracking down this generous man. I wanted to send him a special thank-you letter.

Local and national television networks, radio stations, and newspapers broadcast my story continuously for a couple of days. The news spread across California like one of their famous wildfires. Thousands called the hospital, wanting to help. The staff had to install a special phone line just for my calls.

Television personalities and strangers sent gifts of cut flowers and potted plants. People bearing gifts visited my suite to wish me well.

The evening before the surgery, I enjoyed a delicious baked chicken dinner and then went to bed early. At four o'clock the next morning, a nurse woke me to begin the preparations for surgery.

Tamela stopped by the pre-op room. She'd gotten up early to be with me before going off to the set to film her sitcom. She handed me a Calvin Klein robe, which buoyed my spirits. She prayed with me and expressed her love and best wishes. She held my hand as the doctor told me I would soon drift off to sleep.

I awoke late in the night. Dalena, David, and Tom sat by my bedside. I felt tremendous pain. My belly, the skin-donor site, burned with a terrible, sharp heat. Nevertheless, the support of nurses, doctors, and friends helped me endure, and as the nurse increased my medicine, the pain began to fade.

Layer upon layer of skin grafts taken from my belly and placed on my face made me feel thickly blanketed, like I was in a cocoon. I wondered, *Will I emerge like a beautiful butterfly?*

The next morning, Dr. Kinney came in to clean my wounds and do some tweaking. He explained, "My mentor, Dr. Brody, did the left side of your face; I did the right. I went deeper than he did. I had to cut deep down, next to your facial bone, to remove all those thick keloid scars. As a result, the left side of your face is much smoother than the right. Dr. Brody says that in time both sides of your face will equal out. He's an expert, so I believe him."

Since chewing would require facial movement, he ordered only liquid meals through a feeding tube. "Try not to move your face. Just lie still."

Every day, someone brought in a fresh supply of flowers, and the hospital stocked fruits, snacks, juice, and freshly baked cookies for my guests. Smelling all the delicious food tortured me. I ached with hunger, though I understood the importance of obeying my doctor and not giving in to the temptation.

I had many visitors. Some came to have dinner with me, some brought music, and some sang to me, combed my hair, or just held my hands and showed their love. Dalena and Tamela came often.

Tamela often stopped by early in the morning on her way to the studio or late in the evening between filming breaks. When her co-star became curious about her unusual absences from the set, she told him my story, and he made a gracious contribution to my fund.

Generous contributions to my fund allowed me to have nurses caring for me around the clock during the two weeks I spent in the hospital. I lacked for nothing.

When Dr. Kinney removed the bandages, his hands passed softly over my face like a sculptor running his fingers over the result of his creation. His touch made me think of how flowers must feel when they bloom through the snow under the first concentrated rays of the sun.

He noted that my face was darker than the rest of my body— probably from the skin grafts. I told him it felt stiff. He assured me that the stiffness was due to the swelling, which would start to go down after a few weeks. "Time will improve your looks," he assured me.

When he released me, I tentatively touched my face. For the last four years it had been rough and rigid. Now it felt smooth, though rather puffy and swollen. Before my tragedy, my prominent cheekbones and slightly pointed chin gave my face a heart-shaped appearance. Now it felt round, like a ball.

Before I could ask Dr. Kinney if the discoloration would lighten in time, David Crawford said, "I think when terrible things happen, the people who come out strong in the end are

those who accept the fact that when they put themselves back together, they can't be exactly the same as before. They may have to make a new life for themselves. In a way, it's like being reborn."

His words made sense.

A nurse pushed me in a wheelchair to the main lobby for my farewell news conference. A representative of Century City Hospital placed a large bouquet of flowers in my hands.

I expressed my sincere gratitude and appreciation to my doctors, the hospital management and staff, the Lions Club, friends, and strangers—all who had given me their best.

Dr. Kinney introduced me to Katy Powell, the actress from *General Hospital* who had contacted him on my behalf. She'd come to see me off. We embraced warmly.

With an entourage carrying my flowers, plants, and gifts, I left the hospital. My friend Tom followed David's car to my apartment. The local community hospital had offered to provide registered nurses to come to my home and give me professional care. Tom offered to stay with me until the first nurse came on duty.

I thanked him and then excused myself to go to my bedroom upstairs where I could examine my face in the mirror. The failed cornea still held some clear spots. I pressed my nose against the mirror and used the small glimpses of sight I had left to look at my face.

I did not like what I saw. My face still looked tragic, though not as fierce as it once had. At least I no longer needed to wrap my face in a towel.

The nurse from the registry called, saying that she was at the gate. Tom went to let her in. She entered the apartment, and I heard her talking with Tom downstairs in the living room. She told him she was a licensed LVN and was in nursing school studying to become a registered nurse. Tom poured out my tale of woe to her so she would be aware of what to expect from her new patient.

When the time came for the nurse to give me my medicine, Tom escorted her upstairs to my bedroom. I sat up in bed to greet her. I heard soft sobs coming from the doorway. Then she flew down the stairs, crying. Tom followed her. I heard her ask Tom, "How could she want to go on living looking like that?"

Suddenly feeling sorry for myself again, voices in my troubled mind returned to haunt me. *Aren't you discouraged yet? Aren't you dissatisfied with the past, troubled about the present, and fearful of the future? Look at your situation. Your nurse can't even stomach you. You cry to God, but He doesn't hear you. Does He care that you want to see and have a beautiful face again?*

I heard the nurse tell Tom that my case was too much for her to handle. She promised to ask the registry to send another nurse to take her place.

After she left, Tom came upstairs to let me know about the nurse. He promised he wouldn't leave; my apartment is in the bad side of town next to the alley. "I'll stay downstairs and see you through the night."

True to his word, Tom remained with me until the day nurse came the next morning.

GIFTS

Three times a day, an RN cleaned and dressed my graft wounds and face. Nurse's aides cooked, cleaned, and helped me with my medicines. While I greatly appreciated their assistance, I knew such services were costly, and the money I'd received at the hospital wouldn't be enough to cover everything.

One afternoon, David Crawford from the Lions Club called, his voice sizzling with excitement. "I have good news, Carol, and I can't wait to share it with you. I'm on my way to the bank. I'll be over shortly." He hung up, promising to hurry.

An hour later, David pounded on my door. He practically bowled me over as he rushed inside. He hustled me to the sofa and shoved a bulging plastic bag into my hands. "Feel how heavy that is, Carol? Do you know what it contains? Envelopes."

My fingers sifted through hundreds of envelopes of different sizes. "I don't understand. What's this all about?"

He laughed and then took a deep breath, as if trying to calm his enthusiasm. "These are cards, notes, and letters from people who saw you on television. Many included financial donations, which I've already deposited. It's important that you have someone read these to you as soon as you can."

David snatched the bag back from me, and I heard him rummaging through the papers. He rattled off the names of celebrities from music, movies, comedy, fashion, and Broadway, all of whom had written to me. "One lady sent you the contact

information for Michael Jackson's plastic surgeon, and another lady who has lost a lot of weight has offered you her extra skin!"

I collapsed into the sofa's lumpy cushions, completely overwhelmed. Famous people—people who set trends and helped form social opinions—had heard of my plight and cared enough to respond.

I reached for the heavy bag and clutched it to my breast. Happiness rocketed through me. I couldn't wait to hear what these wonderful people from all across the country had to say to me.

Altogether, David told me, we had collected over fifty-five thousand dollars. The donations would be more than enough to pay for my rent, food, medicine, and nursing services.

• • •

Tom came over occasionally and took me to the beach in Santa Monica. I waded into the water and listened to the gentle sounds of the waves as they rolled over my body. The smell of the sea and the quiet breeze refreshed my soul.

Telephone calls from well-wishers continued for months. Warmed by their offers of friendship, I felt accepted back into society.

A woman named Gwenna called and said she'd seen my story on TV. "I've been through hardships in life, but nothing compared to you. I now have a beautiful home in Pasadena. After seeing you on television, I want to meet you in person."

She arrived at my apartment on the bad side of town at noon the next day. When I went to open the gate to let her in, she said, "I have gifts for you!" She'd brought me a large-screen TV, a carton of movies on tape, and a video player. "Most of these movies are classics; I love watching the oldies, and I thought you might too." I was confident these films would enrich my life. My soul thanked God for directing this thoughtful woman to me.

"One of the newer movies is called *Cool Runnings*," Gwenna said. "It's about the Jamaican bobsled team. Another one is called

Man without a Face. I also included one of my favorite movies of all time, *Gone with the Wind.*"

Many times my troubled mind had asked, *Why persist?* My faith in God had sustained me and comforted me, and people like Gwenna helped me go on with the fight.

As I helped Gwenna carry the videotapes into the apartment, my landlord came by. "What do we have here?" he asked.

I introduced Gwenna and told him that she'd seen me on TV and had come bearing gifts.

"I think I have a dolly around here somewhere," Sandy said. "Let me go get a workman to give you a hand. I think it'll take both of us to carry in that large box."

By the time Gwenna and I had brought in all the movies and other small items, the two men had unloaded the TV onto the dolly and brought it inside.

After the gifts had all been delivered to my apartment, Gwenna and I sat at the dining table and talked. "Carol," she said, "when I was suffering, there were days when I felt like I couldn't bear to live anymore. At my lowest moments, strangers came to help me. They lifted my spirits and enabled me to go on. When I saw you on TV, I decided right away that I wanted to give you some things to lessen your loneliness. God often inspires me to help people who've been hurt by life, to help them not to feel so alone, abandoned, or judged. I'm so glad to be able to do this for you."

I thanked her profusely, and I thanked God for sending her to me. We stood at the gate and embraced, saying our good-byes.

Back in my apartment, I touched the box with the TV Gwenna had brought me. Candace had given me a TV when I was staying at Dr. Robinson's condominium, and Tamela had given me another one. Gwenna's was considerably larger than the others.

• • •

About eight o'clock one night, a Buddhist woman called me. She said, "I saw you on television. You want to find healing, right? I can help you."

She shared an example of a man who'd been involved in a horrible car wreck that left him unable to walk. Years of physical therapy followed, with no difference in his debilitating condition. Then he embraced Buddhism with a passion. "By daily chanting, he received total healing," this woman claimed. I considered my face at the present. It was still swollen. Dr. Kinney had told me it would take a very long time—even years—for the face to be fully healed and shaped. The scars were gone, leaving a smooth face, and it made me happier.

I wanted total healing too, however, I wasn't sure Buddhism was the way to get it.

"Carol," the woman said, "I felt led to call you this evening to teach you to chant." She slowly pronounced a string of strange-sounding words, chanting them as if she were singing. After a few repetitions, she asked me to repeat them after her.

Longing for something to work for me, I repeated her words. They came out all wrong. My tongue just couldn't roll off those funny-sounding words.

My mind asked, *Why are you reciting vague repetitions? This is not for you.*

I felt ashamed for getting caught up in a ritual that betrayed my Christian faith by chanting to a false god. I told the woman, "This isn't working."

She replied, "You're not experiencing anything yet because you haven't accepted Buddhism. I have converted many people who had difficulties at first. You are being introduced to something new. It's normal for your words to come out awkwardly the first time. The more you practice chanting, the better you'll get."

"I really don't think this is right for me."

"Look, I can't do everything that needs to be done for you over the phone in one session. I'll get someone living closer to guide you."

The next evening a woman called and told me she wanted to help me heal. She assured me that I could have a life of comfort over suffering if I would follow her instructions.

I knew I had a choice to make. I could either accept her religion or hold fast to my Christianity. The Bible story of Samson came to mind; his eyes were put out. The only thing he could do was pull down the temple to another god and kill himself. I wasn't going to do that.

I told her, "I am too clothed in my Christian faith; I cannot change and wear somebody else's new idea." Before she could try to convince me otherwise, I hung up the phone.

Several other people called me to say that they could clear my painful path to improvement and bring fulfillment to my life if I would only believe in whatever they believed in. I was introduced to numerous organizations of Christian meditation, science of the mind, witchcraft, psychic healing, holistic education, channeling, gypsy readings, black magic, white magic, and astrology.

As people continued to tell me about their religions and their gods, I began to feel like a rabbit in a trap. Nevertheless, I had learned too much about life to ever again fall victim to a scam.

I told each of them that I would stick to my Christian faith that had been passed down to me through the generations of my family and the teachings of my church. "The God of all creation, the Lord of heaven and earth, is the only God for me," I told them, "and I put Him first in everything—my choices, my time, my priorities."

TALK SHOW SURPRISE

The producer of *The Leeza Show* called and asked me to appear on the talk show, along with other victims of violent attacks. I had listened to Leeza's program many times. I found it interesting, and I wondered what appearing on the show could do for me. I concluded that any publicity was good. Something positive might come from it, and perhaps I should make the most of opportunities when they came my way.

The producer and I conversed for the next few days. She seemed interested in every word I said, especially about my family in Jamaica. Sympathy laced her voice as she dug deeper into my life. Finally, she said she felt ready to set a date for the taping of the show.

My plastic surgeon, Dr. Kinney, agreed to participate. I asked Dalena to accompany me for moral support.

I wanted to let my family back home know I would be appearing on a talk show, but they had no telephone access in the village. So I called Mom's work number in the city. The secretary told me, "Your mom isn't here today."

My mother rarely missed work. I wondered what could be wrong.

For three weeks I called almost every day, but each time, the secretary said the same thing. It puzzled me, but I let go. If something bad was wrong with Mom, someone would have told me.

The night before my television appearance, I had trouble sleeping. At four in the morning, I gave up and spent the remaining hours before daylight listening to the radio. When morning finally dawned, I prepared myself as best as I could.

At 9:00 a.m., a stretch limousine arrived to take me to the studio. The driver welcomed me warmly and guided me into the rear seat. I leaned back on the soft leather and enjoyed classical music—just the way I'd imagined celebrities from television shows and movies doing.

When we arrived at the Warner Brothers studio, my assigned escort welcomed me. She described the surroundings as we passed the buildings where cameras filmed cartoons, television shows, and movies. She told me about famous actors who were filming a movie there right then.

Backstage at *The Leeza Show*, I stretched out in a deep, comfortable armchair. Dr. Kinney and Dalena came in, and we chitchatted about my surgery until someone called me to the makeup chair.

As the hairdresser fussed with my hair, the show's hostess, Leeza Gibbons, came over. With a warm handshake, she said, "When I saw your story on the evening news, I was touched by your courage and knew I wanted to help." All the members of her staff showed the same charming and attentive kindness.

The show's guests assembled on the stage in our designated places. Dr. Kinney stood on one side of me. On the other side stood a victim of the Unabomber and his wife.

With everybody seated on stage, and the audience assembled below, the show began. Leeza started with introductions. When the conversation came around to me, she asked Dr. Kinney to tell everyone what I'd looked like when he first saw me and what he'd done to bring about a significant change.

To illustrate his story, he showed clips of the videotape of the surgery, accompanied by a vivid description of my severe injury and details of the surgery he'd performed.

Then Leeza stood next to me. In an excited voice, she said, "Carol, we have a surprise for you."

I heard movement about the stage near me. I couldn't imagine what the surprise could be. I felt the drumbeats of my heart as I waited in eager anticipation.

Leeza said, "Carol, your mom and your son are here from Jamaica!"

My mouth dropped open. I recalled that when Mom first saw the horror of what I had become, she ran out of the hospital room. I had the surgery a couple months before, and the puffy skin had turned black. Both cheeks were swollen. The tightness of the face caused the bottom lips to protrude. I wished that my face was fully healed so Mom would see a better me. I sat numb for several moments, speechless. No wonder Mom's secretary kept telling me she wasn't at work! She had to have made several trips to the American embassy in order to procure the necessary traveling documents for her and Dale to visit.

As Leeza's words registered, I felt happy and sad at the same time. Though I was excited about seeing my family, of course, I hated the thought of them seeing me while I looked so awful.

Brisk steps came toward me. I stood slowly. My arms opened wide.

My mother whispered my name and stepped into my embrace. Trembling in my arms, she kissed me on the forehead. She felt much smaller than the plump woman I'd known all my life. As I held her close, I stroked her hair and rubbed her back, sobbing uncontrollably.

My son threw his arms around me like a frightened child. The three of us hugged. We clung together in silence for what seemed a long time.

Then Mom said, "Let me take a good look at you."

I let go and stood back a bit. I heard a long, deep breath tinged with sadness and joy.

"I will mourn your tragedy for the rest of my life. God knows I prayed for you. I would have given my life for you." Her words grieved my heart.

As Leeza interviewed her, I learned that my mother had come to America with a hopeful picture in her mind. She'd anticipated a more positive change in my disfigurement, wishing for a miracle transformation, wanting to see my face the way it once was: with big eyes and a smiling mouth—the sort of woman who would turn heads and maybe even incite some envy.

Seeing the reality of what I would look like for the rest of my life destroyed her dreams. "Still, I am grateful to be here and to see my only daughter alive."

"My outward appearance has lost its beauty," I choked out, "but I haven't changed inside." I hoped my words would cheer her.

Stagehands set two more chairs on stage. Mom and Dale sat next to me.

Dr. Kinney and Leeza continued the discussion of my surgery, showing the graphic details on film. Mom gasped several times.

Leeza asked her, "How did you respond when you heard about what happened to your daughter?"

"It was like the spinning of the world had ceased. A light had gone out of my life. I felt as if I had been shot in the gut. My strength left me. I feel the same thing now, seeing her and watching the film of the surgery."

"Grandma is weeping," my son whispered in my ear. "She's waving her hands up to God and shaking her head. Now she's facing you."

"What can I say, Carol? Do I praise God for letting you live? Or condemn this world for the rest of my days?" Her voice—so full of grief, affection, and sympathy—struck me.

"This life is full of disappointment," I said, "often to the hopes we cherish most."

As the show progressed to other victims, I continued to sit there with mixed feelings. I felt pleased to have my family together again. But I knew the graphic details of my brutal attack and the in-depth description of Dr. Kinney's surgery would be a heavy burden on them.

Just before the end of the show, Leeza announced that Mom and Dale would be staying with me in California for two weeks. The producers gave them $1,500 cash—$1,000 for Mom and $500 for Dale—to cover their expenses.

After the show Mom and Dale gathered their luggage, and we all rode to my home at the bad part of town in the limousine.

Once inside, I kicked off my shoes and slumped on the sofa, feeling extremely tired.

Mom and Dale told me about spending three nights in one of the finest hotels in Los Angeles, visiting historic places, and eating in beautiful restaurants. I hadn't even known they were so close.

"Who's taking care of Papa while you're here in America?" I asked.

"He's in good hands," Mom said. "Some family members are caring for him. I left money for them to cook and take care of him."

"And how is he doing?" I asked.

"I'm afraid his condition has changed for the worse. He suffered two strokes that caused damage to the left side of his body, blindness in both eyes, and slurred speech. His mind is filled with vague images and memories. He's like a vegetable."

I hadn't wanted my papa to see me the way I was. My plan was to get fixed up quickly and then go home to see him. Now we were both blind. Neither of us would ever see each other's face.

I had heard that people who'd had two strokes rarely survived a third one.

Dale spoke of his life in Jamaica: his school and the new friends he'd made. Delight filled my heart. He tried to show me pictures of drawings from his art classes, but when I held the papers up to my eyes, I saw nothing. So Dale described his art to me. I discovered he had a tremendous creative ability.

He took out his flute—the instrument he was learning in school—and played a children's song called "Polly Wolly Doodle." He told me he had competed in a semifinal round in the spelling bee competition, and during the event he began thinking of me.

On his turn, the spell master asked him to spell a word that began with the letters C-A (*carrot*). Instead of the word, he'd spelled my name: Carol. We both laughed at his sweet mistake.

Despite the horrors that had disrupted his young life, Dale had done well in school and with his lessons. He'd even brought his textbooks with him to study while he was away.

PERENNIAL FLOWER

The next evening Mom fried snapper seasoned with spices she'd brought from Jamaica. The tantalizing aroma filled my home as the seafood sizzled in the pan.

After our meal, I sat at the dining table with my mom, and Dale sat at the far end of the sofa, deeply engaged in his reading.

Mom told me about the people back home and the changes that had taken place in and around the village. Even when Mom and I didn't talk about Papa, he lingered in the spaces between the words of our conversations. Though she tried to keep her tone of voice light, she could not hide her feelings of sadness and sorrow.

After a prolonged silence, Mom said calmly and slowly, "Carol, I believed a miracle would happen for you by now and that everything you had done in this great country would have magically transformed your face."

"I did too," I admitted. "But I have come to learn that things don't always happen the way we expect. The past is gone. We have to let it go."

"We never completely get rid of the past," Mom said quietly.

"That's true. But I want to use my past to build a better future. I know now that I have the courage and faith to go through life's toughest challenges.

• • •

"I wish you'd never gone into the lumber business," Mom said. "If you hadn't, maybe you would still have your sight and your beauty."

Dale looked up from his reading. "How did you get into the lumber business, Mom?"

I took a deep breath and related the story.

"One of my first jobs after I had graduated high school entailed traveling to countries such as Panama, Curaçao, Haiti, and Cuba to obtain clothes and merchandise to sell in the town near our village. Thousands of other people were selling the same things. So I often couldn't sell my goods very quickly or for much of a profit. So on weekends, I slung large bags of product over my shoulders and walked to villages high in the hills, where I sold door to door.

"During my sales journeys, I walked among enormous cedar, mahogany, and pine forests. These magnificent trees made me think of the sawmill across the street from the house where I lived. Every day the workmen purchased logs and turned them into lumber.

"One day I went to the sawmill and told the manager about the trees I'd seen. He encouraged me to see if I could buy the trees, claiming that I could make more money selling lumber than selling clothes and household items.

"On my next trip into the hills, I inquired of the owners of the cedar trees and asked them if they would sell some of them to me. 'But you're a woman,' they responded. 'That's a man's job.'

"When I proved through persistence that I was serious, they explained, 'The reason these trees are standing is because all the men who have tried to buy them seemed dishonest to us. So we refused their offers.' Deciding they would rather do business with a woman than with a dishonest man, they agreed to sell me their trees.

"In order to negotiate the best price, I looked at the trunk of each tree and figured out how many two-inch planks and one-inch boards could be cut from it and the lengths of them; then I calculated the going price of lumber. I considered what else could be obtained from the remainder of the tree, like three-by-threes, four-by-fours, and six-by-sixes from the big branches. I

also thought about what could be made from the lumber for the construction or furniture industries. Then I determined the cost of cutting down the trees and transporting them to the sawmill for processing.

"I pursued the lumber business with a passion and managed to collect a good stockpile of wood to sell to the sawmill. But one night, while I slept, every piece of wood I'd purchased was stolen. I was devastated. I felt certain my supply would be stolen again if I stocked up a fresh supply. So I quit the business."

When I noticed Dale yawning, I stopped my musings and suggested he get some sleep. He made me promise to tell the rest of the story some other time. I pulled him close to me, wishing I could see his face. I kissed him on the forehead, letting my lips linger an extra second. "Good night, son. Sleep well."

He brushed my hair as if I were made from fine china. Then he shuffled to the bedroom.

In a resigned voice, Mom said, "Despite the negative reactions I've expressed, I am grateful to be near you again. It's just that every time I think about all you've been through, part of the richness of the world goes out of me. Now that I'm with you and beholding your affliction afresh, the sight of so much hardship and suffering stirs up bitterness in my heart." She choked back a sob.

I told Mom that the unconditional love she'd always given me was the greatest gift she could ever bestow.

Before retiring that night, Mom and I worshiped together. She read from the Bible—Psalms 31 and 102. Afterward, we knelt together, holding hands.

"Father God," Mom prayed, "I believe that You are the true and living God, and You reward those who seek You. You are a miracle-working God. Like little children, we bow humbly before You this night. I know You can do things outside the natural realm. I bring before You my only daughter. You know the pain and suffering she has endured. I pray You will heal Carol of her afflictions. I pray for total healing of her body and mind."

In my heart I echoed her prayer as I squeezed my mother's hand.

"Father God," she continued, "sometimes I think evil thoughts about those who destroyed what You blessed my daughter with. I ask You to forgive me of my sins. As we live day by day through Your Spirit, remind us of what it means to walk with You in faith. Help me to keep trusting You, whether or not I ever see the miracle of healing I want for Carol."

Her words continued, "I pray for Your continual healing and restoration of her sight. I thank You for her life and for all the people who have shown mercy to her—those who are swift to kindness, tender to her sorrow, and understanding of her stress. Help us to trust You and to draw strength from You, the only source of life."

After her prayer, we stood and embraced. New strength flowed into my being, and I went to bed peaceful.

In my bedroom I listened to the Gospels on tape for several minutes. In the silence of my room, God impressed upon me that He would take care of me—He loved me, regardless of my looks. I found peace of mind and freedom from anger, guilt, and fear.

Excitement began to build inside me. The next morning, as soon as Dale got up, I instructed him to jot down my thoughts for my mother. He wrote what I dictated, then read my words back to me:

> Mom,
> If you could hear the voices in my heart, they would tell you there is hope in the face of my hopelessness. There is beauty in the face of my ugliness. I am still your perennial flower. I will bloom again in heaven, and you will be there with me.
> While the waiting time seems long—and filled with grief, faith, hope, and charity—your love has comforted my heart. In addition to sharing all my joy, you have shared my tender memories of the past.

Cheated by the power of darkness and robbed of my birthright of ease and joy, the raving beauty I once was is no longer. Yet you still find beauty in the face of my ugliness, hope in the face of my hopelessness.

We have endured terrible disappointments. But as the sunshine touches the morning glory, the beauty within me still ignites. Whatever perishes, the best remains. A song of praise is on my lips for losses that will someday be gains.

My adversity and sacrifice are far more than I ever imagined. However, I abide in full assurance of the good—a heart aching with righteousness.

Pleased with the results, I said, "That's everything I want her to know."

After reading my letter, Mom's sadness seemed to dissipate like mist. She became composed and affirmed, her attitude revolutionized.

TERRORIZING
GUNMEN

The phone rang. Dale answered. "Hi, Dad!" he cried out.

I didn't even know Donald had my number.

After a lengthy, enthusiastic recounting of all the exciting things he'd done while in America, including being on television, Dale handed the phone to Mom.

The last time I'd seen Donald was when he visited me with Dale at the hospital in Jamaica. He'd laughed at my pain and seemed to rejoice in my suffering. Surely he knew I would be treasuring this time with my family, yet he called and interrupted the mood. A pit of bitterness lodged in my stomach.

When Mom hung up, she said, "Donald has submitted paperwork to the American embassy in Jamaica for Dale to live with him in New York."

My stomach clenched at the memory of the last time Donald had tried to take Dale away from me.

When our son was four years old, Donald had broken into the house when neither Mom nor I were home and taken Dale's clothes. Then he went to Dale's school and kidnapped him.

I marched right over to Donald's mom's house and asked every family member to help me find my son. Not one of them gave me any answers. I guessed that they knew where Dale was but wouldn't tell me.

After an extensive search of everyplace I could think of, I went to the school where Donald's girlfriend, Jennifer, worked as a teacher. I asked to see her, but was informed that she wasn't there. I told the principal and another teacher that I believed my child might be enrolled at their school. They looked surprised, but offered me no assistance. So I went to the police and filed a report.

For two years Donald hid my son from me; for two years I searched tirelessly for him. I sensed that my son wanted me as much as I wanted him.

Multiple times I went to Donald's mom's house to inquire about my son's whereabouts. One weekend I saw Dale in the yard, playing with other children.

I walked up to my now six-year-old son and asked, "Do you know who I am?"

With his head lowered, he said no.

"I'm your mother. I've come to take you home."

Dale's face looked worried. I assured him that I would take good care of him. He finally gazed up at me with an expression that said he trusted me to do everything I had said.

Donald came out of the house and sat on a porch chair. "You want him?" he hollered. "You can take him. But if you do, I will never send you any support for him."

A sense of relief filled my heart.

But now Donald seemed intent on stealing my son again.

"If I live with Dad in America," Dale said with a trill in his young voice, "I'll be close to you, Mom. I'll be able to see you anytime I want."

Neither Mom nor I had the heart to tell him that New York was a long way from California.

I put my fears aside, determined to enjoy the last few days of my family's visit. Dale's desire to be close to me warmed my soul, and I forced a smile for his benefit.

• • •

Over the next few days, a friend named Jim took time off work and made himself available to my family. He drove Mom and Dale to Sea World, Disneyland, Knott's Berry Farm, and several shopping malls while I stayed home. One evening, after a trip to the mall, Mom invited Jim to stay for dinner.

After our meal, Dale asked me to continue my story about how I got into the lumber business. The next part wasn't very nice, and I didn't think it would go well with dessert. But my son insisted. When Jim confirmed that he would enjoy hearing my story, I took up where I'd left off.

After I stopped purchasing trees for the sawmill, I needed to find other employment. The owner of one of the businesses I had supplied with lumber hired me to be his assistant.

One day, I was taking my lunch break, scratching lottery tickets with a couple of coworkers, when I noticed two men standing on the road at the entrance of the business, looking in my direction. One was taller, maybe five feet ten. The other looked about five feet four. They seemed jittery; their bodies were constantly moving, and their eyes flashed.

I whispered to my coworkers, "Two men are coming toward us. I think they might be armed."

They stopped scratching lottery tickets and followed my gaze to the entrance of the business. When the men saw us looking at them, they exchanged a few words. Then they walked through the open gate.

The tall one was well groomed, and he had the short haircut of a police officer. The shorter man looked wiry and was dressed in rags.

When they were about thirty feet away, the tall one reached into his waistband and brought out a handgun. It looked like a policeman's weapon. He waved his pistol back and forth among my coworkers and ordered them to turn out their pockets.

The shorter one reached into his waistband, and with both hands, he pulled out a rifle. He pointed it straight at me. He

pressed the muzzle into my ear and twisted it. "You," he barked out. "Give me all the money you have here. Hand over every penny, or I'll blow your head off."

I thought, *If I obey, he might take my life. But if I don't obey, he will certainly kill me.* I didn't know what to do.

I stood on wobbly feet. With the gun to my head, I went to the different spots where we kept money until it could be taken to the bank. I retrieved all the cash from a desk drawer and in paint cans stacked in a corner behind a box of invoice forms. I handed him the money with shaky hands.

He looked at the big bundle of bills, and a smile lit up his face. He ordered his partner to come get the money. The taller man reached into his pocket and pulled out a black plastic bag. He snatched the bundles of cash from his partner and placed them in the bag.

The shorter man jerked the gun in my ear. 'I've been watching this place since this morning,' he said, 'and I know you've made more money than this. Where's the rest?'

"I've given you everything," I insisted. "All that's left is the coins in the cash pan."

His partner emptied the contents of the cash pan into the bag. The short gunman ordered my coworkers to get inside the warehouse. They instantly obeyed. Then he told me to follow them. He walked close to me, his gun still at my temple.

In the center of the warehouse, he shouted, "Stop here!" He ordered my coworkers to lie flat on the floor side by side. They immediately fell onto the hard, dusty concrete.

The man with the gun in my ear lowered his rifle and ordered me to lie on top of my coworkers. My blood rushing and my thoughts reeling, I did as he instructed. Then he said, "I'm going to kill all three of you right now."

I expected to hear gunshots and to feel the sting of death; those men would be my last memory. Clinging to hope and life, I prayed that God would have mercy on us. I bargained with Him, *If You help me survive this, I will truly be Your servant.*

"I'm going to kill you now," the shorter gunman growled.

"Give them a chance," the other man said.

They argued for a while. Then I heard someone moving about in the back of the office. I recalled that six other coworkers were in the next building, cooking chicken and dumplings for their lunch. The gunmen stopped fighting, and the office became silent.

After a few minutes, I whispered to my coworkers, "I think they're gone." They didn't want any of us to move. So I continued lying on top of them for another ten minutes or so.

Still hearing nothing, I got up and confirmed that I was alive, and the gunmen were gone. I wondered for what purpose was I born. I vowed I would always live in the moment and trust in the purpose of my existence and let meaning come to me. I ran to the next building and told the others what had happened. They followed me back to the office, where my two coworkers were still lying on the floor.

For several months after that incident, I battled a terrible case of nerves. Whenever I picked up a utensil or a cup or a plate, my hands shook uncontrollably. I had to quit my job because I could no longer work there.

I saw a few doctors to see if they could help me. When the medical expenses became a financial burden, I decided to apply for health insurance. But the agent I consulted only sold life insurance. So I took out a life-insurance policy that covered both death and disability. The money I received from that policy after my acid attack ended up paying for my visa to come to America.

I believe God knew what would happen in my life, and He made a way for me to leave Jamaica even before I knew I would need to. He sees the future, and sometimes He allows bad things to happen so that good things will come along down the road.

NO PAIN, NO GAIN

"What a terrible life you've had," Dale whispered, his last bite of ice cream melting in his bowl. "Why didn't you ever tell me all this before?"

I took my son in my arms. "I didn't want to burden you with things you didn't need to know about. But this is what I want you to know. Living in this world, you need to know what you can focus on and hang onto in the midst of all the circumstances. In all my stories of triumphs in the midst of seemingly impossible obstacles and circumstances I faced, truth is what helped me survive them. God is the truth."

My friend Jim stared at me, wide-eyed. "What happened after your experience with those gunmen?"

"For six months, I was unemployed, but I needed to find a way to survive. So I put my fears behind me and thought about what I could do with the knowledge and skills I possessed. That's when I decided to start my own lumber business," I replied.

"And six months later, your successful life turned to ashes, pain, and misery. Carol, your life's joys are undoubtedly coupled with misery!" my mother moaned.

I thought of each person in the room with me at that moment and carefully considered my next words. "I can't explain why all those bad things happened to me. I made certain choices—some turned out to be wise decisions, others may seem like mistakes. All I know is that God uses everything for our benefit, to

strengthen our faith. I believe I am where I am now because God directed me here. He designed a plan for my life that is beyond my comprehension.

"I don't know, Mom," Dale said. "It seems to me that you've had more than your fair share of bad luck."

"I think that sometimes, too, but in many ways I have been very lucky."

"How?"

"For one thing, I feel extremely blessed to be in America. The people here have embraced me and loved me. If everything I experienced in Jamaica hadn't happened, I would never have met the friends I have here." I hoped Jim knew he was included in that list. "I've been the recipient of more selfless giving than most people will know in their entire lives."

"Carol," Mama said, "I wanted to help you so much, but there was nothing I could do except love you."

I took her hand in mine. "Your love made my suffering easier to bear."

I turned to my son. "Dale, what I want you to learn from my experiences is that life isn't always what you want it to be. You're happy right now, eating ice cream and fruit with your family and a friend. But your circumstances could change in the blink of an eye. The important thing to remember is that you can face any trial if you maintain a positive attitude and a strong faith in God."

"I don't understand."

I chuckled. "Someone once said that life is a mystery to be lived, not a problem to be solved. I believe that if we simply live the mystery of life, rather than trying to figure it all out, our lives will be what God meant them to be."

"Don't you ever get upset about everything you've gone through?" Jim asked.

"Of course I do," I admitted. "But whenever I start to feel like nothing is ever going to go right for me again, I pour out my woes to God, and He reminds me of all the things I have to be thankful

for: my family, my friends, going to church, and my passion to write and speak. Those things fill me with hope."

"Maybe," Jim said, "you were given the gift of pain for a divine reason."

I liked that expression: *the gift of pain.*

Remembering all the times I had come close to being killed in various mishaps and foul play made me realize that on each occasion, just before I would have surely died, God reached out and pulled me back. *I guess He wants me on this earth for some reason. He must have a special purpose in keeping me alive.*

"I believe with all my heart," I said, "that God allowed me to escape so many brushes with death, and sustained me through so many trials, for a grand purpose. I am determined to discover the full extent of that purpose. For now, I think His plan is for me to comfort others in their afflictions."

Jim touched my arm. "Well, I know you've inspired me more than any therapist or preacher possibly could."

Everyone in the room laughed. The beautiful sound cleansed the air.

After Jim and Dale finished their second helpings of dessert, they went to the movies. While they were gone, Mom read the Bible to me, sang with me, and prayed for me. The touching simplicity of her prayers—filled with earnestness enriched with the promises of Scripture—worked miracles on my shattered emotions.

• • •

All too soon, the two-week visit with my family came to an end.

As we gathered all the purchases my mother and son had made and packed them in suitcases, Mom cried. At the break of dawn, saying our good-byes brought tears and lamentation.

An airport shuttle pulled up to my gate to take Mom and Dale to the airport. My son and I held hands as the driver stowed their belongings in the trunk. I enfolded him in a long embrace. We just stood there, unmoving, until the driver said, "We need to go now."

Mom drew Dale away, and once again I cried. I wondered when we would meet again.

As the doors closed and the motor started up, the snippets of wisdom Mom had given me throughout my life rolled through my mind.

Always express gratitude for everything you receive.

Life is for prayers.

Many powerful lives start in expectation.

Hold on to God's promises.

Keep trying.

The love of God can get you through any darkness.

You have a heart for loving and a brain for reasoning, but listen for that still small voice within and obey it.

With hope, effort, and God's grace, anything is possible.

• • •

Daylight came, and the apartment felt lonely and still. *I will get through this day, and I will get through tomorrow and the days to come. I will use my creativity and think of things to do.*

I strolled along the street with the aid of my walking stick, hoping to fill the chasm in my heart with a change of scenery.

Getting back to day-to-day living—cleaning the house, cooking, taking out the trash—took an effort of will. I drank and ate little and slept even less.

The will to live gave me the strength to continue fighting to fix what had gone wrong in my life…and to praise God, no matter what.

TV NEWS
OPPORTUNITY

Three weeks after Mom's departure, my friend Marney invited me on a ride to Newport Beach. I hadn't left home much and welcomed the opportunity.

As we walked side by side along the water's edge, I listened to people chattering, children playing, and fishermen discussing their hobby. The roar of the ocean surrounded me. The sea breeze refreshed me. Cold waves rolled against my ankles with comforting consistency and predictability.

Recalling my walks along the beach in Jamaica, I knew that each time a wave withdrew, it carried with it whatever had marked the sand, creating a smooth surface. I envisioned a huge wave coming onto shore, consuming me. When it receded, I had been washed clean of all my earthly unpleasantness. My struggles dissipated. A magnificent radiance filled me, releasing the worries, disappointments, and shames of the past. The ocean reminded me of the world of possibilities open to me, and a strong hope resurfaced.

We walked to a restaurant on the boardwalk and sat at a table on the terrace. Marney told me about the vessels moored close by. She lived on a boat, so throughout dinner, she gave me a running maritime dialogue. I looked in the direction of the ocean and pictured the boats she described.

Back home that evening, the television news featured a segment on a natural treatment for scars, using aloe vera as the main

ingredient. Wondering if this treatment might smooth the scars on my body, I grabbed my cassette recorder and taped the broadcast.

Afterward, I called Dalena and told her about the product. She promised to contact the television station and track down the speaker, a woman named Vera Brown. A couple of days later, Dalena met with Vera over lunch, told her my story, and arranged for us to meet at Dr. Kinney's office.

When we arrived, Vera greeted me with a handshake that led to a hug. Her embrace felt real and warm, and I breathed in her light, sweet cologne.

"Carol," she said, "Dalena told me about your situation. What are your plans for moving on with life?"

Her question took me by surprise. But I told her I longed for more than the fearful, meaningless, fruitless existence forced upon me by my limitations. I desired an extraordinary life of peace and fulfillment, joy and purpose. "I want to read and write again," I replied. "I want independence."

Vera told me inspirational stories about many women she and other Hollywood celebrities had helped over the years through the charities and shelters they sponsored. Vera owned and operated a boutique and day spa where she employed many of the former down-and-outs she'd championed.

"I sit on several boards in the Los Angeles area, and one is the Foundation for the Junior Blind. This institution equips blind and deaf people to live more productive lives. They also help people with other physical and mental disabilities. If you want, I can call the administrator and set up an appointment for you to take a tour of the facility. If you like what you see, I can get you a fellowship to cover your expenses."

Dalena and Dr. Kinney exclaimed over the news.

I stared, stunned by this woman's kindness. "I would very much like to attend those classes."

Vera hugged me before we parted, promising to call. The next day, she called, saying she had made an appointment for me to tour the institution.

My friend Tom drove me to the facility. Dalena, Vera, and the administrator, Bob Ralls, showed us around the place. They took turns describing the wide-open spaces, tall buildings, and landscaped compound of the Foundation for the Junior Blind.

The large facility accommodated kids as well as adults. They had separate children's quarters and a special school for the very young. Volunteers from nearby beauty schools offered adult students hair grooming, facials, skin care, and nail services on a monthly basis. They also taught the blind how to apply their own makeup.

"Even the handicapped need to feel beautiful," Vera said.

I couldn't have agreed with her more.

The moment we reached the office, I enrolled as a student and arranged to live in the adult dormitory during the school week. On Friday afternoons, I would return to my apartment and spend the weekends there.

Tamela's husband's personal assistant arranged with a limousine company to drive me to and from school, and wherever else I wanted to go. The following Monday morning, a stretch limousine pulled up to my apartment. I felt like a celebrity!

My first week at the facility, some staff members and students expressed alarm at my disfigurement. But after they got to know me, their attitudes changed.

The computer lab was divided into three sections: beginner, intermediate, and advanced. I was placed in the beginner group. Never having learned to type, I had to memorize the keyboard without the benefit of ever seeing one. To progress to the next level, I had to type fifty-five words a minute. Once I achieved that goal, I could receive advanced instruction in computer skills.

The instructors introduced me to Braille—using my fingers to feel raised dots on hard paper in order to read.

I learned to use my walking stick better and to decipher the sounds around me. The instructors taught me how to utilize landmarks to determine my position on a sidewalk. I progressed to navigating a train station, purchasing a ticket, and locating the correct train. At school I used a computer with voice-synthesizer software that converted printed text into audible speech. This enabled me to read and write documents.

On Friday afternoons, my mobility teacher, Virginia Piper, and I walked around the community where I lived. She helped me find important places, such as bus stops, taxi stands, the train station, the post office, and the market. I also learned how to use the ATM. On a few occasions, I switched the limousine ride for a train ride so I could put into practice what my teacher had taught me.

On Friday evenings, I looked forward to the privacy of my modest apartment. My Braille teacher loaned me a textbook so I could practice over the weekends. Each Monday I returned to school more advanced than when I'd left.

I devoured my studies with the hunger of a starved mind. As soon as my lessons ended for the day, I shut myself up in my dorm room to do the assigned homework. Something buried deep inside me began to come alive again.

• • •

Through communications with Mom, I learned that Dale's immigration process for moving to New York had progressed beyond the basic paperwork. She'd taken him for the health screenings required by the US embassy.

Remembering the time Donald had kidnapped him from me, I feared that I would never see or hear from my son again. I pictured Dale living with Donald and his current wife, Jennifer, one of the women who used to come to my home whenever I went to visit my parents.

Then I considered the possibilities that living in America would present to Dale. This wonderful land of opportunity would

nurture him, just as I'd been supported and loved. I could not stand in his way for a better life. Allowing Donald to bring Dale to New York and live with a family—no matter how painful it was for me—was the right thing to do.

Each time I called Mom, Dale promised me, "I'll write to you every day and call you all the time. It'll be easy because we'll be in the same country!"

Dale had much to learn about America.

My schoolwork took on an even greater depth of purpose. With the skills I was learning, I vowed I would one day take care of my own needs and provide a stable home for my child. Then I would bring him home to live with me. Hope and determination sprang forth anew.

When my classmates learned the cause of my blindness, several said to me, "I can't believe that so much wickedness exists in the human race. How could someone inflict such cruelty on another person?"

"There are many good people in this world," I would reply. "But there are also some who are mean. I leave those who have hurt me deeply to God. He will take care of them in His time."

Vera visited me in the classes and encouraged me to keep up my studies. She frequently called me in the evenings to check up on me. She introduced me to other friends she'd helped.

One day Vera brought Linda Ocean, a philanthropist with her own foundation in Los Angeles, to the blind school to meet me. Linda gave me two tickets to an orchestral performance at the Dorothy Chandler Pavilion.

The following Sunday evening, dressed in my finest, with one of my teachers, Dianna, escorting me, I attended a symphony for the first time in my life. I had seen concerts on television and in movies, but actually participating, among thousands of people, gave me shivers of delight. Listening to such great music transported me to a different world.

Tamela telephoned often to follow my progress. She bought me a computer, scanner, and printer—the same kind the school had—so I could practice my typing skills on the weekends. I scanned books into the computer and utilized the speech synthesizer to read them.

In seven months, I finished the program with excellent grades. I sank to my knees and thanked God.

Every day, hunched over my desk in my semi-dark bedroom, I answered the letters that thousands of people had written to me after hearing about my story in the newspapers or on television. I scanned the letters into the computer and listened to the voice synthesizer read them. I joyously responded to every one. Writing on my computer—with my own hands—gave me some feeling of control over the events in my life.

An urge to further my education consumed me. I went to a state college to enroll as a full-time student, but couldn't convince the administrator that I could sustain myself financially.

That night, Mom called. Though she tried to keep her voice light, I sensed something was wrong. After several minutes of chatting and catching up, she said, "Dale left for America two days ago. He wanted to speak to you before he went, but I couldn't call you sooner. I'm so sorry."

Grief at the abruptness of my son's departure struck me. I'd thought we would have a few weeks or even months to speak the words that would sustain us through the time of separation. I felt crushed that Dale and I had been unable to say good-bye. Numb disappointment blanketed me for days.

Then determination returned. I resumed my dream of living a normal life and providing a good living for my son and myself. I would succeed in bringing Dale to California.

• • •

I tried to get a job as a transcriber for a medical doctor or a lawyer, but nobody wanted to hire me. Several said they wanted someone who could speak Spanish.

When Jim came over to visit next, I shared with him my frustration and my desire to learn Spanish. He told me he had a collection of Spanish tutorial tapes he could loan me. I gratefully took him up on his offer. Unfortunately, my Jamaican tongue found it almost impossible to say some of those Spanish words the way the narrator on the cassette did.

One day, as I was struggling to learn this new language, the phone rang. Dale's voice sang through the line. "Mom! It's me!"

Joy flashed through me, bringing a feeling of renewed faith and hope.

ALMOST KILLED

One night I dreamed of my dad in his favorite short-sleeved sky-blue shirt and blue jeans, clean shaven, with a wide smile. In my dream, as I gazed at his handsome features, he called out my name, his voice heavy with sorrow and pain. Then I woke suddenly and sat up in bed, feeling disoriented and sweating profusely.

I felt around with outstretched arms, my head aching and filled with cobwebs. I opened a window and inhaled the fragrance of the predawn morning. Despite the warmth of the air, I felt a chill.

Unable to sleep any longer, I decided to take a walk, hoping the exercise would rest my troubled mind. Dressed in a sweat suit and tennis shoes, I grabbed my walking stick and my tape recorder with directions, then embarked on the journey. I took the shortest route to the bank, planning to get some cash out of the ATM for the coming week.

When I reached the first road intersection, a couple greeted me cheerfully and told me they were on their way to church. They asked if I needed any help. I seriously considered their offer, but remembered that my mobility teacher wanted me to learn how to find my way on my own. So I told them no, thanked them, and continued toward the bank.

Halfway to my destination, I paused at a train crossing, searching my senses for any vibrations of earth and air that would indicate an oncoming train, but I felt no movement and heard

no sounds. My walking stick did not encounter the crossing gate barring the way, so I walked over the raised tracks. They seemed more rugged than on my trip to the bank two Fridays prior. I remembered hearing a local news report about construction work taking place to build an overpass across the tracks.

I suddenly heard a tremendous roar. The earth vibrated. A train horn bellowed in my ears.

In a panic of terror, I ran toward the far side of the tracks, awkwardly flailing my walking stick. On one section of track, my shoes came off. I continued to run in stocking feet. My walking stick fell. I dropped the recorder. I couldn't stop to retrieve them.

The more I ran, the more raised train tracks I encountered. I didn't remember there being this many before. Thinking the distance I'd come might be shorter the length I still had to go, I turned back.

Just as I crossed the last track, a train engine, followed by several cars, roared alongside me. The violent pulse of air nearly sucked me beneath the thundering wheels. Images of people killed by trains fluttered through my mind. I shook so hard my teeth clattered.

I covered my eyes and let loose a scream that seemed to reverberate to the sky. My cry of anguish diminished to a thin wail as the locomotive passed.

I wondered if my walking stick and tape recorder had been crushed by the train. I needed that stick to safely feel my way around. And the tape contained vital contact information, as well as Braille shorthand I was memorizing and ideas that had come to my mind in awkward moments that I wanted to record in a journal.

Filled with fear and confusion, I stretched out my arms and wobbled on shaky bare feet, wanting only to get back home.

I caught my foot in a hole and stumbled. When I tried to move, pain radiated from my ankle. I finally pulled my foot out of the hole and limped on.

Construction material lay along the side of the road. Instead of smooth concrete pavement, I had to walk a circuitous path on dug-up earth. I didn't hear any vehicular traffic or human voices. I guessed the road must be closed.

How am I going to find my way home?

The sun had still not risen, so I couldn't feel its warmth to determine my bearings. Fog misted the air. I wished someone would come by so I could ask for help, but the traffic sounded hushed and distant.

I knew the only one who saw me was Jesus. Surely He was looking down on me with love and concern.

Please, Jesus, show me mercy. Be my guide. Help me reach home. The sweet thought of my Savior comforted me in my misery.

A thought flashed through my mind. *Keep moving. Walking is better than standing still, barefoot and vulnerable.*

I dragged my feet to feel the way. When I stopped to listen to the faraway traffic, I realized I'd veered west instead of south. I turned around and continued until I reached the road I thought I had taken on the first leg of the journey.

When the sounds of automobiles surrounded me again, I felt fairly confident that I was at the intersection where I had met the couple going to church. I wanted to flag someone down to ask for help. But I figured anyone who saw me in this state would consider me a mad woman. So I lowered my head and ran my foot along the curb.

My feet were bruised, cut, blistered, and aching, but I continued. With agonizing slowness, I felt the driveways, sidewalks, and paths along the yards and homes on the avenue. Several times dogs barked at me. My body shivered with fright.

I kept on until I believed I had reached the entrance to my apartment complex. My shaking hand found the familiar gate knob. *I'm home!* With a tremendous sigh of relief, I opened the gate and trudged up the pathway.

Once inside my apartment, I flopped down on the sofa. My whole body throbbed. I could still hear the rumble of the train in my head. Anger at myself for being so stupid spread through my veins. I had nearly killed myself.

But once again, God had snatched me out of the claws of death.

Slowly, with the aid of the banister, I walked upstairs to the bedroom. I sat on the edge of the bed, submerged in mental numbness that precluded all intelligence and reasoning. I selected one of my Bible tapes and inserted it into the player, hoping its words would calm me.

Since I didn't know where I'd lost my walking stick, shoes, or the recorder, I couldn't direct anyone to go out there and look for them.

I eventually replaced the walking stick and purchased a new recorder, but I spent many weeks re-recording all the contact numbers and Braille shorthand I'd lost.

PAPA'S DEATH

The evening after my near death by train, I received a call from my cousin, Desmond. When we were children in Jamaica, he lived with my family for a short time. During his early adult life, he'd shown up at my doorstep seeking financial aid, and I had helped him out.

When an American policewoman had vacationed in Jamaica, she and my cousin fell in love. They married, and he moved to the United States. After that, he attended school and received his doctorate in criminal justice. He now lived in Philadelphia.

I knew Desmond must have heard about what happened to me from our relatives. But he'd never called or written to express any sympathy. When I heard his voice on the phone, a sting of anger threatened to rise up within me. But my heart sank when I considered the most obvious reason an estranged family member would be contacting me. Forcing my resentment away, I asked, "Are you calling about Papa?"

"Yes."

After a moment of silence, I whispered, "Is he gone?"

"Yes. He died Saturday evening at home. Aunt Joyce has been trying to reach you, but she couldn't get through. So she called me this morning and asked me to relay the message."

Desmond's words unraveled my world. *My father died yesterday, and I almost died today.*

I remembered the many mornings I had clutched my dad's legs as he left the house for work; the times when he'd carried me over his shoulders and given me piggy-back rides; all the meals he'd cooked for the family; and the pictures of cows, horses, and dogs he'd drawn for me.

My memories were so vivid, I could still hear his voice—so deep and compelling—challenging me to defend my opinions, making me a better thinker and a better person. Papa often said to me, "You have to pass through dark clouds to reach the silver lining." I could practically hear his laughter and smell his scent.

I recalled the last time I saw him—two weeks before my attack. We were on one of our fortnight treks to take money from Ocho Rios to the little village of Mount Vernon, along with Kentucky Fried Chicken, Shakey's pizzas, and Bailey's Irish Cream. Dad put his hand on my shoulder as we walked and said, "I'm proud of you, Carol. And I love you."

That was the last time we talked face-to-face.

Tears fell into the silence of the telephone line. My cousin said nothing to ease my suffering. I thanked him for passing on the information and ended the call.

The village still had no telephone service, but because Mom often went to my Aunt Joyce's home on Sundays, I called there. My mother wasn't around. I left a message for her to contact me.

That evening, Mom phoned from Aunt Joyce's house. She and my brother had been busy all day making funeral arrangements.

I asked her how much it was going to cost to have Papa buried properly.

"The days of simply buying a coffin and taking it to the cemetery are over," she said. "Funeral homes are selling packages now, and they're not cheap."

She told me the "in" thing in Jamaican funerals entailed a party for the dead. The family of the deceased was expected to kill either a cow or a couple of goats and provide a feast, along with music for dancing and plenty of liquor.

"The last funeral I attended," Mom told me, "had palpitating flames of light, and people were dancing and eating and drinking around the deceased."

I recalled my dad's reaction whenever people died in the village and their relatives fussed over donations and such. He used to say, "When my time comes, just get me a cheap pine coffin and put me in the earth."

When I had my lumber business, most of my customers were cabinetmakers. Poor people usually had them build caskets for loved ones rather than pay the expensive price charged by the funeral homes.

During the time I was living in Jamaica, the dead were taken to the cemetery in a truck. The well-to-do were driven in a black hearse. These days, Mom said the dead were transported to the cemetery in chariots built from fiberglass, pulled by a black hearse. On either side of the chariot were pictures of the deceased. The cost of a good modern funeral buzzed at the $4,000 mark.

I knew my mom didn't have four thousand dollars to bury Papa. I prayed that I would have the opportunity to share my family distress with my friend Tamela. Perhaps the blessings of God would flow out of her life into ours.

Mom and I talked for over an hour, sharing memories.

Then my grandmother came on the line. In a husky voice, she said, "Death is not the end. The chord that binds us together shall never be cut." In a sadder tone, she added, "I wish you could have been with him at the end. You were so close to him, and he was so proud of you. You're a lot like him, able to keep going when life sends you challenges."

My throat closed up, but her gentle words reminded me that I had to endure. My father had given me that character trait, and he would want me to use it to its fullest.

After the conversation ended, I called Tamela and told her about my dad's death. I heard affection and sympathy in her

voice. She prayed eloquently with me, using just the right words. I wished I could pray as beautifully as she did.

After the prayer, she asked about the cost of the funeral. When I told her, she promised to write me a check. "Everything's going to be okay," she said. "You can call me anytime. I'm always here for you." Her optimism lifted my spirits. Her loving words flowed into the bruised spaces of my heart.

The next day, I received a check from Tamela for $4,000 via special delivery. Her thoughtfulness touched my heart. I forwarded the check to Mom.

I spoke with my family back home every day up to the day of the funeral. It was difficult for me to not be there. On the Sunday afternoon when services were held in the old Baptist church in town, I sat in my bedroom, picturing it all, and wept.

Afterward, Mom sent me a videotape of the funeral. Dad was buried in style—with people dancing, grieving, and feasting. He had a fine casket and the grandest funeral in the history of the village. I was grateful to have provided the means to accomplish that for him.

Still, Dad's death devastated me. I wished I had swallowed my pride and gone to see him before leaving for America. Regret hounded me. I declared that I would somehow find a way to make peace with him and with myself.

I prayed for forgiveness and understanding. I prayed that God would take my father's soul and spirit into the most tender place of His heart. I prayed for the strength to remember that Dad would not be gone from me forever, for we would meet again in heaven.

• • •

One of the many letters I received from people who saw my story on television came from a lady named Joan, who was a massage therapist. She explained what massage therapy entailed and the healing effect it could have on an injured body. Then she offered

her services to me for free. I gratefully accepted her offer, and we agreed on a date for my first of three sessions.

When the day arrived, Joan came to my home with her massage table, a bouquet of fall flowers, frankincense, and perfume. The moment she lit the frankincense, its heady scent spread throughout the apartment. Under her direction, I laid my nervous and aching body down on the padded table in the center of the living room. She put on a Kenny G CD. With music in my head and the fragrance of burning incense in my nostrils, I felt her gentle hands on my shoulders.

Her touch released cleansing tears, and my body trembled. She stroked my back, rocking me slightly. Her fingers felt warm against my skin. I groaned with indescribable satisfaction.

Later, in a phone call, I told Tamela about Joan's massage and how much I had enjoyed the indulgence. Tamela told me she often had massages, especially during filming when she worked up to eighteen hours a day. "You should come to Los Angeles," she said. "I'll ask my massage therapists to give you all the massages you could ever want."

After we hung up, I rejoiced in the blessing of this special friendship that God had arranged for me in the midst of my suffering.

TOURING ERROL FLYNN'S ESTATE

Three months after moving to New York, Dale got into a bitter argument with his father and came to live with me. Although the reason for our reunion had caused my son pain, I rejoiced in seeing him again.

Dale, now a teenager, had an aura of fun about him. Humor returned to our daily lives. Together, I knew we would grow strong.

When I told Dalena about Dale living with me again, she invited us to her home.

On the appointed day, Dalena sent her friend David Easter to drive us. This was the same man who had accompanied her on her first visit to see me.

David opened the car door and greeted my son and me in a cheerful, feminine voice. When I stretched out my hand to him, he shook it warmly and said, "Your smile transforms your face. You should use it more often."

He walked me to the car and helped me into the backseat. Dale sat in front. We chatted along the way.

When David announced, "We're here," and opened the car door, the sweet scents of pine and flowering plants filled the air. Dogs barked from within Dalena's house.

Dalena and her boyfriend, Bruce, came out and greeted us with warm embraces. We stood in Dalena's front yard and chatted about the films David had worked on at the Disney

Studio, as well as Bruce's job giving Hollywood actors voice training and singing lessons.

Dalena and I left the guys to their conversation and strolled around her gardens. The lawn felt like thick carpet. Dalena stopped from time to time to cut flowers for the house. As she snipped the blooms, she told me their names: violets, freesia, tulips, marigolds, daffodils, bougainvillea, amaryllis, jasmine, and a variety of roses.

My fingers stroked the silky petals. Joy came to me as I recalled my early childhood, chasing yellow-and-orange butterflies in the fields of Jamaica.

When her basket was full of cut flowers, Dalena and I ascended the steps to the interior of her home. As I crossed the threshold, I walked close to Dalena so as not to accidentally cause anything to spill or get broken.

After arranging the flowers into vases, Dalena took pictures of my son and me. Then she announced in a cheerful voice, "I have two tickets for Universal Studios. Dale, would you be interested in going there with Bruce? Or would you rather stay here with your mom and me for the day?"

Dale laughed. He and Bruce departed, chatting happily.

David, Dalena, and I sat in her living room, enjoying one another's company. When the doorbell rang, she told me she'd invited my friend Tom to join us. After introducing Tom to David, Dalena gave us a tour of the house, explaining all the paintings that lined the walls and the art objects and awards that graced the mantle and shelves. She encouraged me to reach out and touch the furniture's smooth surfaces and carvings. I was happy to get to experience this place of beauty by my sense of feel. When she described the handcrafted mahogany, cherry, and oak furniture, I knew Dalena's home was the fanciest I had ever entered.

After the tour, we returned to the living room and sat on comfortable sofas. I smelled fresh flowers and summer fruits. Dalena brought out glasses of iced tea and lemonade. Following a lunch of tuna sandwiches, Dalena took us for a drive to show us Tamela's new estate in Beverly Hills.

Near the end of the drive, I felt the car going up a long hill. We parked on a slight incline. Tom guided me out of the car and toward the entrance of the property, where I felt a huge wrought iron gate. As Dalena searched for the right key, I touched the plants surrounding the gate, examining the leaves, stems, and buds with my fingers.

"When this property came on the market," she explained, "I knew it was a must-have for Tamela and her husband. This place once belonged to an actor named Errol Flynn."

I tried to recall where I had heard the name before. Then it came to me. I had heard that Errol Flynn once owned a little island off the coast of Jamaica. Back then, I was not allowed to go to the island. Now I stood at the gate of this famous actor's previous home, about to tour his estate in America. I thought, *In this country, all things are possible.*

Dalena told us the old mansion would soon be demolished and a new one built to replace it. We walked across the yard to a huge swimming pool, also destined for demolition. The architects had designed a new pool for a different area. When Tamela had bought the estate, she decided that everything on it had to be torn down and rebuilt, including the landscaping.

I summoned up mental images from magazine pictures. I wished I could see it with my eyes.

As we walked the grounds, our zigzag path sloped downhill. The embankment had been cut with climbing stones intricately positioned as steps. They led to what felt like a steep, dangerous edge. A wave of caution swept over me, but I was determined to get down it. With Dalena's guiding hand, I safely descended.

At the end of the walk lay an area of flat, open land covered with thick grass that reached above my ankles. The afternoon sun shone down fiercely on us. Gradually, I felt the shade of tall trees, refreshingly cool. I listened to the rustling of the branches and the gentle murmur of flowing water over stones.

"There's a creek ahead," Dalena said. We all walked toward it.

A flock of birds took flight before us. The flapping of their heavy wings sounded like a round of applause. I listened to frogs and crickets living in the shrubbery surrounding the creek bank. A cool wind whistled through the trees, producing vibrating chords like organ music. My mind composed its own accompaniment, and I created lyrics to go with a Reggae beat:

> Standing by the banks where water
> flows gently, clean, and clear.
> Birds singing sweetly in the treetops.
> Gentle breeze blowing. Peaceful water flowing in the creek.
> At the water's edge there is rest and
> peace and renewal of strength.
> Flow, water, flow. Flow, water, flow.
> Flow, water, flow. Flow along.

We lingered at the creek, listening to a gentle breeze rattling the branches of trees and the sounds of birds and other creatures. Then we retraced our path up the hill to the mansion.

Bruce and Dale had returned from Universal Studios, both of them soaking wet from the water rides. They took showers while their clothes tumbled in the dryer.

Bruce led us into the music room, where he played the piano and sang. He had an excellent voice. From time to time we joined him in singing. Bruce serenaded me with a song called "On Eagle's Wings." I wiped my eyes with the back of my hand.

At the end of the evening, we parted in sweet sadness. Dalena's hospitality had given pleasure and comfort to all of us.

On the journey home, the beauty of what I had experienced throughout the day replayed so strongly in my head that it seemed to stand out in front of me. That night, in my dreams, I gazed upon the beauty of Tamela's estate and walked along the paths, this time seeing with my eyes what I'd pictured in my mind.

HORSE RIDING AND
PARTYING

One evening, I got a call from Erica Hanson, the producer for the NBC magazine show *Extra*. We had met during the press conference before my surgery with Dr. Kinney. "Carol," she said, "how would you like to go horseback riding with your son next Saturday? My husband and I usually go every year about this time, but I'm pregnant. I'd like you and your son to take our places at the ranch."

Erica assured me I would be safe because this ranch accommodated people with special needs. I eagerly accepted the invitation. Dale could barely sleep that night, dreaming of his first horseback ride.

The following Saturday morning, Erica and her husband, Josh, pulled up to our gate. As we drove, Josh talked about places he'd visited while on business, including the Caribbean and Jamaica.

Throughout the drive, Dale interrupted our conversations with eager questions. "What is it like on a horse ranch? Are there other animals there? How many horses can I ride? Will there be food to eat?" Josh and Erica answered his questions with laughter, patience, and understanding.

At the ranch, we waited by the car for the stable hands to prepare horses for our ride. Dale shuffled about, kicking up small pieces of wood chips that covered the dirt. Sporadically, he'd burst into song, twisting and jumping about.

Suddenly he grabbed my arm and cried, "Mom, two horses are coming this way. They're both brown. One is led by a woman, and the other by a man."

I heard the horses slow down and stop close by. A man about eight feet away from where I stood gave Dale instructions on how to mount and use the reins. Dale repeated the commands and then abandoned me for the excitement of his first ride. As I heard the horse move down the lane, Dale said to his guide, "Can we gallop fast, like the horses at the racetracks?"

Once they were out of earshot, the other horse clip-clopped toward me a few steps and halted again. A woman told me in a gentle voice that it was my turn.

The horse's hooves scraped against rocks embedded under the wood chips. The sound brought back a memory of an accident in my childhood. I had been walking behind a donkey coming from the market with a heavy load on her back. Her mistress had whipped her cruelly. I told the woman not to beat her donkey, but when I moved close enough to intervene, the poor, terrorized beast kicked me to the ground.

With this experience in mind, I became anxious. I cautiously drew closer to the horse and traced my fingers along his body. I could tell he held his head high. The ranch lady assured me he was a loving horse and had carried many disabled people. She showed me the correct way to mount. In an instant, on my own, I sprang into the air and landed upright on the saddle. Once I was seated comfortably, the horse trotted off in smooth steps.

As I rode tethered, my guide described the trail and the squirrels that scampered across our path. I felt disappointed when my enjoyable ride came to an end an hour later.

• • •

Dale and I spent most of Sunday reading some of the condolence letters generated by my television and radio appearances. The flood of goodwill touched me.

One of the letters was from the owner of a resort in Mexico who had seen my story on television while on a business trip to Los Angeles. She invited me to spend a two-week vacation in Puerto Vallarta.

About the same time, someone contacted the Lions Club and invited me and a companion to spend a week in Las Vegas—all expenses paid. Like many of my benefactors, he asked for his identity to remain anonymous, so I had no way of thanking him in person.

I mulled over the two invitations. Concerned about crossing the US border on a visitor's visa, I chose to go to Las Vegas. I dreamt of spending a week in a hotel suite, eating delicious food, playing blackjack in the casinos, and sightseeing. Since Vegas was no place for a teenage boy, my friends, Fay and Gill, offered to take care of Dale in my absence.

I fantasized about buying new dresses, shoes, perfume, lipstick, and other luxury items for my trip. Then I dragged my mind back to reality and went to my closet. My sparse wardrobe did not dampen my spirits. The day before the trip, I got a ride with Jim and went to the mall. I found a perfect dress that covered my scars.

I flew to Las Vegas with Dianna, the teacher who worked at the school for the blind and who had escorted me to the Symphony at the Dorothy Chandler Pavilion. She guided me through checking into a room and then gave me a short tour of the strip. We dined on lobster, smoked salmon, a variety of chicken dishes, and several wonderful entrées I didn't recognize. I also sampled some wine, vintage champagne, and lots of fruit and vegetable juices. We went to noisy clubs, casinos, and two jazz concerts. We visited a different casino each day and played games.

We took a tour bus, and I listened attentively to the guide's and my companion's descriptions. A few people came up to me and asked about my appearance. Each time, I gave a short summary of the evil plight that had befallen me. They all remarked on how hard it was to fathom and praised my remarkable courage.

This generous act of people giving so freely of their time and money took me back to the hour of that vile day of my life. I contrasted it to the present—one person caring so much, the other possessing evil to destroy me as if I were nothing of worth.

When the reality of what I had become sank in, I was shaking with rage, mad at God, consumed with *why* questions. In my anger and rage, I asked, "Where is God? If He is God, the supreme ruler of heaven and earth, why then wouldn't He stop those men from hurting me? I valued my eyes and face and my physical appearance, and those hoodlums destroyed them. Why did God allow them to destroy my greatest assets—my eyes and face—that He had uniquely blessed me with? Why had God brought me into this amazing situation to experience evil on a scale that few people would ever experience?" The rage I felt was a real thing you could almost take out of me and see, like a red mist. But no answers came to my *why* questions. People were shocked at my devastation.

I thought of the people who had given me wonderful experiences and those who had inflicted blindness and disfigurement. The same God Who created one created the other. While one executed a plan to make me experience the worst of suffering, the other made me know that I mattered.

The Bible teaches that God Who is the Creator of heaven and earth created man with the option to make choices. God does not force His will upon man. We are all capable of evil of good. It is about the choices we make.

This does not mean that God is indifferent, uncaring, unjust, or powerless to protect us. Bad things happen because we live in a fallen world where both believers and unbelievers are hit with the tragic consequences of sin. God allows evil for a time although he often turns it around for our good (Romans 8:28). We may have no answers as to why God allows evil, but we can be sure He is all-powerful and knows what He is doing.

Readers, the next time you face trials and dilemmas, see them as opportunities to turn to God for strength. You will find a God

who desires to show His love and compassion to you. If you can trust Him in pain, confusion, and loneliness, you will win the victory and eliminate doubt, one of Satan's greatest footholds in your life. Make God your foundation. You can never be separated from His love.

· · ·

Back at home, I spent the rest of the summer with renewed energy and enthusiasm. That fall Dale enrolled in high school. I followed his progress, talked with his teachers over the phone, helped him with his assignments, and applauded him on his achievements.

I thought about going to churches and other groups to tell my story. I mentioned this idea to David Crawford from the Lions Club, and he told me about Toastmasters.

I called the regional office and asked about joining the organization. They referred me to a group in the city where I lived. I called the president, and he invited me to attend the next local meeting. A cab took me there.

As a first-time visitor, I sat and listened while the members went through their presentations. I hoped to be able to tell my story as professionally as they had.

I visited the group a couple more times. When I asked if I could tell my story, they assigned a coach to me. He acquired an audiotape of the Toastmaster's manual, which detailed the process of becoming a good speaker. I listened to the tape over and over. My coach gave me additional tips for public speaking.

Because of the complexity of my tale, I couldn't sum it up in the ten minutes allotted. So I decided to cut the events into different sections. One week I would speak on blindness, another about courage, then on finding hope in the face of hopelessness and beauty in the midst of ugliness, and living a life of significance.

I hardly slept the night before my first speech. Even though I couldn't see myself, I stood in front of the mirror, as my coach had suggested, and turned on my tape recorder. I rehearsed

each important phrase and repeated the points that I needed to emphasize until I knew it all by heart.

I woke early and went over the speech five times. All the preparation proved worthwhile. Despite my nervousness, my presentation earned the number one vote due to my enthusiasm and passion. In the ensuing weeks, I captured more number one spots.

I showed David my plaque and ribbons from the Toastmaster's competitions. He in turn shared my success with his club members. Through his efforts, I was asked to speak at the Lions Club Regional Conference.

The following Saturday afternoon, I spoke before a much larger group of people than I'd ever experienced. Yet the words came effortlessly, as though I had spoken many times before. Applause from the crowd thundered through the conference room, and everyone stood.

I remembered my divine vision on that horrible day, as I fought death strapped to an office chair, covered in acid. God had promised me this would happen.

The Lions Club presented me with a check for $1,000—my first public-speaking payment. I was thrilled. Holding the check in my hand, I knew God had blessed me with the craft of speaking.

FIVE MANUSCRIPT PAGES

More than a year after the press conference at Century City Hospital, Dr. Kinney's colleague's comment continued to weigh on my mind. Perhaps my story was worthy of becoming a book. Could I really lead people into my world, bare my soul to them, and make them want to read my words? Could such a prospect be possible for someone like me?

I recalled the major events of my life—things I believed would be of interest to others. It occurred to me that my story was not only about abuse and violence, but of the indomitable human spirit within all of us. To my amazement, an outline slowly developed in my mind.

In conversations with people, I shared my desire to write my story of struggle and victory.

Charlene, one of the teachers at the school for the blind, told me she had a Hollywood scriptwriter friend named Gigi. Charlene believed Gigi would be a suitable ghostwriter for me. Gigi traveled from Los Angeles to my home. During a couple of visits, I shared my history with her.

Gigi reacted enthusiastically. "Carol, I am so excited about writing your story. It may even appear on Oprah's Book Club. Start looking for a publisher!"

She left my apartment with notes in hand and laughter in her voice, and I pictured her smiling face. I called Tamela and asked if she knew of anyone in the publishing industry who might be

interested in my story. She mentioned someone who had accepted a book her co-star had written and promised to contact him.

A couple of days later I received a call from Rob Weisbach. I told him about the events that had changed my life. He told me he pursued books about famous people, mostly celebrities. However, he asked me to send him a few pages.

Two weeks later, Gigi came back to my home with five manuscript pages. "This is my best work ever," she said. "I have never spent so much time writing five pages and for free. But I know that when we get the book deal, I will be compensated greatly." She had dreams of my signing a contract with a well-known publisher, giving her big cash rewards. She started counting all of her friends and relatives, trying to figure out how many books she'd need to give away.

With great optimism, I sent Gigi's pages to Tamela to forward to Rob. But when he called me on the phone, he told me that Gigi's writing wasn't good enough for him to offer a book contract. He recommended a ghostwriter named Mim, a woman he had attended school with years before. He believed she would do a better job for me. Rob promised to call her as soon as he hung up.

When Gigi stopped by that afternoon, I told her the bad news. Her hopes dashed, she spoke slowly, "I spent two weeks writing those five pages without a signed contract from you. That was a big mistake." Her voice turned hard and cold. "You should pay me for my time. And if I ever see my writing used in any capacity, I will sue you!"

Her anger and threats frightened me. The moment she left, I destroyed her work. But I still worried that someday a policeman would drag me off to court.

The next day, Mim telephoned. I described my life in reverse, going back to my childhood in Jamaica.

Mim said, "I have too many writing assignments right now to make a commitment to you. But I'd like to meet you. I teach a two-hour writing class in Los Angeles on Saturday afternoons. I

wrote Della Reese's book, and the writing class I teach is in the same building as her church office. If you can find a way here, come on by."

I agreed to meet her the following Saturday.

Mim greeted me warmly. She introduced me to the members of the writing class. I sat quietly, listening to her teach with passion.

Many of the students seemed destined to become authors. Some of them worked in Hollywood as writers, others as assistants to movie directors. One woman named Michelle wrote wonderful poetry, some published. Another student, Jill, was writing a play and a book, both based on her family stories. Most of the class members wrote screenplays or book manuscripts.

While I sat among these people with big plans and dreams for the future, thoughts swarmed through my head like bees about a ripe mango. I remembered vividly my lust for life when I ran my own business and wondered if I would ever be able to start afresh.

I had a fine imagination. But I didn't believe I could put my thoughts into writing. *If only I could see. Then I could weave into designs the tangled ideas flowing through me.*

After class, Mim and I moved to a table some distance away from the others and munched on snacks. Sitting across from each other, Mim said, "Your story is larger than life."

I pictured her looking at me with a great wave of sympathy. I smiled at her and said, "I know my story explodes beyond the boundaries of the life that most people are living. But there is more than what the eyes see. I have been having constant and recurring dreams in which I see myself back in school with my classmates doing term papers. Every exam I take, I fail. In my dreams my subconscious mind was telling me that I need a career upon which to restructure my life. I need to do something about my being poor."

"On the day of my affliction, during the most miserable hour of my life, I had a vision. In that vision, I received a calling to write. The problem is that I have not been trained as a writer. I

want my story to be a book. I feel that God has brought me into this amazing situation for a purpose. I am looking for someone to write my story. I want a different life When people ask me what I do for a living, I want to be able to hold my head high. I want to be measured by the same measuring stick that everybody else is being measured with. Can you please write my story?"

"Your story has true potential. You have identified that what is holding you back from the writing of your story is your lack of knowledge about how to write a book. Your gift and your desire to tell your story in a book are valid, but *you* are your own major barrier. Stop cutting away at your confidence to write your story. You have what it takes within you to write your story. You must face the empty page. Find the confidence. The Bible says there are treasures hidden in darkness (Isaiah 45:3). But I can't even begin to imagine living a life in darkness."

"Mim," I said, you are looking at a woman whose life has never been butterflies and happiness. I have grown in the valleys, mountains, and the trudging of the trails. Walking through all these difficulties of life has given me a story to share with the world. I want to write this book to change lives, because I have had a changed life myself."

"What is your take away?" asked Mim.

"Hope! I want people to know that all is never lost when God is allowed to take control of their lives," I replied. "No matter what the circumstances, out of their pain and brokenness, they can bloom exactly where they are. They can turn the page to write new chapters for their lives to find freedom and fullness. The cuts, scrapes, the fragmented and worn out places of their lives do not take away their usefulness."

"Your life has a unique message," Mim responded. "Your views, your spiritual understanding, your characters, your story, these are things that only you have. You can give your spiritual message the emotional impact of your own experience in a way that has never been done before. Others have used their stories as

a mean of livelihood. Today's market needs your story. But how do you get your story to a point that is commercially possible?

"If you get the calling to write your story, the writing talent will come too. The flesh eating acid didn't burn away your courage, resiliency, intuition, creativity, and passion for life. Once you start the writing, your courage will ignite your other strengths. The Scripture says: *For the righteous man may fall seven times, and rise again. The righteous may have seven setbacks, but he will get up and get going.* Proverbs 24:16.

"My days are full," she told me. "I'm finalizing a book I wrote for a client. The publisher's editor asked for a different ending, and I've made two revisions already, but the editor is still not pleased. The story is currently in production for a movie with Denzel Washington in the starring role. In addition, I'm writing a book for Victoria Principal from the TV series *Dallas.*"

I was impressed.

"My husband is an actor; he appears in films with Antonio Banderas. He doesn't work steadily, so I can write only for people who can afford to pay for my services. I need to take care of my family."

I certainly understood that, but my hopes of working with her were dimming.

Mim stood. "I hope you'll keep coming to the class. You might learn some writing techniques and acquire the skills to be a good storyteller yourself one day."

Encouraged, I accepted her invitation and returned home with high hopes. I would write my own book. I knew nothing about the rules of grammar, but I had my own writing style that I felt would be effective and powerful.

The interest Rob had expressed in my story spurred me on. With finances lean, I worried about whether a book about my experiences could lift me out of a life of deep poverty and destitution.

• • •

My expenditures had exceeded donations. The costs of nursing care, prescriptions for anti-rejection drugs, rent and utilities, and raising a son all added up. I had only enough money to continue living in the apartment for another three months or so.

Each time Linda Alvarez aired an update on my progress, I received a few more donations, but nothing so big as the first round of giving. My nest egg was quickly shrinking.

An idea pecked at my brain like a chick ready to be hatched. I felt certain that the people in my writing class could bring a change in my circumstances through their social standing, connections, and influence. A glimpse of the future lit up the present.

That Saturday evening, I received a phone call from Mim. "When you shared your story in class and I saw the result of your affliction, my heart thumped, and a dull terror took possession of me. After I got home, I was overcome with hysterical weeping. I was deeply disturbed by the wrong done to you. You see, my son— my only child, Eli—was born the same evening of your tragedy."

My heart broke with sorrow for her.

"I want to support you as much as I can. Together we can prove to people that there is more in the world than hatred, greed, and cruelty."

Tears flowing, I wondered what she had in mind.

"Could I tell Della about you—share your story with her?"

With implicit faith in Mim, I agreed wholeheartedly to her request.

As I crawled into bed that night, I indulged in a quiet smile of satisfaction, envisioning a brighter future.

DELLA REESE'S
LOVING TOUCH

Mim called Ms. Reese and told her about my poverty and helplessness, my endless needs, and my ongoing medical necessities. She asked if she could take me to her church and introduce me to the congregation. Della agreed, and Mim faxed my contact information to arrange our meeting.

A cabby friend of mine named Jarvis offered to take me to the church service for free. His generosity surprised me. He had a wife and seven children to support.

The following Sunday, Jarvis drove Dale and me to Los Angeles. The members of my writing class greeted us cheerfully. Mim introduced me to Della Reese, her immediate family, and other leaders of the church.

The writing-class students and Mim, her husband, and her friends all sat with me on the first and second rows on the left side of the church. I smiled contentedly.

Midway through the service, Della called me up to the pulpit. Mim assisted me by taking my hand. As I walked forward, I felt all eyes staring at me.

Della embraced me warmly. Her touch brought peace to my soul. She introduced me to her congregation. As she relayed my story, I heard her sniffling, and I could picture tears of sadness flowing from her eyes.

"This is a church," Della said passionately, "where there is a strong belief in God. The Bible says we must feed the hungry, clothe the naked, and comfort the desolate. We need to do as God bids and help this poor soul."

Della poured her heart out in prayer. Afterward, the deacons collected more than $5,000 in donations for me.

"Thank You, Lord," I prayed from the pulpit. "I ask for Your blessings on those who have so generously given to me the best of themselves so I could feel love again. All good things come from You. I know these people gave as a result of Your influence."

At the end of the service, the members of the congregation came forward and shook my hand. Some hugged me; others sobbed. A few offered me their business cards. Several took my contact information and extended an invitation of friendship.

The next Sunday, I attended Della's church again. I sat with the rest of the congregation and listened attentively to the service. As on my first visit, a band accompanied the joyous voices of the choir and the congregation. My body swayed to the rhythm, and I felt the tension leave me.

Della delivered the message that morning. She started off speaking calmly and thoughtfully. Her words held respect and grace. As the sermon progressed, her voice became heated and more powerful. Shouting and ranting from the pulpit, she spoke about the baptism of fire. I felt as if she were talking directly to me—understanding my worries, believing in me, and cheering me on.

I decided to join the church as a member—not only for social and financial support and prayer for healing; I wanted to be a part of this church because I knew its mission was to carry on the teaching ministry of Jesus. Their calling involved attending to the physical, emotional, and spiritual needs of those they served.

I craved a personal relationship with my Creator, amazed at the reality that He wanted to engage in a relationship with me.

I invited Tamela to attend Della's church with me. She agreed. Tamela, her husband, Jamie, and I sat in the front row on the left

side of the church. Della beamed when she recognized my guests. At the beginning of the service, she invited Tamela to join her at the pulpit and introduced her to the congregation. She and Della chatted about life in Hollywood and discussed an abruptly canceled television pilot they'd worked on together.

• • •

I began to contemplate having another surgery to restore my sight. Maybe my eyes would never be as good as they once were, but deep down I believed there must be a way to get back some of my vision. I searched the Internet for "restoration of sight." (My computer is equipped with special software that reads the text for me.)

On the ABC news website, I learned of a breakthrough surgery that could return sight to the blind. The procedure entailed a stem-cell transplant to treat the affected area and create an environment where cells could regenerate.

The following morning, I called the television station. They referred me to their bureau in Washington DC, and I contacted the correspondent who had reported the story. He gave me the names of the two doctors he had interviewed—pioneers in that kind of surgery.

I telephoned the first doctor and left a message. Two days passed without a return call. I dialed the second doctor's number. He answered personally. I had never called a doctor and immediately talked directly to him without having to pass through staff workers.

Maybe this is the work of God, I thought.

At the end of our conversation I made an appointment to see him at his Boston office. Tamela and her husband provided airline tickets and hotel accommodations for my son and me.

At the hospital, Dr. Foster conducted a thorough examination and assured me that my vision could be partially restored. But he would not consider doing surgery on my right eye with the lid in its present condition. The eyelid had drooped since my last surgery with Dr. Assile. My eye needed to have full closure for Dr. Foster's

procedure to be successful. I would have to undergo another eyelid surgery before Dr. Foster would even touch my face.

Though I had no money for such a thing, I felt overjoyed at the chance to have my sight restored. I knew God would work behind the scenes, inspiring professionals with the wisdom to use their knowledge to produce the miracle for which I had waited and prayed.

In the hotel room, as I packed for our trip home, I happened to turn on *The Oprah Winfrey Show*. The program featured a man who'd had his nose burnt off by frostbite while climbing an icy mountain. Dr. Kenneth Salyer, a well-known plastic surgeon, had reconstructed the man's nose with complete success. At the end of the show, Oprah mentioned that Dr. Salyer worked at the Cranial Institute in Dallas, Texas. My return flight had a long layover in Dallas.

Hardly daring to hope, I picked up the phone and asked the operator to help me call Dr. Salyer. While I waited to speak to the doctor, I touched my nose, which Dr. Kinney had tried to reconstruct. It had no bridge, and one nostril had collapsed.

When Dr. Salyer's assistant came on the line, I explained my situation. She put me on hold to speak to the doctor, then came back on and told me she would arrange for a car to pick us up at the airport during our layover and bring us to the institute for a consultation.

In the spacious medical offices in Dallas, while Dale sat in the waiting room, Dr. Salyer tilted my head left and right, up and down, and cleared his throat. In a coolly professional voice, he said, "Your case is very different from the other burn victims I've worked on. I would have to carve a new nose out of tissue taken from your arm. It is a difficult procedure, and your nose will not be the same as it once was. Your disfigurement would still be obvious. In addition, your arm would end up being deformed. The cost of this operation is significant, as is the extended hospital care."

I swallowed, imagining my arm fixed in some awkward position for several weeks as the new nose was being produced. Even if I had the money to pay for the surgery, the deformity that would result from the procedure would have been too much for me to bear. I decided to stay as I was.

I thanked the doctor for his time, collected Dale from the waiting area, and took the institute's car back to the airport. We arrived just in time to catch our flight to California.

YOUR FRIENDS,
MY FRIENDS

Over the next few months I received letters from my doctors in Boston reminding me they were ready to operate on my eye. My job turned to obtaining the financial help I needed.

Shannon, one of Mim's friends, worked for Capital Investment Company. Mim asked her to get coworkers interested in pooling funds and having the company set up a fund to pay for my pending surgery. They all agreed. With their matching grant, I received $20,000—enough to pay for the first of three surgeries: the one to correct the eyelid of my right eye. I made an appointment and booked a flight.

Because I needed a place to stay for a month, I went online to search for a hotel near the hospital, but could not afford the high nightly rates.

With only three days to go, Michelle, a friend from the writing class, called to tell me that she was trying to find a place for me. She assured me that everything would work out somehow, and I shouldn't worry. I tried not to.

Mim called numerous friends and acquaintances to see if they knew of anyone who could help me. Those friends asked other friends. With so many people working together for one cause, I knew good had to prevail.

The evening of the day before I was to leave for Boston, I received a telephone message saying, "My name is Marie Probst, and I'm calling to offer my home for Carol's month-long stay in Boston."

All things *were* possible. I had only to believe.

Shortly after I received this good news, Michelle called. "I didn't want to say anything to you until I was absolutely sure this would work. But I shared your story with Denise Winston, my prayer partner in New York. She's offering you the opportunity to stay at the Omni Parker Hotel in Boston for two days before your surgery."

Unable to control the flow of joyful tears, I told Michelle how grateful I was for her friend's generosity and asked her to express my sincere gratitude and appreciation.

"Denise will meet you in Boston," Michelle said. "She wants to take you to dinner at the best restaurant in town. She'll pick you up at the Omni Parker, and she'll be at your side in the hospital throughout the day of your surgery."

I felt deeply loved. Imagine, a stranger going to Boston just to see me and be with me, as well as spending her own money for me to stay at a nice hotel for two days.

The afternoon before I left for Boston, I called my cabby friend for a ride to the bank to get a cashier's check to pay for the surgery. When I returned home, I checked my answering machine. One new message played from a woman who called to say that her foundation in Boston, the Rose Fund, had heard of my story from Mim, and they would take care of my present medical bills, so I didn't have to bring money to pay the doctor.

Overjoyed, I hopped into Jarvis's cab. He took me back to the bank, where I redeposited the money into my account. Once again God had come through at just the right time.

Fay, from my writing class, offered to have Dale stay in her home while I was in Boston. She came from Jamaica; her husband hailed from the Virgin Islands. They promised to provide Dale with all the necessities: food, shelter, transportation to school and

sports, all free of any cost to me. Fay even volunteered to meet with Dale's teachers to check on his progress and make sure he did his homework every night. With everything taken care of, I left California. I landed at Logan International Airport at two o'clock in the morning. I could hardly wait to see what wonderful things God had in store for me in Boston.

A BOSTON WELCOME

Just as I was telling the flight attendant in the airport that I expected to be met by a lady, Marie called my name. We embraced warmly. She took my hand, and we walked to the baggage area.

Outside the airport, snow fell heavily…my first experience with the cold, wet powder. Marie told me it looked like a clean white blanket had been wrapped around the town and countryside. As we traveled to the hotel, she described in detail the homes where Christmas lights twinkled in the windows.

Marie parked her car in front of my hotel. I felt a freezing wind that seemed capable of causing icicles to hang from one's nose. Marie grasped my hand and led me inside, where a bellman took my luggage. At the front desk the receptionist handed me the key to my room along with a key to a private bar.

Marie and I followed the bellman to the eleventh floor. At the door, Marie stopped for a long moment. "This is the Honey Fitzgerald suite," she said in astonishment.

"Who's Honey Fitzgerald?" I asked.

"He was the grandfather of John F. Kennedy!"

Denise called management to make sure there hadn't been a mistake. She was told that when she booked the room and told my story, they had upgraded me to this suite. I could not believe my ears. I felt so important.

The hotel had provided fresh flowers, assorted fruits, and an abundance of peanuts, granola, and dried fruit—all of my

favorite snacks. The private bar was fully stocked, though I would never use it.

That night, Marie stood beside me at the window and described the panoramic view of the historic city of Boston. I wished I could have seen it.

Marie described the pictures of the Kennedy family decorating the walls. I walked about the suite and touched all the portraits before retiring to bed.

The following evening Denise flew into Boston. She arrived at my suite bubbling with enthusiasm, and Marie and I greeted her like old friends. I told Denise how grateful I was that God had put us together at a time when my life loomed so dark.

We held hands on the way to dinner at the hotel's restaurant. They served lobster with fresh vegetables. It was the best food I'd ever tasted.

At eight o'clock the next morning Denise knocked at my door to take me to the hospital. We took a cab in thirty-degree weather with falling snow. I had never experienced such cold.

Denise guided me through my pre-surgery procedures—blood tests, heart rhythm monitoring, blood pressure checks, etc.

My television reporter friend, Linda Alvarez of KCBS in Los Angeles, had called their affiliate station in Boston and asked them to film my surgery. The news anchor and a cameraman came to the hospital and conducted interviews with me, the manager of the Rose Fund, the doctors, and the hospital personnel to be aired that evening in the health slot.

During the surgery, Denise waited in a special room where the doctors updated her on my progress. I was not in great pain, only feeling a stinging sensation at my graft areas. It brought comfort to my heart to have her there, checking on me and loving me. This was something I had not experienced with my previous surgeries.

After surgery, Denise fed me my dinner—mashed potatoes, stuffed chicken, and vegetables. Then we watched my television news segment. It sounded so inspiring!

The following morning my roommates, the hospital staff, and the other doctors congratulated me on the interview. Their comments lifted my spirits.

Marie picked me up after work and took me to her home, where she gave me her big, comfortable bedroom—the closest room in the house to the kitchen and bathroom—making it easy for me to function.

Lying in bed with the windows open, I listened to cars passing and the wind rushing through tree branches. The peacefulness lulled me to sleep.

The next day, Marie told me a large bouquet of pink roses and purple heather had arrived for me. The attached note said, "From the members of the writing group." She placed the bouquet on the dressing table beside me. I took deep breaths of the scent, which comforted me in my pain.

In an attempt to get from one room to another, I accidentally broke a picture on the wall, but Marie forgave me.

She treated me to any kind of food I wanted. Every week she went to produce markets, the seafood market, and Indian and Italian restaurants to bring me meals she thought I would like. If I asked for anything, she quickly and gladly gave it to me—no questions asked.

Marie and I talked often. She always seemed interested in what I said.

On my first weekend there the bandages were removed, and I was feeling well. Marie took me to a hairdresser and a manicurist. Twelve inches of snow covered the town. Marie had to park some distance from the salon. As we walked, snow fell on me, and the wind howled around me. In spite of the cold, I enjoyed the experience tremendously.

The month I stayed at Marie's house, she refused to accept payment for my food, my phone bills, the hairdresser, the manicurist, or even my medication.

Marie told her boss and coworkers about me and asked for time off to take me to the doctor. She had to make up for lost time at work, so she went into the office in the evenings, often returning home at two o'clock in the morning.

Mim called often to encourage me, wish me a speedy recovery, and follow my progress. She told me the Rose Fund was pleased with the television interview. For weeks, their phone had rung off the hook with people calling to offer help.

At the end of my last visit to the clinic, the doctors told me they were satisfied with the results of the surgery to ensure full closure of my right eye. Two more surgeries lay ahead for my right eyeball. They explained in detail what the next step would entail—the advantages and disadvantages.

I perceived a glimmer of hope, and that was all I needed. I would go ahead with the surgery. Nothing would stand in my way.

I had no job or financial resources, but I had caring friends. An abundance of assistance waited for me. Victory was within my grasp.

I asked the hospital personnel in charge of billing for an estimate of how much money the remaining surgeries would cost. She could not give me a precise number, but told me the hospital required a down payment of $20,000 for the stem-cell transplant. The stem-cell transplant would give me a better chance for the cornea transplant to flourish. Since the Rose Fund had paid for the first surgery, I still had the $20,000 the Capital Funding Group had raised on my behalf.

Having the down payment in the bank buoyed my spirits. Somehow, I knew the rest of the money would come in when I needed it.

Marie had made arrangements for her best friend and the friend's family to vacation with her in her home, so her house would not be available for me to stay on my return trip. Still, I felt confident that God would provide a place for me as well.

THE STEM CELL
TRANSPLANT

I strolled with confidence through the doors of the Boston Ear and Eye Infirmary for my meeting with Dr. Foster. In his office, he explained, "Stem-cell transplanting is the process of taking healthy stem cells from a donor and putting them into the affected area of your body to promote new growth. The first step is to find a donor with a blood type that matches yours. Tell me about your family."

"I have a mom, a brother, and a son."

"Your brother and son are the two most likely candidates for this procedure; their blood type is likely similar to yours. Genetically, most patients are more likely to be transplant compatible with a brother or child than with a parent."

Dr. Foster asked his assistant to order the necessary tests; then he handed me several forms.

Doctors in California tested Dale and me for the donor match. I sent a set of medical request forms to my brother, Dennis, in Jamaica. He promised to go to the hospital to have his test the day he received my package.

A couple of weeks later, Dr. Foster called. "Your brother is a match."

Dennis would have to use up all of his vacation time to come to the US and undergo the surgery with me. My beloved brother didn't even ask about the details of the procedure.

Mom volunteered to fly out and watch Dale during my surgery and recuperation. She could take about seven weeks off work, more than enough time to get me through the worst of my recovery period.

Once the stem cells were implanted, I would need anti-rejection drugs—extremely expensive without health insurance. I pondered various ways to raise funds: newspaper interviews, hosting a dinner party like politicians do, holding an auction with donated valuables, finding a large corporation willing to adopt me as its charity. But none of my ambitious ideas ever materialized. As a result, I missed the appointed date for my surgery.

Letters arrived from the hospital, but I ignored them.

Mom and Dennis called, wanting to know our next step. I put them off, unwilling to admit another failure.

Dr. Foster telephoned. "I'm ready to help you get your sight back. All I need is the surgery date."

"I can't afford it right now, doctor," I choked out. "But I will keep trying to find a way."

I hung up, desperate for a solution. Then an idea came to me.

That Saturday evening after class, I told my fellow writing students all the facts Dr. Foster had told me about stem-cell transplantation. I explained how the surgery would help me enter a new life with independence. They erupted in cheers, applause, and whistling.

After the excitement died down, Mim said, "Prepare a needs list for us. Bring it with you next week. We'll discuss it at the end of the next class."

I spent the next several days listing the things I'd need. I added up the total amount of money required for the operation and for medicine after the surgery.

The following week, I gave a copy of my list to everyone in the class. They brainstormed options. At the end of the session, they agreed to host a fundraising event. Each person promised to invite all the people in their circle of influence. Intense relief flowed through me.

The next day, with a tremor of anticipation, I called Mom. She said she would tell Dennis my news when he next visited the village.

Three weeks before my scheduled surgery date, Leslie, an actress in the writing class, announced that she had signed a contract for a leading role in a network sitcom. Everyone cheered her news.

Taking my hand, Leslie said, "Carol, God has really blessed me with this job. I want to bless someone in turn, and that someone is you. I will pay for your round-trip plane tickets to Boston."

The group shouted with joy as I embraced Leslie.

• • •

My brother needed a visitor's visa to come to the United States. However, because most of the young people in Jamaica who obtained visas never returned home, the American Embassy made the process difficult. The office in Jamaica routinely turned down applicants, regardless of the circumstances.

I told Dr. Foster about the situation. He provided me with a letter addressed to the immigration office at the American Embassy in Jamaica. In it he outlined the details of the stem-cell procedure. He explained the reason to seriously consider my brother for a visitor's visa.

A lawyer from Della Reese's church also wrote an influential letter to the immigration office.

When my brother went to the emergency window of the American Embassy, he received the necessary paperwork without much interrogation. He called me excitedly to let me know he had obtained the visa.

The good news overwhelmed me with joy. I triumphantly confirmed the appointment for my surgery in Boston.

At the same time, my friends from the writers' group set the date for the fundraiser party. John, the lawyer who'd given me the letter for the embassy, teamed up with Lori, a member of the writing class, to find a venue. A friend of John's who owned a

restaurant in Beverly Hills generously offered to donate his facility for the event.

The morning of the benefit, I went to the beauty salon and had my hair done. A red dress with matching jacket made me feel bright and lovely. Dale wore a gray suit with a white dress shirt.

David Crawford picked us up.

Dale and I held hands as we entered the restaurant. Music played softly in the background. Waiters served cocktails to arriving guests.

I settled myself in a comfortable chair between Dr. Kinney and Vera and asked for a cold juice. People around me spoke in happy tones.

Once everyone was seated and served, Mim called for order. She introduced me, spoke a bit about my situation, and explained the purpose of the gathering. "Carol's happiness is important to me. No failure distresses her. No unfavorable circumstance can crush her. Her strength and courage and determination attract me to her. Financially, she relies entirely on what people offer her. I pray this evening you will find it in your hearts to help in the most generous way you can."

The lights dimmed and the audience viewed a fifteen-minute film of my surgery and the interview done for KCBS in Los Angeles. Then Mim invited me to share with the crowd.

Beaming with the love and acceptance I felt, I walked to the podium under many camera lights. I called on all the inner strength, courage, intuition, creativity, and passion I could muster to give the best presentation.

At the podium, after taking a deep breath, I described the day that had changed my life. I told how I'd found hope in the face of hopelessness, beauty despite my ugliness. I ended my speech with a plea for help so I could build a new foundation of resistance against the hurts of the world, a place from which I could start life afresh. I spoke calmly, clearly, firmly, and precisely, with a tone of conviction and animated facial expressions and gestures. "What we give out, that we get back."

When I returned to my seat, people gathered about me, shaking my hand and telling me how I had touched their hearts. One said I'd caused her spine to tingle. A waiter told me he felt so moved he was going to donate all of his tips for the evening.

However, after counting all the money, the total came to less than a thousand dollars. I felt weakened from the disappointment, but not broken.

Back at home, I lay in bed and looked blankly up at the ceiling. My old foe taunted me: *Where will you get the money?* Sleep took hold of me before I could find an answer.

• • •

Several days later Denise called. "Carol, I can pay for you, your brother, and me to stay in a hotel suite for three days. I'm sorry, but that's all I can afford to do right now."

I thanked her. Every little bit helped, but after those three days, I would need a place to stay for two weeks until Marie's houseguests left and we could live with her.

Despite my anxiety, I called to confirm my travel date for the trip to Boston.

Mom arrived a few days before my departure. At night, she read the Bible to me. The comforting rhythms of her voice put me to sleep.

Just before embarking on the journey to Boston, excitement engulfed me. I felt eager to get on with the procedure that would help me to see again.

An hour after I arrived in Boston, my brother's flight from Jamaica was scheduled to land.

Marie could not meet me at the airport and provide a ride to the hotel, as she had on my previous visit. But her employer graciously offered to arrange transportation for Dennis and me. Marie gave the limousine driver a description of me so he would recognize me at the airport.

I disembarked the plane and walked through the terminal with the aid of a flight attendant. The driver came up to us and introduced himself. I took his arm, and we proceeded to baggage claim. After he retrieved my luggage, we went to another terminal to await my brother's arrival.

Five years had passed since Dennis and I had seen each other. When I heard his voice calling my name, a sense of relief and peace came over me. I eagerly turned my head and called out, "Dennis!"

Heavy steps ran toward me. We embraced warmly, rocking from side to side. As I held him, fragments of memories from our childhood scattered through my mind.

Dennis, seven years younger than I, always wanted to accompany me to the water tank, but never wanted to walk the distance. So I carried him. That way, I reasoned, my little brother could see the world from the same perspective I did. With him on my left hip and the shiny bucket in my right hand, we ascended the hill. I set my brother down and filled the bucket with water. After I'd placed my brother back on my hip, someone would lift the full bucket to my head, and I used my right hand to balance it as I descended the hill to home. This was an everyday occurrence for many years.

I also taught my brother to read and count. By the time he entered elementary school, he was reading above his grade level. I was always proud of him.

The driver took us to our hotel and then departed. Settled into our suite, Dennis and I caught up.

"Grandma gave me a letter for you," he said. I heard rustling as he searched through one of his bags. Then he placed a crumpled envelope into my hands.

I lifted it to my nose, wanting to smell the earthy perfume my grandmother always wore. My fingers caressed the creases, savoring something that had been in my beloved grandmother's hands not long ago.

"Would you read it to me, please?" I asked Dennis with a catch in my voice.

He took the envelope, tore open the flap, pulled out the letter, and read.

Dear Carol,

As you know, I do not like writing; I am not a woman of pen and paper. Nor am I a youngster anymore. My eyes are dim, arthritis has taken over my body, and I do not hear well. It takes every ounce of willpower and strength for me to sit down and form this letter. But you are very special to me, and you have been away for such a long time. When I heard that Dennis was going to see you soon, to donate stem cells from one of his eyes so as to help you in the restoration of your sight, I knew I must write to you.

We all would do anything we could that might be helpful to you. Before that terrible misfortune, you gave selflessly of yourself to us. Now it is our turn to give selflessly back to you. You have done well for yourself to have survived life despite the sufferings and hardships you encountered. I am praying that you will be able to cope with these pending surgeries. I pray you will regain your sight at the end of this series of surgeries.

Rough times, trouble, and tragedies seem to latch onto you. I believe you survive because of all the prayers sent up for you. I want you to know that I am praying for you. Lean on the promises of God, Carol, as outlined in the Bible.

I leaned back in my chair and let Grandma's words wash through my mind. I could picture her hunched over her old kitchen table, scrunching her eyes up, and painstakingly scratching out each letter.

When Dennis stopped reading, he put the note back in the envelope and handed it to me. I held it against my heart, treasuring the gift from home.

Dennis told me he felt a bit nervous about the surgery. He understood very little about the procedure, only that the doctor

would go into one of his healthy eyes and collect stem cells to transplant into mine. "But," he said, "my mind is made up to do this for you. I may live with a deformed eye when this is over, but I will risk anything to help you see again."

I sensed his fear, but also his unconditional love.

"Dr. Foster didn't say you would be deformed. Have faith. Everyone says he's the best."

In the morning, we took a cab to the hospital. With Dennis's guidance, I went to the financial office to pay for the surgery with the $20,000 I had withdrawn from the savings account. I promised the clerk the balance would be paid soon, though I had no idea how.

She gave her approval to proceed.

We met with Dr. Foster for a brief pre-op visit. Dennis voiced his concern about living the rest of his life with a deformed eye. Dr. Foster's voice registered surprise. "Your eye is in perfect health. I expect it to heal completely. You won't even be able to tell you had this surgery."

On the way back to the hotel, Dennis was filled with energy and enthusiasm. The doctor's assurances had relieved him of a heavy burden.

The following morning, I did a television interview with my brother—a continuation of my story for the media in Boston and California. I told my well-wishers and supporters I had reached a point where I no longer worried over unresolved questions. I wanted to forget about everything bad that had happened to me and wake up to begin life anew.

At the end of my interview, I walked with my brother to the hospital's surgical center. Nurses took our vitals and hooked us up to IVs to prepare us for the surgery.

Lying beside my brother, I had no doubt that Dennis's sacrifice would lead to the restoration of my sight. As doctors and nurses worked all around me, a pleasant drowsiness buoyed me. They calmly talked us through the procedure, explaining each step.

Stem cells and conjunctiva were harvested from my brother's eye and implanted into mine. The doctors used embryonic membrane to cover the newly implanted cells.

I spent a couple of hours in recovery and then left the hospital with eyes scratchy and painful. With Denise's help, we took a cab to our hotel.

Dennis's one eye was bandaged like mine, but he managed to guide us around our room without mishap. I listened to my interview on television before sleepiness enveloped me.

At the end of our three-day stay at the hotel, at 8:00 a.m., my brother and I returned to the hospital so Dr. Foster could remove the bandages. The doctor strode into the room with student doctors in tow. They all greeted us warmly.

After removing the bandages and examining our eyes under the microscope, Dr. Foster said in a sparkling voice, "I am pleased with both surgeries."

He handed me a pair of protective glasses and told me to wear them at all times. He also gave us prescriptions to be filled at the pharmacy. The money from the fundraising party was only enough for me to purchase part of our medication.

We returned to the hotel, and while we had lunch, I did a general accounting of our financial situation. Dennis had used up all of his savings to purchase an airline ticket to come to America, so he could not help with expenses.

We checked out of the hotel, having no money to pay for another night.

We had no luck finding a motel in Boston that fit our meager budget. For a few days we lived in train stations and at bus stops, dragging our heavy luggage from one area to another.

Two priests we encountered during our search told us about a foundation that would offer me a night's rest, but they could not do the same for Dennis because he was not a resident of the United States. I refused to leave my brother alone on the street.

My head throbbed in agony; nausea surged up in me. I struggled against pain in my head and eyes. I breathed deep and fast to keep warm.

When we ran out of places to sleep, we rode whatever trains we could afford, not caring where they went. Between my groans, I vaguely heard conductors shouting the names of places the train passed through. Dennis and I had no bed on which to rest our weary bodies and not enough food in our stomachs. Hunger gnawed at me.

Late one night we climbed the steps of a large cathedral. After persistent knocking, a church worker peeked out the door. He told me we might find inexpensive accommodations at the YMCA in Charlestown, but no matter how cheap it was, we had no money. Mom and Dale came to mind. I pictured them staying at my apartment in California next to the alley at the bad part of town and hoped they were safe. I knew Mom couldn't help me financially; she barely had enough for herself.

I thought of the people at Della's church. I hated the idea of asking them for more financial help, but memories of the great love they showed me and the ways they had so gracefully helped me filled my mind. I did not want to place more demands on my friends, fearing they might think of me as a pest, but I saw no other way out of my dilemma.

The next day I called Della's church and my friends in California. They came through for me again, collecting money and depositing it into my account. I spent that money very carefully—only on the things we needed to survive.

I first purchased a month's supply of eye medication. Then I went to a public phone and called the YMCA in Charlestown. I had just enough money for a room with two single beds for a few nights.

Dennis and I took a bus from Boston to Charlestown. Once we got settled, I contacted local foundations, asking if they could help me find a less expensive place to stay. I had no luck until I

called the Rose Fund. The president came to the rescue, offering us a two-bedroom luxury apartment at Northeastern University for five days. Markets and pharmacies were in short walking distance. I fell to my knees and gave tearful thanks to God. My brother and I rested well at Northeastern. At the end of our time there, my friend Marie invited us to stay with her, now that her houseguests had gone home. More and more, I thought about Mom and Dale staying at the apartment in the bad side of town. With telephone privileges extended to me at Marie's, I called to thank her and update her on my surgery. She said I was a woman of attitude.

My brother's eye healed fully after three weeks. His rapid recovery amazed the doctors. After they discharged Dennis from their care, before he returned home to Jamaica, he spent time with our relatives in Florida—the ones who had been too fearful to take me in.

I lived with Marie for five weeks after my brother's departure. She generously provided me with food and necessities.

Because the hospital was seventy miles away, Marie could not take me to my doctor's visits. I took two trips by taxi, but due to the high cost of this form of transportation, I missed a few appointments.

I called the Jamaican Embassy in Washington DC for help. A staffer connected me with a woman named Pam, who came from Jamaica and lived in Boston. We met for coffee and hit it off immediately, two kindred souls away from home. Pam took me to and from the hospital for the next five weeks.

The obscurity clouding my eye gradually became less dense. I still couldn't see very distinctly, but I *could* see. I could read extra-large letters, and I wrote down phone messages for Marie using thick markers. I could finally find my way around Marie's house without bumping into things.

Dr. Foster told me, "It's hard work to control the inclination toward blindness, but it can be done. Once your eye has healed completely, our next step is the cornea transplant."

Marie and her boyfriend, Larry, took me to Boston one weekend to see the parade of ships in the harbor. The three of us strolled along the water's edge, browsing through vendors' displays. I saw vague outlines of the boats, people, and uniformed sailors. My vision was somewhat cloudy, but I felt enthusiastic that my sight would eventually return completely.

FREAK ACCIDENT

At the end of my five-week stay in Boston, I returned home to California. Being back in my own apartment made me feel refreshed. Everything felt right.

Most nights I enjoyed pleasant, sighted dreams. In them, I viewed everything with intricate detail. I dreamt of my village on a sunshiny day. I strolled through fields, gathering wild Spanish needles and dandelions. I wandered through gardens, touching the plants and flowers, smelling the heady fragrances. In one dream, I walking along the riverbank under a brightly shining moon surrounded by millions of stars.

Upon waking from those dreams, I vowed I would do whatever it took to raise enough money for the balance I owed the hospital and for the next surgery.

During my recuperation, I went back to writing. I listened to books on tape and believed I had a good story that could become a powerful book. I noted that the very act of my writing brought peace to my soul; the reoccurring dreams in which I was failing in school had stopped. Once I started receiving royalties, I figured, I would never again live a life of poverty.

I also reasoned, *If God has allowed me to go through all these things and live, He must be keeping me on the earth for a purpose. So I'm going to follow as He leads.*

I made sporadic visits to Della Reese's church. On occasion, Mom accompanied me. She adored Della's television series,

Touched by an Angel, and she enjoyed seeing celebrities among the congregation.

I also decided to reconnect with old friends. When I called Mim, she told me, "I'm no longer teaching the writing class. We haven't met for the past couple of weeks."

My heart sank. The class had been a creative joy and a staunch support for me, emotionally and financially.

I called Jarvis, the taxi driver, to arrange for a ride to Della's church. In a grim voice, he said, "I stopped going to church, and I don't have time for you anymore."

My heart grieved. I felt like I was losing all of my special relationships. The remaining time allotted on Mom's visa would run out soon, and I would no longer have her companionship. I would be utterly alone.

I refused to allow myself to stress over my struggles and disappointments. I needed to find fellowship with a Christian group. I wanted to belong to a church where people knew my name.

The next day, I received a call from Dianna, the teacher who worked at the school for the blind. "What's going on in your life these days?" she asked.

I briefly filled her in and then asked about her life.

"I'm working at a hardware store close to where you live. I'm an active member of the singles' Bible study group at Grace Church of Cypress. We have about sixty members, and we meet on Wednesday evenings. Would you like to join us?"

I told her I was definitely interested, but I needed a ride. She promised to contact a member of the group who worked in the city where I lived.

The following Wednesday evening, two men from the church, Gregg and Thomas, came to take me to the adult singles' fellowship. As I got into Gregg's car, he told me Thomas was also blind. I felt an immediate connection with him due to the disability we had in common.

"I haven't always been blind," Thomas told me. "A pituitary tumor took away my sight in the right eye. Then I developed retinitis in my left eye. As the disease progressed, my eyesight became more and more blurry. Now all I can see are shadows."

"How does someone get retinitis?" I asked.

"It's hereditary. I have eight siblings, and four of us are blind. The other four have perfect sight."

My heart went out to him, but I thanked God for connecting our paths.

At church, Gregg and Dianna introduced me to the class as a new member. I stood hesitantly, pasted a smile on my face, and briefly told them about myself. I received a standing ovation, and everyone welcomed me.

Though I hated to think like a leech, fundraising ideas dominated my thoughts as the president made announcements for the evening. I figured attending this class was not only an opportunity for me to get out of the house and interact with other Christians my own age, but also to discover financial, social, and emotional support. If I found the perfect time and the right way to tell these people I needed assistance, I felt sure they would help.

I attended faithfully, every Wednesday night.

After class one week, Dianna and Gregg discussed my financial situation with the group leaders. They collected more than $650 in donations.

Though I greatly appreciated their generosity, the amount was not near enough to pay for my third surgery and the cornea transplant. So I decided to host a raffle.

I designed a sample ticket on my computer. Dale and I took the bus to a print shop and had tickets printed in denominations of $5, $10, and $20. I chose to raffle off the big-screen TV Gwenna had given me, which was still in its box.

The following Wednesday I went to church with a large box of raffle tickets. The guest speaker, a college professor, spoke of the adversity she had experienced at an early age and how, by

hard work, she had overcome life's harsh realities and earned her degree. She had also formed a ministry to help kids in Mexico.

At the end of her presentation, a discussion followed. We shared the adversities in our own lives and talked about how God had changed us for the better. The presentation and the discussions deepened my faith.

With Dianna's help, I sold several raffle tickets.

Back home, as I was preparing for bed, I walked to the chest of drawers to retrieve my night clothing. When I bent down to open one of the lower drawers, my right eye jammed into the sharp, pointed edge of the cabinet door I'd inadvertently left open.

My spine tingled at the impact. Terror rushed through me. My head seemed to expand. I couldn't speak or move. I just stood there in shock, fear, and burning agony. My heart sank. I knew my eye was in trouble.

Another pain shot through me. I stamped my feet in anguish. *God, please help me. With Your power that can raise the dead, I pray You will have mercy on me and make my eye whole again.*

I put a hand over the eye. I felt no thick liquid, only tears. I breathed a sigh of relief. *If it isn't bleeding, there's hope. Maybe it isn't too badly damaged.*

A strange sort of darkness loomed before my eyes. Not even a single streak of light pierced the black. All the improvement I'd had since the transplant surgery had disappeared. Confusion filled my soul.

My mom sat at my desk with her back to me, reading the Bible as she did before retiring every night. I opened my mouth to tell her what happened, but reconsidered. Would saying the words out loud make my fear a living reality?

Terrified of jinxing myself, I squeezed my lips tightly together, but the hammering pain increased. When it lessened a little, I stumbled to bed and dropped onto the comforter. Cold sweat made me tremble with fear. I remained still until the pain broke. Then I gathered my strength and reached for my nightgown.

Agony struck again, worse than before. It seemed to come from behind my eye.

With no health insurance, and no money to pay a large hospital bill, I could not go to an emergency room.

I had to tell Mom. As my lips struggled to utter the words, she turned and looked at me. "What's the matter?"

I told her what had happened. Mom tried to speak, but her throat must have closed on her.

She walked to the bed. We sat side by side in silence for a few moments. Then Mom broke into violent, hysterical weeping.

When she had spent herself, Mom gathered me into her arms. Her tears fell on my shoulder and down onto the pillows.

All night I lay in ghastly wakefulness, listening to the hours ticking off in painful suspense. *What if I am blind forever?*

I rose as soon as day dawned, hearing Dale move about downstairs, getting ready for school. He left early every morning, so he would not know anything had happened to me until evening when he came home from the Boys and Girls Club.

The walk to the bathroom was pure agony. Standing and moving made my eye and head throb severely. The pain barely allowed me to breathe. I stumbled back to bed, feeling weak and broken until sleep mercifully overtook me.

I awoke with a feeling of terror, still surrounded by blackness. I called Dr. Assile. When he answered the phone, I told him what had happened. He asked me to come to the office immediately.

I called David Crawford and asked for a ride.

"Do you want me to come with you?" Mom asked.

"No, thanks," I said. I knew my eye was badly damaged. But if my mother didn't hear what the doctor said directly, I could share the news with her in a milder way, thus lessening her pain. "David and I always go to the doctor together," I told her. "I'll be fine."

About twenty minutes later, when David called to let me know he'd arrived, I shuffled to the gate. Mom clutched my hand and helped me into the waiting car and then returned to the apartment.

BOWED IN WONDER

In the car, I bit my tongue against the urge to speak of the destruction, fear, and chaos that had replaced my happiness. When we reached the doctor's office, I walked through the door in gloomy grief. Standing at the reception desk, I listened to David explain my emergency.

"Dr. Assile is seeing a patient right now. As soon as he's finished, he'll see you." The receptionist showed us into an empty examination room. With David's guidance, I sat in a chair. Cold sweat covered my body.

When Dr. Assile walked in, I recounted what had happened during the night. Heavy frustration laced my voice.

After careful examination under the powerful microscope, Dr. Assile said, "The eye is punctured and badly damaged. You'll need immediate surgery to repair the hole and save the eye from further deterioration. But that will be a temporary fix. You'll require more advanced surgery later."

Horror shook my limbs. I sat in miserable silence, quivering and powerless. I could not even cry.

Dr. Assile went into his private office. I heard him on the phone, first with the organ bank to get a cornea to repair the punctured eye, then with Dr. Foster in Boston. He described what had happened and the procedure he planned to do.

When he returned to the exam room, he told me Dr. Foster wanted me in Boston as soon as possible.

With David's help, I walked out to the waiting area. Mournful and anxious, I did not hear the conversations of other patients around me.

David drove me home. We didn't speak. During the drive, I progressed through the stages of disbelief, anger, denial, more anger, and finally acceptance.

Once inside my apartment, Mom embraced me. Then I immediately retired to my bedroom.

I heard Dale rush into the house with his usual vitality. "I'm home!" The front door slammed. A moment later music boomed from his favorite video game—normal fifteen-year-old.

When I heard the music shut off, I guessed Mom had told him she wanted to speak to him. I pictured her telling my son what had happened to me. My chin quivered with the threat of tears, but I fought crying, afraid of doing more damage to my eye.

Quick steps came up the stairs and into the bedroom. I sensed Dale standing at the side of the bed, searching for something to say.

Carefully, Dale crawled into bed and curled up beside me—all six feet of him. He reached an arm around me and hugged me tight.

After about an hour, Dale relaxed against me, and I realized he'd fallen asleep. I touched his face—it was wet with tears.

Mom came in and woke him, whispering that it was dinnertime. Though they spoke in low voices, a few snippets drifted to my ears. Dale's apprehension over this newest setback made him sound weary.

Before turning in for the night, Dale came up and sat next to me on the bed. "I'm so sorry, Mom." He paused. "Do you need anything?"

My throat closed up, but I managed to choke out, "Just your love and your prayers, dear."

With extreme gentleness, he gave me a hug and kissed my cheek. "I love you, Mom. Good night."

The next morning, I got up and made him breakfast, determined that he not worry about me during the day. I put on

a big smile and waved him off as he jogged down the path to the front gate. I maintained my happy façade until I heard the bus go down the street. Then my body slumped, and I staggered back into the apartment.

In my bedroom, furious anger took possession of me...all focused on that chest of drawers. I resented its presence. I could not live with it a second longer. With Mom's help, I emptied the drawers, and together we dragged it down the stairs and out to the alley.

Day after day of agony followed. At night in sleep, I cried out in pain. My eye throbbed mercilessly. Painkillers were of little use.

Mom's one-month stay in California was almost up. Her visa allowed her a six-month visit in the United States, but it was time for her to go to our cousins' house in New York to find a job. She would work there for five months, then return to Jamaica.

As she waited for the airport shuttle to pick her up outside my apartment, sadness overcame us. "I wish I could make everything you've been through go away. I wish I could go through the agony for you. I would trade my life for yours if it was possible."

When the shuttle arrived, Mom kissed my cheek and then climbed onboard. As it drove away, she leaned out the window and shouted, "I love you, my darling. I always will."

Sadness filled my heart, causing tears to flood my eyes. "I will always love you too, Mom."

• • •

One morning shortly after Mom's departure, I awoke to acute pain shooting into my right eye. Medicine didn't help.

I turned to God. "Father, have mercy on me—help me."

An overwhelming sense of determination and strength absorbed the despair.

I needed to get back to the Ear and Eye Infirmary in Boston, but the drawing for the raffle was still months away.

I went to two neighborhood churches and asked the pastors if I could make an appeal for help to their congregations. I assured them my presentation would be inspiring. Both pastors sent me away.

At first I deeply resented their lack of mercy and compassion. Then I thought of Jesus hanging on the cross between two thieves. He too was rejected by men. The reminder calmed my bitter spirit.

Many of the people who'd sold raffle tickets told me they were selling well, but when I asked people to give me the money and any remaining unsold tickets, I received neither.

Still believing that Jesus had a purpose for me, I decided to do whatever I could for myself. In the past, cleansing my body of impurities had opened my mind to wisdom from heaven, so I decided to fast for twenty-four hours. I would partake of no food and drink only water.

All day, I humbled myself on my knees. I prayed for His will to be done in my life, hoping His will would align with my needs. Hunger pangs kept me in tune with my immediate need for money. In denying myself, I focused on the Lord, becoming more sensitive to the Holy Spirit.

The next day, I squared my shoulders and went to other local pastors. They listened to my plight and allowed me to present my needs to their congregations. Though many people expressed sympathy for my situation, no one truly understood the horror of seeing only darkness, with little hope of overcoming total blindness. The meager donations from those churches did not even cover the cost of my airfare to Boston.

I called everyone I knew, asking if they would be willing to help sell raffle tickets. Some said yes; others laughed at me. The negative reactions did not deter me. I believed that if people saw me trying to help myself, they would want to join in.

I went through my mailing list and sent two raffle tickets to each of my supporters—250 people who had previously given to my cause. The response was lukewarm. While some generous

souls sent money—many far more than the value of the tickets—others sent barely enough to cover the tickets. Most didn't reply at all. The raffle failed.

I could not think of anything else to do. I was at the end of my rope.

SIT AMAZED

I discussed my need to return to Boston with my son. Dale surprised me by expressing a desire to live with his dad in New York and attend school there. Apparently he'd had a few run-ins with some gang members at the Boys and Girls Club, and they'd threatened to beat him up on several occasions.

As we spoke, I realized how fearful he had become. He hadn't wanted to burden me with his troubles, so he'd kept the severity of the problem a secret. But now, faced with my long recovery period away from home, he thought he would give his father another chance. Besides, he missed his half-brothers, who lived with Donald and his wife, Jennifer.

With as much cool self-confidence as I could muster, I told Dale to call his father. After a long, pleasant-sounding phone conversation, he told me to make the arrangements. Since Donald would not help with the travel expenses, my meager funds would be stretched even further. I called a friend and asked if she could try to find a cheap one-way fare for Dale.

By the next day, everything was arranged. A church member agreed to drive Dale to the airport for me.

The moment he walked out the door, I missed my son terribly, but I knew his moving to New York would be best for both of us, at least until I could pick up the pieces of my life and support us again.

Destitute and desperate to get to Boston, I remembered Angela Seymour from Della Reese's church. Angela worked as a flight

attendant for Delta Airlines, her regular route being California to Florida. Between flights, during layovers, she worked as a travel consultant.

When she'd put her business card into my hand, she had said, "Call me anytime if there's anything I can do for you."

I waited until ten that night before calling, hoping she would be off duty by then.

She remembered me immediately. We spoke of activities at the church; then I told her about my urgent need to get to Boston. "But I don't have a plane ticket, and I can't afford to buy one."

"Oh, Carol," she said, "I have been wanting to do something special for you. I can get you a round trip to Boston with my frequent-flyer miles. What day would you like to travel?"

I eagerly accepted her generosity and gave her the information. Then I phoned Dr. Foster's office and told them when I would be arriving. I did not mention that I had no money to pay for a consultation, let alone another surgery. I prayed for forgiveness and hoped the Lord would step in at the opportune moment.

Dr. Foster's assistant assured me that he would keep some appointments open for me. All I had to do was call once I settled in.

Next I had to figure out where I'd stay.

At the Charlestown YMCA, where I'd stayed during my second surgery, I had learned of a YWCA in Boston that provided lodging at reasonable rates. Tamela Johnson's mother, Dalena, president of Tamela's foundation, offered to pay my accommodation expenses at the YWCA for two months out of the foundation's funds.

God had once again blessed me with a miracle. I confidently placed my trust in Him to meet the rest of my needs.

As if guided by a divine hand, a representative from CBS television contacted me. They had broadcasted updates on my condition over the years for their human-interest segments. When the station manager heard my latest news, he sent a remote team to my apartment to interview me. They asked my permission to have their affiliate station in Boston interview my doctors and me at the hospital for a later broadcast in Los Angeles. I gladly agreed.

About the same time, Pauline, a TV reporter for Fox Family Channel, called me. She explained that Erica Hanson had told her about my upcoming surgery. Pauline asked if she could interview me upon my return to California. She seemed completely confident that I would have my sight back by then. I hoped she was right.

• • •

After a good night's rest at the YWCA in Boston, I called the doctor's office. He said, "Come in as soon as you can get here."

At the hospital, Dr. Foster examined my eyes. He suggested immediate cornea transplant surgery and said, "There is still hope."

I trembled with joy and fear. "I'm ready."

I was prepared emotionally, physically, and spiritually, but not financially. I completed my pre-surgery examinations, but avoided the accounts department. Fortunately, my surgery took place in the early morning, before the accounting staff came on duty.

When I awoke from the surgery, I was shivering with cold, as if bathed in ice water, and in excruciating pain. The nurse wrapped warm blankets tightly around me, but it didn't help. I still shuddered uncontrollably, and the intravenous pain medication didn't fully take away the discomfort.

I reminded myself that recovering my sight was the most important thing in the world. So I endured the agony.

The bedside phone rang, and I jumped. Who could be calling? I hadn't shared my schedule with anyone outside the hospital staff.

I answered the telephone.

The caller identified herself as the hospital accountant. My heart skipped a beat.

"I just learned you had surgery this morning," she said in a shrill voice, "even though you haven't paid yet."

My heart thumped. In a voice still thick from the drugs, I whispered, "I'm going to call my friends and see if they can help me with the bills."

The woman's voice did not soften. "Fine. I'll call you tomorrow."

I phoned Dalena to see if Tamela's foundation could help me. Unfortunately, she said no.

I couldn't think of anyone else to try.

Throughout the duration of my hospital stay, the financial officer kept calling and pressuring me. "How do you intend to pay for the surgery?"

A couple of times she came to see me in person, sounding as if she'd like to shake the money out of me.

If I had my sight, I could get a job. I wanted nothing more than a chance to work, to earn enough money to pay my bills.

After five days in the hospital, I returned to my room at the YWCA to wait for the healing to reveal itself. Every day for a week, I carefully removed the bandage from my eye and blindly applied the eye drops.

Midway into the second week, sitting at the edge of the little bed, when I removed the dressings from my eye, light broke through. I blinked a few times, then concentrated on the light shining around me.

I viewed my room in detail. Everything looked strange. I felt as if I had never seen color before. But I had my sight back!

I shouted an incoherent cry of joy and triumph, loud enough for everyone at the YWCA to hear, probably loud enough for all of Boston to hear.

Filled with excitement, I went to the call box and made a phone call to Mom in New York. "Mama," I shouted, "guess what? I can see!"

After a long pause for the news to sink in, she said, "Oh, Carol, I'm so thankful."

She shared my good news with the cousins she was staying with. One by one, they came on the phone and said, "Praise God. I'm so happy for you!"

I couldn't wait to actually *see* my friends back home in California. I thought of Dalena and Tamela and David Crawford from the Lions Club. I practically burst with impatience to visit

them, to see their wide smiles of joy. So many people came to mind that my brain went on overload. I had to see them all!

I called David first. I breathlessly told him the good news. He expressed his overwhelming joy for me and then promised to spread the word of my sight.

My next call went to Dalena. She clapped and screamed at my news. She was so excited that she told me she had to call Tamela that very moment and hung up abruptly. I chuckled, thrilled to be the bearer of good news for once.

The idea of seeing all the stores I'd blindly passed on the sidewalks sparked my fancy. I rushed outside to take in the sights. I went to the little fast-food joint next to the YWCA I had frequented, using my walking stick, for their delicious chicken wings.

Color and movement assailed me, and I gloried in the full spectrum of my senses. When I began to tire, I headed back to the YWCA. On my way I decided to visit a grocery store. Another thrill of victory shivered through me. I could finally buy my own food, unassisted.

I entered the supermarket and stopped and stared. Like the first time I ventured into a market in Florida with Jasmine, I marveled at the richness of this land. Seeing everything that an American grocery store held overwhelmed me. Compared to the little produce stands and neighborhood markets in Jamaica, the countless overstocked shelves, the display of produce, the fresh deli, the bakery, and everything else took my breath away. I thought, *So much wealth!* I walked up and down the aisles, my head spinning with the multitude of choices and the stunning abundance.

How could people not believe there is a God from Whose hands came all this colorful and luscious food to nourish His children?

At the checkout register, a magazine cover with Tamela Johnson's name on it caught my eye. I picked it up and found a photo of her inside. Her beauty struck me with awe. I added the magazine to my purchases.

Back in my room, when I knew Dale would be home from school, I called him. "Honey, I can see! I'm walking around by myself. I can see people...their faces, the color of their eyes, their eyelids moving up and down, even wrinkles. I see bright colors. Everything is more beautiful than I remembered."

"That's great, Mom. Success at last!"

The following day I called my brother in Jamaica. "Dennis, it worked. I can see again. I can't thank you enough for how good you've been to me."

"I'm so glad for you. And I'm thrilled to be a part of what made it all possible."

I awoke early every morning, filled with thanks to God, who gave me the victory over blindness.

With joy in my heart, I tenderly cared for my eye, applying drops and taking the anti-rejection drugs. My sight became brighter with each passing hour. Waves of vigor flowed through my body.

I determined to live fully now to make up for the wasted years in blindness.

KILLED CLOCK

As I sat in a cab on my way to the doctor's office, I looked from one side of the street to the other with the gaze of a wondering child. I alighted from the taxi without having to ask for help and found my way into the hospital, to the elevators, and then to the clinic.

Dr. Foster asked me to describe his tie. With delight, I said, "It's blue, yellow, and white."

He grinned and asked me to read the eye chart.

I read the larger letters, my heart swelling with pride.

Dr. Foster and his assistants congratulated one another and me on the success of the surgery. He prescribed glasses with powerful lenses to further improve my vision.

It took a while for me to grow accustomed to those glasses. Images were enlarged so much, they seemed to rise up out of pages and walls and almost hit me. The distortion became worse when I walked. The floor appeared to move, and steps disappeared beneath my feet. I had to blink often to regain my focus and keep from falling. When I finally adjusted to the change, the glasses helped me to see more of the things I'd missed.

From my experiences with the other cornea transplants, I knew I would need follow-up care for many months. I had no idea how I would get the money to pay for extended lodging, medical bills, and transportation. If I could find a church to attend in Boston, I could share my needs with the pastor and ask the congregation

for their financial support. After searching through the telephone directory, I obtained the numbers of three churches and called the pastors for appointments. At each interview, I told my story and asked for the opportunity to present my plight to their congregations. Two of the churches welcomed me on different weekends.

At the end of my presentations, I stood beside the pastors as they appealed in powerful voices to those in attendance to help me financially and prayerfully. Their special collections helped me purchase medication and pay for a few weeks' living expenses.

One of the congregations had several people from my homeland, so I enjoyed a fellowship with them that made me feel connected. I even discovered a cousin with whom I'd attended school, who presently owned two restaurants in Boston. She and I warmly embraced and chatted about our days back in Jamaica, remembering old friends. She agreed to bring me meals.

Other members of the congregation offered help with transportation to the church and lunch after services. Some visited, bringing gifts of soaps, toothpaste, and snacks. All prayed with me before they left.

I attended different churches four to five times a week, seeking assistance. As I traveled to and from the hospital and churches, I seemed to move among rivers of headlights. I thrilled to see the different kinds and styles of cars, people dressed in colorful clothing, the choir singing and swaying to the music—all marvelous to my eyes.

Walking the red brick pavements of Boston on my way to fast-food restaurants and pharmacies, I paid special attention to the architectural designs of buildings, both commercial and residential.

It felt good to go to the market and buy fresh produce and personal items without having to ask cashiers how much money I held in my hand. Most people take this little act for granted, but it brought joy to my heart.

Marie visited me. Seeing her in the flesh for the first time, I looked her over carefully, from her shiny light brown hair to her fashionable shoes. Her face glowed with freshness and vigor. She had soft, beautiful eyes and stood tall and slim.

Marie and her boyfriend, Larry, took me to dinner at an Indian restaurant, and after dinner, we went clothes shopping.

What a glorious day, I thought as I prepared for bed that night.

In the daytime, driven by the desire to make up for lost time, I strolled around the neighborhood with my head held high and a spring of confidence in each step. I even went for a short run in the park.

On my many follow-up visits, the doctors explained the importance of keeping my eye moist. My eyelids were not perfect. I had to be very careful.

I needed medication constantly, and no one person or church could provide enough financial support. I searched for more churches nearby and learned of a Baptist church about four blocks away.

I walked to the church and introduced myself to the office manager, asking her to put my letter of appeal on the bulletin board. She invited me to come back.

On my next visit I met the head pastor and told him my story.

The following weekend I attended services. The music wasn't as exciting as the music at Della's church, but it captured my attention. Nothing raises the spirit more than big drums and brass, playing behind a choir belting out black gospel. I stood along with the others in the church, swaying, clapping, and waving my hands to the rhythm of the band and choir. I felt connected.

At the end of the service they hosted an altar call. I felt a stirring in my soul to get out of my seat. I walked up to the altar to be prayed for and to give thanks to God for His grace and mercy in my life. The pastor took my hand and introduced me to the congregation, then asked for a special collection. They gathered more than two thousand dollars for me that morning, which enabled me to pay my rent and buy medicine.

• • •

With Christmas only a couple of weeks away, a woman resident, also named Carol, told me one night at dinner in the YWCA's dining room that she rang the bell for the Salvation Army red kettle and that they generously provided for the needy people of the community. I asked her if she would take me to their headquarters.

The following morning, Carol and I walked to the Salvation Army office, where they gave away clothing, food, and toys. I did not want those things; I needed medication.

A social worker listened attentively to my plight and offered to help. We took my prescriptions to a few pharmacies in the area. They seemed cooperative, but when he asked if they would accept a voucher from the Salvation Army for payment, they refused.

Back in his office, he told me to wait in the lobby and then left. Three hours later, he returned with my medicine. He'd paid for it from his own pocket.

I wept with gratitude. The loving-kindness I received motivated and inspired me to keep forging ahead.

For the next twelve weeks, my sight increased steadily. The sky sparkled; the earth blossomed. Color surrounded me. I felt happy, yet I yearned for a more active life—and to no longer be a beggar.

Though I enjoyed my sight, a financial rain cloud always followed me. The thought of my overdue hospital bills loomed large in my mind each morning when I woke and shadowed my steps throughout the day. Just before I went to sleep at night, I prayed an answer would reveal itself the next day.

I progressed so well in my healing, the doctor released me to return home for two months. With my luggage packed, I called a cab to take me to the hospital for a final visit before leaving for California.

Seated in the lobby of the YWCA, waiting for the taxi, I suddenly felt sick. Two sharp pains exploded in my right eye. I

immediately closed my eyes and prayed that God would make everything all right.

I heard the cab driver call my name. I rose slowly and walked toward his voice. Through the pain, I apprehensively opened my eyes to see my path. Everything around me had turned to darkness, just like when I'd punctured my eye on the chest of drawers. A pang of terror passed throughSevere pain hit me like metal rods poking through my eye. I screamed, yanked in a breath, and cried out again.

Someone eased me down into a chair.

I held my head down, hoping that might ease the pain somewhat. But instead it worsened. I fell to the floor and writhed on the carpet.

Hot tears mixed with the cold sweat and trickled down my neck. I lay on the floor, hearing people around me. Millie, the manager of the YWCA, asked me if she should call an ambulance.

"No! I can't afford it."

When the pain decreased a little, I asked the cabby to take my hand and lead me to his car. "Please drive me to the hospital. Fast!"

He rushed me to the doctor's office.

I told some of the doctors in training what had happened. One of the residents told me that the pressure in my eye had elevated enormously, and the embryonic membrane covering my eyeball had burst due to severe dryness.

They applied medicine at regular intervals, trying to decrease the pain and reduce the pressure.

Someone tracked down Dr. Foster, and he came to see me. "Due to the extensiveness of your injuries, the eyelid simply will not close adequately to give the desired protection to the eyeball. Because of this exposure, the eye is not retaining moisture, but drying out."

Floods of denial sieved through my mind. I had expected everything to go right. I had believed that after this surgery I could start re-weaving the fabric of my life.

"But doctor," I wailed, "I kept my eyes closed as much as I could. I squeezed them together most of my waking hours. And I wore eye patches over my eyes at night."

The examination room went silent. I could feel the doctors looking at me.

People moved about me, making telephone calls to the operating theater. They scheduled me for immediate surgery.

As I waited, I thought, *How can I go back to California and face all the people who have supported me?* The media—and my family and friends—all expected to hear about the success of my surgery.

I had spent every penny people had given me, and for what? More pain? A return to blindness?

A nurse guided me to the operating center, where I underwent corrective surgery. The doctor put a special medical bandage over my eye to protect it and reduce dryness. He then stitched my lids together to further protect the eye so it could heal.

Afterward, he instructed me to come in every weekday the clinic was open so he could make sure everything was okay with my eyes.

Two weeks after the surgery, after I was examined, a staff doctor told me the pressure in the eyes had gone back to normal, and everything looked good under the microscope. He assured me that my sight would come back in due time. But for now, I had to practice extreme caution not to hurt myself again. I needed to continue using the medication and had to wear a protective pair of sunglasses Dr. Foster had prescribed.

MIGHTY IN STRENGTH

I spent two more weeks in Boston and then left for California. At home, I made no contact with the people in my circle, too ashamed of my failure.

I spent my days resting, lying in bed for long periods, praying for God's mercy and for my restored sight. People called, having heard that I'd returned, but I dodged my well-meaning friends and wallowed in self-pity. I just wanted to be left alone.

I applied the eye medicine through a slit between the lids where the thread that stitched the lids closed had loosened a little. I should have been able to see something through that slit. But I hadn't seen anything, not even a thin streak of light, for nearly two months.

I thought that if I went outside in the bright sunlight, I might catch a glimpse of my returning sight. So I walked out onto the porch and felt the warm sun on my body. I forced my eyelid open as far as the stitches would allow and put up my hand before my face. I saw nothing. The world remained in black darkness. With a deep sigh, I felt my way back into the apartment.

I spent four agonizing months sequestered in my home. Every evening, just before sunset, I stood on the porch and held my hands in front of my eyes. The eyelids were sewn shut, but between the small spaces of the stitch, if the sight had returned, I should have been able to see light. It was all darkness.

I lapsed into doubt. In the dead of night, I cried out, "Jesus, this is the worst thing that could ever happen." I had so much I wanted to get out of life. If only I could find a way to sustain my sight.

The urge to return to Boston and learn the status of my healing became overwhelming.

I turned once again to Angela Seymour, the woman who'd given me her frequent-flyer miles. She said she didn't have enough miles at the moment to give me, but she'd ask a family member to donate hers.

Without a penny to my name, but putting my trust in God, I made an appointment to see Dr. Foster. I also made lodging reservations at the YWCA.

I went through my address books many times, but my conscience would not let me dial a single number. I couldn't pressure my supporters more than I already had. *These people are surely tired of me,* I thought. *Even with their generosity, I am much too needy.*

I went down on my knees. "Oh, God, please lead me to the path of financial aid."

My landlord informed me that he'd found a young man to be my new roommate. This meant someone would be in the apartment, and my belongings would be safe during my stay in Boston. I considered this to be a sign that I should keep moving forward.

Two days later a Jamaican woman named Elena called me. I had met her at one of the churches in Boston. She said, "You touched our lives so much with your strength and courage while you were here. My family wanted to give you a gift of two hundred dollars."

Gratefully, I asked her to deposit the money into my lodging account at the YWCA.

With only four days left before my flight, I still did not have enough money for basic expenses. Throughout my daily chores, I prayed for God's guidance and blessings.

Two days prior to my planned trip, I attended church with my blind friend, Thomas, who had gone with Gregg and me to

the adult singles' fellowship at Grace Church of Cypress. After the service, while Thomas and his girlfriend, Gayle, greeted old friends, I sat alone.

A man joined me. "I was sitting in the back row and could not take my eyes off you. My name is Michael, and I'd like to be of help. Would you mind telling me a little about yourself?"

His frank and friendly way of speaking struck delight in me. I summarized my story for him.

"Would you accept money from me?" he asked.

My heart leapt with joy. "Yes."

"I need to get my checkbook from the car."

He came back and handed me a check for two hundred dollars. We exchanged telephone numbers and then parted.

I asked Gayle to take me to the bank. Along the way I told her and Thomas about my new benefactor. Apparently inspired, Gayle wrote me a check for a hundred dollars.

On Monday a few $50 checks came in the mail from people who had donated to me in the past. This surprised me, because I had not sent out letters asking for financial aid for quite a while. I looked up to heaven and thanked God for His provision in times of need.

With a grateful heart, I deposited the checks on my way to the airport.

The ticket lady behind the counter greeted me warmly and offered to upgrade my seat to first class.

During the flight, I eagerly strained my eyes through the darkness, longing to catch a glimpse of the new life I'd live once my sight was restored. The attendants stopped by often, asking about my surgery and my hopes.

A man across the aisle must have overheard, for he came over and sat in the empty seat next to me. He touched my shoulder, took my hand, and put $500 in my palm.

I accepted his generosity with joy.

When the plane landed in Boston, I stayed seated, waiting for a wheelchair. The flight attendants and captain stood at the door, thanking passengers for flying with them. When the crew was ready to leave, one of the stewardesses told the captain she would have to wait with me since a wheelchair could not be readily located. Instead he offered to escort me. He took my arm and my carry-on luggage. Side by side we walked out of the plane, to the escalator, and on to baggage claim. He helped me locate my luggage and placed it on a cart. Then he asked an associate to secure his belongings while he escorted me to a cab.

The captain held open the passenger door, waited till I was safely inside, wished me good luck with the doctor's visit, and said good-bye. I thanked him for his gallant assistance and settled back while the cab driver placed my luggage in the trunk.

• • •

When I entered the examination room, Dr. Foster introduced me to some colleagues he'd called in to consult with on my case. He cleansed my eye and removed the bandages and surgical threads. I blinked, then opened my eyes wide, but saw nothing.

I held my head steady in the slot of the microscope as several doctors-in-training took turns looking at my eyeball, scanning it from different angles.

Dr. Foster ordered a series of tests. Technicians checked the retina and optic nerve, and measured eye pressure in an attempt to find out why I still could not see. All the while I imagined my medical bill steadily increasing, along with the pending hospital expenditures.

Back in the examination room, Dr. Foster flipped through my thick file. He shut the door softly. I prepared myself for the news.

"Carol, the test results show that you have glaucoma, an eye disease. It's very bad. We need to perform surgery this afternoon."

Had I come so close and then lost all? I had prayed earnestly and repeatedly, but my prayers seemed to have fallen on deaf ears.

Why is God doing this to me? I had put all my trust in Him, thinking He would divinely heal me. I knew He loved me. Apparently that wasn't enough. God's love did not heal my sickened eyes from disease or set my fractured and twisted face straight. My confidence in the Lord began to fade.

That afternoon, I underwent glaucoma surgery. Dr. Foster inserted a medical apparatus into the eye to drain built-up fluid.

Upon waking from the procedure in my hospital bed, pain showered me. The nurses anointed my eyes with medicine to control the discomfort.

I wanted to pray. But what good had my prayers done so far? Apparently God didn't want to heal me, so what was the point?

I left the hospital grieving. The forty-five-minute ride to the YWCA left me feeling cold and restless.

The cabby took my arm and led me to the entrance. I found my way to the elevators and went up to my quarters, shut the door, and flung myself across the bed. After a while, I walked to the only window in the small, stuffy room and opened it to let in a fresh breeze. With a bitter heart, I thought of all I'd lost.

I couldn't pray; I was at my lowest point. I knew my family, friends, strangers, and churches were praying for me. Perhaps God would answer *their* prayers.

Dismayed by the odds against me, I locked myself in my room for two days. I didn't sleep or eat. I lay in bed for hours, thinking of death.

On the third day, eyes heavy, I wrapped myself in the covers and finally slept.

Upon awakening, my heart beat violently, and my brain churned. I felt cramped and stifled. Craving space, I felt my way down to the lobby and sat on the sofa. Gazing blindly around me, I listened as people went about their business.

I begrudged them their good sight. They did things I could not. A fierce fire of hate beat in my heart.

My name announced over the intercom interrupted my morose ruminations.

I made my way to the receptionist.

"You have a phone call."

I shuffled to the call box.

In a rushed voice, Dale said, "Mom! Go look at a television. Somebody bombed America!"

Background voices around me sounded like a swarm of worker bees. I could not make sense of the conversations, nor could I fathom what Dale had said. I hung up, felt my way to the elevators, and returned to my room. I switched on the television and listened.

BETWEEN TWO WORLDS

News reporters described a situation of unimaginable anguish and terror. Two planes had crashed into the twin towers in New York. People were burning or jumping to their deaths. Another plane had slammed into the Pentagon.

I switched channels, but the same story played on all the stations.

I felt sick to my soul for those hurting people. *Why is life so full of pain? Why does tragedy always aim its venom at people who don't deserve it?* A flood of bitterness filled my spirit.

Those people had sight, beauty, education, and secure jobs. They were healthy and had families. They had everything going for them, and in a brief moment of time, their lives ended.

My feelings of personal failure vanished, and hope took its place. Rather than dwell on my own afflictions, I thought of those who were dying, and those who had lost loved ones, as a result of this senseless tragedy. All the despair and outrage that accompanied the pointlessness of this loss chilled me to the bone. At least I still had life in me—I hadn't died.

Unable to bear any more, I turned off the television and lay with my face in the pillows. I thought about every moment of my life. I'd brought on devastation worse than death to those I loved: the anguish of witnessing my failures while supporting my needs.

From the descriptions reported on television, I pictured the people who'd died: women with clear eyesight, husbands and

children, their extended families; people with meaningful lives, going to their jobs every day, making a difference. I compared myself to them: sightless, with no outward beauty, unable to provide for myself, trying desperately to change my circumstances but always failing.

Their souls had joined the immortals, and I had been left behind. *Why?*

A small voice deep within answered, *Even though you cannot see what's around the corner, you are here for a purpose. God will take the darkness meant for evil, turn it over, and use it for good.*

Those words gave little comfort to my aching heart. I needed to see and to pay my rent.

That night, I dreamed that I found my attackers. At first they ran from me. Then they slowly turned toward me and smiled. They held knives to my throat and my heart.

I wanted to run, but fear held me. I felt angry with myself for initiating the chase. I'd wanted to show those men that I had the power to thwart their plans and force them to treat me with respect. Instead I stared at them with dread, sensing danger.

They grinned at me without pity or compassion and performed a ritual dance around me. In that moment I stared death in the face.

Summoning enough willpower to run, I fled down an endless road. Drenched with sweat and aching with tiredness, I continued to run. I felt them behind me, gaining on me with supernatural swiftness.

I kept on until darkness fell, and I could see nothing. Loneliness and fear struck, and I felt completely lost.

They caught me, forced me to lie down, tied me up, and poured more acid into my eyes. With wide grins of pleasure, they said, "This time we'll make sure you're dead."

My head burst into my eyeballs and blinded me. My lungs ached. My skin cracked and shredded. My eyes withered away into formless knobs.

I screamed in pain and pleaded for my life. Cold sweat ran down my body.

At that point I woke up—gasping for breath, my hair and body soaked with perspiration—and lunged out of bed.

"Thank God that was only a dream."

I felt exhausted in every limb of my body.

This dream recurred over a hundred times. In each episode the terror felt as vivid as the first.

I spent many early-morning hours praying, clutching my Bible, until the streaks of dawn peeked through my bedroom window and warmed my skin. Tears flowed down my face.

Eventually, something came to me through the intelligent, reasoning portion of my brain: I had the power to choose.

I perceived that I teetered between two worlds: a world controlled by external circumstances and one of wholesomeness and boldness. I stood between the two.

I did not want to forgive my attackers, but I could not continue living in chaos, destroying myself from the inside out. The recurring dream represented my inner turmoil. The assault had pushed me down, but I wanted to rise again.

In my mind's eye, I gazed at a hill far away and saw an old rugged cross. Focusing on it, I pictured Jesus Christ nailed there, and I felt God's undying love for me.

I could choose to forgive.

I needed to go through the process of forgiving the people who had wronged me and to extend that forgiveness to others who had treated me badly, just as the Almighty had forgiven my sins.

Coldness clutched at my heart. I considered the many reasons I couldn't and shouldn't forgive my attackers, but the more I justified myself, the sicker I felt. I could no longer harbor hatred in my heart. It had taken control of my life, causing me to be angry and bitter, giving no peace or rest.

I decided to trust God, to leave the vengeance to Him. I prayed, *Jesus, give me the strength to forgive those who have hurt me.*

A tremor passed through my body. It sprang into my limbs and flooded my whole being.

At the foot of that imaginary cross, with my eyes closed and my hands grasping the Bible to my chest, I said aloud, "I forgive you, brothers." And, indeed, I did forgive them, with all my heart. I also forgave everyone who'd ever done me wrong.

I felt refreshed, as if I'd just been released from a seven-year prison term.

• • •

I attempted to make a flight reservation to return to California, but no planes were flying because of the 9/11 disaster. I was stranded in Boston with no money for food or rent.

At night when most of the tenants at the YWCA slept and the receptionist was not too busy, I asked for his help in finding the addresses and telephone numbers of local churches. The understanding clerk read the information into my cassette recorder for me.

In the morning, I phoned the churches and made several appointments.

At a United Methodist church in Watertown the female pastor listened to my story and invited me to share with her group the following Sunday.

"There is a rebellion in the congregation presently. Half of the members want a more liberal church. The other half is conservative, traditional. The liberal half is staying away in protest. Maybe your presentation will impact our members in a positive way."

The following Sunday I took a cab to the church. About twenty people attended that morning.

A couple visiting from England had arrived in town the night before the terrorist attacks and decided to attend the first church they found. The husband worked as a public health doctor with the military and had come to America to attend a conference at Harvard University. After my speech they both told me how I had touched their hearts. They wrote me a check for $500.

Other members echoed their sentiments, and their contributions totaled $289.

Two other churches in Boston invited me to share my story with their midweek Bible study groups on alternate Wednesdays. The donations I received from them took care of my immediate needs.

• • •

I was sitting on a sofa in the lobby of the YWCA one day when I got a phone call from my landlord. "Carol," Sandy said, "I had to evict your roommate. He hasn't paid his rent for months, and he ruined the apartment. I had to hire a professional to clean the sofa and the carpet. I painted the walls and cleaned the kitchen so everything will look good when you return."

I thanked him for taking care of my home in my absence and expressed my sorrow over the disappointing tenant. But in my heart I was glad to hear he was gone. I'd found him to be cold and distant. It was a little scary living with him. Most nights I half wondered if he would come through the door and try to hurt me. However, I didn't want to bother my landlord with my fears, so I did my best to get along with this roommate. Now that he was gone, I felt greatly relieved.

As soon as commercial planes began flying again, I made a reservation to return to California. I hoped that after I got back home, my life would be peaceful with no worries or sorrow. In the back of my mind, I wondered what God had in store for me next.

PITY THE POOR BEGGAR

I desperately wanted to escape a life of hardship and begging. With sight, I could do things to earn a living, but I continued in darkness. I returned to my apartment as blind as when I left—and filled with hopeless anger at my fate. Everything I'd tried had failed.

In the silence of the night, I cried. My weeping did not make me feel better, but it wore me out enough to sleep. I didn't want to go on living with blindness, yet I knew I must. My heart continued beating to the rhythms of life.

My conscience troubled me. In Boston I had doubted God. I had willfully allowed tribulation to separate me from His love. I went to my knees and repented, begging God for forgiveness.

The next morning I called the nearest Seventh-Day Adventist church. I'd attended denomination's private schools in Jamaica. And an SDA church in Connecticut had paid for my trip from Florida to California six months after my arrival in America. They'd also been very generous during the early phase of my time in California and on my third visit to Boston.

I asked the pastor of the Garden Grove SDA Church to perform my baptismal ceremony, and he invited me to come in for a meeting. I wanted water immersion, hoping it would make me feel reconnected to God.

Since I had been away so long, the limousine company account had been closed. I didn't want to call any of my wonderful friends

who had already volunteered their time to drive me around. I couldn't face anyone asking, "How'd the surgery go? How is your vision now?" So I called for a taxi. The cab to Garden Grove cost $25 each way. I spent the last $50 I had to my name.

Pastor Daley seemed to hesitate before inviting me in, but then he sat down with me and asked to hear my tale. (He later told me that my face had frightened him when he first saw it.)

I told him a little about myself. Then I asked about my renewal baptism. He agreed to give it to me. He also set me up with the church's food bank to provide for my meals. And he had the secretary call members who lived near me to find someone to drive me to church. A man named Chuck volunteered for the duty, and he took me every Sabbath from then on.

The pastor told me that whenever I needed things like household cleaners and such, I should let him know, and he would discuss it during staff meetings. If everyone agreed, the church would purchase the items for me.

The following weekend, I celebrated my public baptism in the church pool in front of the congregation. As I walked out of the baptismal water, sealed with the love of God, I felt assured that He would enable me to conquer the uncertainties of my life.

Back in my apartment, I sang and sang and sang. Mostly I repeated the chorus to the Gaither praise song, "Because He Lives." Singing it gave me confidence that with God's help, I could face every tomorrow ahead of me. I felt certain that the power of the Holy Spirit dwelled within me again, and my mind felt at rest. I trusted completely in His providence.

During the week, I submerged myself in my writing. Even though years had passed since the tragedy, everything remained clear in my mind. The words seemed to flow from my fingertips into the computer. The closer I came to the end of my story, the more excited I felt, but then dread would return to torment me. I had sustained so many crushing defeats, how could I believe that

my story would have a happy ending? I prayed for God to release me from hardship and blindness.

When the depression of reliving my life through my writing became too great, I got up from the computer and cleaned something.

On weekends, I attended church services and prayer meetings. As members of the congregation became aware of my circumstances, some came forward with small monetary donations. One man had a friend who sold produce out of a warehouse. From time to time he brought me the market's rejected oranges, apples, mangos, and tomatoes.

Figuring that the best way to get rid of sadness is to do something productive, I found strength in the solitude of manual labor. Every day, I cleaned my apartment from top to bottom. Since I had no quarters for the laundry anyway, I washed clothes by hand in the kitchen sink or bathtub. I scrubbed the kitchen and bathroom floors. I cleaned walls, polished windows, and scoured the stove. I wiped down the fridge and counters, doors and doorknobs. I even shampooed the carpet. Then I went outside and washed down the porch and cleaned the metal rails. The harder I worked, the better I felt.

Even though I could not see the results of my labors, I wanted to make my little place in the world as bright as it could be.

Friends from church gave me fragrant flowering plants for my birthday and holidays. They filled my home with a pleasant aroma.

I wanted to start a vegetable garden on my porch. Betty, who took me to church on Saturdays, drove me to the local garden center and purchased all the seeds I wanted. I grew peppers and tomatoes, peppermint for my tea, and thyme and rosemary to flavor my food.

I worked the soil with a spoon and watered it with a cup from the kitchen, touching the plants whenever I could. They developed nice fleshy leaves and carried small pods at the ends of their tiny stalks. Inside those pods, I knew, blooms waited to

burst out in nature's time. My plants may have been small in size, but their design seemed gigantic to me. I talked to them in the mornings while watering, and I pictured the garden in my mind with thanksgiving in my heart for my Creator, who'd given me the privilege to feel His creation again.

Though my garden brought me joy, my circumstances continued to cause sorrow. I fell behind in my rent. A lady at church told me about their benevolent fund for people in the congregation who had needs. I told the pastor I needed financial help. He called my landlord to confirm, then paid two months' rent and gave me a check for $300. As he put the check into my hand, he said, "This is all we will do for you, so don't come back."

I made the most of the church's support money, but wondered what I would do when it ran out.

• • •

I started feeling sick, and for weeks I experienced severe abdominal pain. I called David from the Lions Club for a ride to the community clinic. There I met a pleasant manager named Joan, who assisted me with registration and completing the medical forms.

After a preliminary examination, the on-duty physician referred me to a surgeon. I endured a lengthy and painful exam, where the surgeon discovered foreign bodies imbedded beneath my inflamed skin.

Dr. Robinson had used tissue from my lower abdomen to resurface my face. Apparently, during the procedure, he'd left gauze and threads from stitches inside me.

The surgeon extracted the left-behind items and described to me the "horrible infection" I had been living with for years. He was outraged, and I felt angry and bitter.

I called Dr. Robinson's office to tell him what had happened. His clerk informed me, quite abruptly, that they no longer had my

records because so much time had passed. "Besides, the statute of limitations for suing the doctor has passed."

I hung up, disappointed by such callous treatment.

During one of my follow-up visits to the community clinic, while studying my paperwork, Joan became aware of my financial situation. She suggested the hospital nutritionist might be able to help. "Much of the food here goes to waste because the patients don't eat much. Maybe you could get some of the leftovers. It's perfectly good food."

She offered to talk with the nutritionist for me that evening. The next day, a hospital worker carried large boxes of cooked food to my home. He returned every two weeks with more for about four months.

Joan also told me about a group of Catholic nuns—the sisters of St. Joseph of Orange—who might be helpful. She gave me their contact information and encouraged me to share my story with them.

That evening, I wrote to the sisters and enclosed pictures of myself. A week later, I received a check from their organization for $1,000.

I figured God must want me to continue living since He kept providing for me through the generosity of His people. And if He had a purpose for my life, I needed to find out what it was.

HOUSECLEANING
SERVICES

My friend Thomas called and asked how my surgery in Boston went.

"It didn't work out well," I told him.

He expressed his sorrow for my disappointment. When I asked how he was doing, he said, "I've been walking four miles every morning. I've lost weight, and I'm feeling great. The route I walk takes me close to your apartment. You should join me. I think it would be good for you."

Recalling my harrowing experience at the train tracks under construction, I told him I was surprised that he could get around so well on his own.

"I grew up in this city," he said, "so I can easily find my way around, even with blindness."

I figured walking the neighborhood with Thomas would be beneficial to my health, both physical and mental. I agreed to join him.

The next morning at 8:00 a.m., he and I embarked on the four-mile trek. We enjoyed lively conversation and fresh air, and we had a chance to catch up on each other's lives.

At the end of the walk Thomas said, "I have a little extra money that I'd like you to have. But instead of just giving it to you, I want you to work for it. If you clean the house for Dad and me once a week, I'll give you twenty dollars each time. That way

you'll be earning something instead of just getting charity. I know the amount isn't much, but every little bit helps, right?"

I was excited about the idea of working for Thomas, doing something to help both him and myself. "I'll do it. Thanks."

The following Thursday, Thomas picked me up and brought me to his house to work. At the end of the day, when he gave me my pay, I felt great about having earned it.

After that, whenever people visiting my home expressed amazement at how clean and tidy everything looked, I mentioned that I also cleaned a friend's house for money. Some of them asked if I would clean their homes for pay too. I told them all yes.

Soon I was working in several people's homes. I made beds, scoured bathrooms, tidied up kitchens and dining rooms. The hard work gave me a sense of peace. And it felt wonderful to pay for my necessities with money I'd earned instead of relying solely on charitable donations.

• • •

My landlord introduced me to my next roommate, Steve. He was a sickly man, and the fridge became his medicine cabinet. Steve turned the fridge's temperature down to the level ideal for his medicine. As a result my food spoiled. So I turned the fridge up to a temperature that kept my food fresh. The two of us went back and forth, repeatedly turning the fridge's temperature up and down.

One morning my landlord came to the apartment. "Carol," Sandy said, "Steve has complained to me that you're not being a good roommate. You keep turning up the fridge and destroying all his medicine."

"What about my food being spoiled?"

"The rental contract states that everything in the common area is to be shared equally. You two need to work this out."

The tenuous relationship between Steve and me became even more distant. We passed each other in the apartment without saying a word.

One morning when I walked downstairs to make breakfast, I found the carpet soaking wet. The kitchen was flooded and smelled like sewage. I called the landlord. He came and discovered that during the night Steve had stopped up the toilet. Instead of using a plunger to clear the blockage, he had flushed again, and it overflowed, causing the waste to flood the bathroom, kitchen, and living room.

Sandy yelled at Steve for making such a terrible mess that he had to clean up.

"It's not my fault," Steve said. "I was under the influence of my prescription drugs."

The landlord gave him notice to move out.

"I'll sue for discrimination of the disabled," Steve warned. But Sandy insisted, and Steve left in a huff. I breathed a sigh of relief.

A month later my landlord introduced me to a new prospective roommate, a woman named Jean. He left us to get acquainted. We sat at the dining table and talked. Sandy had already told her a little about me, and I filled her in on some of the details and then asked about her situation.

"My boyfriend kicked me out of the house and left me with nothing," Jean said. "We lived together happily for many years—no problems. I gave him my paycheck, and he paid the bills. That was our arrangement. So everything was in his name—including the house and the cars. Then he found another girlfriend."

I told her I was sorry for her circumstances and then asked if she thought she'd want to be a roommate with someone like me.

"I've looked at other rooms in the complex, and none of them are as clean as yours. I don't know how you do it when you can't see what you're doing."

"From the time I was a child, I watched my mother clean floors, polish furniture, wash walls. She also taught me how to cook and sew. Whenever I have to do those things now, I remember her example. Besides, with the blindness, I've learned to use my other senses to get things done."

Jean asked how I paid the rent, and I told her about my housecleaning services.

"I know a guy whose house needs cleaning. I could ask him if he'd like to hire you."

I was touched by this woman's thoughtfulness.

Jean took my hand. "Carol," she said, "I would very much like to be your roommate."

I told her I felt the same way.

Shortly after Jean moved in, she tried to seduce my landlord. Sandy rejected her advances, telling her he didn't date tenants. Jean was so crushed, she found another place and moved out.

But the friend she recommended my house-cleaning services to still hired me.

• • •

When I wasn't cleaning houses, I continued writing my story. I also sought speaking engagements, but they were few and far between. I occasionally spoke to churches and women's groups without asking for a donation, trusting that God would provide in other ways.

Medical bills came in from Boston every month. I wished I could pay them. But my housecleaning income barely covered my bills.

John, the social worker assigned to me by the hospital, helped me fill out forms and get medicine to me—on some occasions, for free; other times, at a steep discount. But John suffered from heart disease and sometimes couldn't return my calls for weeks at a time.

During one conversation, he told me that my case would be reassigned to another social worker because he could no longer work. I despaired of being able to purchase the expensive anti-rejection drugs.

• • •

On a telephone chat with Mom, I learned that things had changed for the better in our little Jamaican village. New homes had been

built, and more people had moved in. They now had indoor plumbing, telephones, and electric service.

In the background I heard the pitiful cry of a child. The sound pierced my heart.

"Mom, who is that?"

"His name is Nelton. He's five years old. His mother abandoned him shortly after his birth. Grandmother is taking care of him."

My grandmother was a widow, living in poverty. She received no social security or welfare, as seniors in America do. A few of her children, like my mom, helped her some, but not enough to feed Grandmother and a small child.

"She can't adequately take care of herself, much less a toddler."

"There is no one else," Mom murmured.

The child continued to cry throughout our phone call, and I thought I heard a summons from heaven: *Carol, help him.*

My mind replied, *I can't help this child. I'm struggling to survive each day myself.*

The voice told me, *Have mercy.*

I asked Mom to describe Nelton to me.

"His bones were not fully developed at birth, and the kneecaps did not form. I don't think his mother had adequate food to eat during her pregnancy." All that Grandmother could spare to feed the toddler was a little powdered milk mixed with sugar and water—not very nutritious.

"I help as much as I can," Mom said. "Buy a few bottles of formula, take him to the doctor once in a while, and purchase some medicine. But I can't afford to take full responsibility for him."

She told me the villagers disliked him because most people hated his mom. She had a mental problem and slept around with everybody. After giving birth to Nelton, she didn't want anything to do with her son.

My throat went dry hearing his story.

"He is so thin; his clothes hang on him like a scarecrow. He'll starve if no help comes for him soon."

As Mom spoke, I continued hearing what I thought was the voice of God urging me to help this poor little boy. I could almost see his crooked little legs and his distended belly full of pain. But I was a beggar myself. The only clothes I had were what had been given to me.

Still, my heart wrenched with pity. Nelton would come to view life as hateful and monstrous and see himself as a horror. He needed someone to love and comfort him.

Perhaps I was supposed to be the answer to his prayers. Because of my own experience with hardship, I felt very uncomfortable hearing about someone in torture and misery.

I asked Mom to send me pictures of the child.

When the photos arrived, I went about the community showing them and told his story to all I met. Some gave $5 or $10 for provisions.

The children in a Sunday school class, with the help of their parents, held a lemonade and cookie sale. They used the money raised to purchase clothes, Christmas gifts, and food for Nelton. They also held an arts and crafts sale, making Christmas cards to sell. All the money earned went to Nelton.

I journeyed from church to church, collecting donated clothes for him. I showed his picture to numerous people and church groups, hoping to find someone to commit to his aid. I even tried to find someone in America to adopt him. The response was not great.

One day a woman named Lisa came to my home for a visit. As we talked, I felt led to show her a picture of Nelton, along with a letter about his health. I told her of his harsh life.

Lisa agreed to take Nelton's information home with her and see what she could do to help. A few weeks later, she sent Nelton a box of toys she'd collected, hoping to keep him occupied inside the house to reduce the chances of him getting into trouble with the neighbors.

Soon after, Lisa and her close friend decided to take full financial responsibility for Nelton. I praised the Lord!

• • •

Dale called and told me that he and his father had had a terrible fight, and he'd left his dad's house.

Mom had returned to New York and was staying with her cousins. She arranged for Dale to take a train to her. After a few weeks, she bought two plane tickets and brought Dale out to me.

Though I hated the thought of Dale having a bad experience with his father, I rejoiced in having my sixteen-year-old son back home with me. The apartment seemed to fill with new light and happiness, and the air felt fresh and clean.

One day, I noticed the medical bills had stopped coming. Had someone taken care of them? Or was I about to be sued for my overdue expenses?

A few days later, my social worker called to inform me that the Rose Fund had intervened on my behalf, and the hospital had forgiven all my outstanding debts. I was one of only five patients to benefit from that generous organization.

A great weight fell away from my shoulders. Without the continual worry of paying enormous medical bills, I could finally start out fresh.

INSIGHT FOR LIVING

O n New Year's Day 2002, I vowed not to succumb to despair but to believe that doctors would find a cure for my blindness. I refused to remain blind for the rest of my life. I reasoned, *Sometimes the thing we are searching the world for can be found right at the place we are.* I determined to trust God to lead me to a doctor in California who could restore my sight.

One afternoon, a woman named Linda called. She said, "I work with Insight for Living. You sent a letter to the ministry, seeking help. The Evangelical Free Church of Fullerton is attached to Insight for Living. It is close to where you live. If you go there and share your story with them, I'm sure you will get the help you need. Pastor Dave Carder is the senior counselor there. Ask for him."

I thanked Linda and promised to take her advice. One morning, as my blind friend, Thomas, and I were walking on our regular route, a man stopped us. He introduced himself as Hans. He told us we had been walking past his home every morning, and he had been admiring the two of us blind people, talking so cheerfully.

Hans told me, "You should come to my church. It's the Evangelical Free church in Fullerton."

Having received two separate invitations to visit the same church, I felt confident that this was the rock upon which I would make my stand.

Back home, I printed my pictures and my written story and then took a bus to the church—only a fifteen-minute ride away.

Pastor Carder told me about his work with families, especially those affected by divorce and adultery. He said, "For your physical

needs, the Care and Concern pastor is the person you want to see. His name is Jay Williams. Concerning your emotional needs, I want you to see Wally for counseling. He's a retired pastor, and he'll give you one-on-one Bible study. Make an appointment with my secretary to meet with him."

I did as he suggested, then went to see the Care and Concern pastor. He wasn't in, so I left the envelope containing my information with his secretary.

The next day, a woman named Eileen Anderson phoned. "The church secretary from the Care and Concern division asked me to call you. I'm a member of Second Wind, a group of retirees. I can arrange rides for you to doctor's appointments. Whenever I can't take you myself, I'll find someone from the group who can."

I thanked Eileen profusely.

The following week I met with Pastor Wally. He asked me how I was doing.

I answered honestly. "Discouragement is rooted deep in me. My helplessness bothers me a lot. I wonder whether my life makes any sense. What I want most, I can't have."

Wally spoke calmly, soothing my grief and depression. He helped me focus on the present instead of the anguish of a grim past and a bleak future.

"Don't discredit God because you feel pain and suffering. The world is filled with both good and evil—that's the way life is. And we all go through tough times. You're the only person who will travel your exact trail. But in the dark valley of life, you are not alone. The will of God, His purpose and plan for our lives, is unique for every one of us. He does have a purpose for your life, Carol, and it will soon be revealed to you."

I met with Pastor Wally regularly for Bible study. We quickly established a warm, comfortable relationship.

Our lessons often took us to the books of John, 1 Corinthians, and Ephesians. His knowledge of the Bible amazed me. I enjoyed learning more about God and His awesome grace for sinners like me.

Wally told me God loves me beyond my imagination. The verses he shared with me kept me company long after our appointments ended. They cheered my days.

As I continued to attend the church, people extended their friendship, forming a support community for me. Some provided rides to the market, others took me into their homes or out to a restaurant for lunch. I felt a sense of belonging. Their loving-kindness and tireless dedication strengthened my faith.

One Friday afternoon, as I sat in the church lobby waiting for my Bible study with Wally, the entrance door opened. I heard the clicking of heels on the hardwood floor of the office—two sets of feet, one walking heavily and the other lightly. The footsteps stopped at the receptionist's desk, and a woman and man asked to see one of the pastors. The receptionist told them to sit and wait.

From my seat at the far corner of the lobby, snippets of their conversation caught my attention.

"He helped me to see after my horrible car accident," the woman said. "I believe God really works through him." She went on to describe a miracle-working Christian doctor, portraying him as a restorer of sight to the blind.

I walked up to them. "I couldn't help but overhear your conversation. I'm blind. I wonder if you could give me the contact information for the doctor you were talking about."

The woman shook my hand and introduced herself as Melody. "I'm sure Dr. Herrick can help you. He's an ophthalmologist who believes God has called him to use his talent to restore sight to the blind."

She wrote down his contact information for me.

"The Lord can heal every sickness, trouble, and pain. All we have to do is ask. I hear His voice in my head all the time. I know He is going to heal you. Dr. Herrick will restore your sight. You'll see!"

I wanted so much to believe her prediction; I would try again.

A MIRACLE-WORKING DOCTOR

The following week, Melody picked me up and took me to Dr. Herrick's office. He affirmed what she had told me about him.

After examining me, Dr. Herrick suggested I have surgery on my left eye. I'd only had surgery on my right eye, because it had received less damage from the acid. The left eyelid needed advanced reconstructive surgery before a cornea transplant could take place.

Dr. Herrick warned me that the first stage of the procedure, the eyelid reconstruction, would use no anesthesia, only numbing medication. A large leather chair would be my recovery bed.

I was willing to risk any surgery for a chance to see.

Dr. Herrick had years of experience, not only as an ophthalmologist but also as a family physician. I figured as long as I didn't die, the risk was worthy of taking. My thoughts skipped beyond the details to my happy, *sighted* ending. I decided to go for it.

Back home, I started the process of getting money to pay for the surgery. I went to church, planning to tell Pastor Wally what had happened and ask for his help.

When I arrived, I met Eileen. She said, "If you would allow me, I'd like to get to know you better and learn more about your special needs. I want to get involved in your life."

She took me to lunch, and I told her about my visit to Dr. Herrick. We discussed my never-ending medical expenses and the struggles of everyday living.

Eileen took it upon herself to raise funds from the people in her circle of influence. Over the next couple of weeks, through her efforts, combined with collections gathered by the SDA Church and the Evangelical Free Church, I received enough money to pay for the reconstructive eyelid surgery and the cornea transplant.

Eileen drove me to my consultation appointment with Dr. Herrick. As we pulled into the parking lot, she described the office building to me. "Carol, it looks like a shop front. It's in the middle of nowhere—not in a big city. The windows are dirty. The paint is peeling. Everything looks shabby."

But I didn't care what the place looked like. I thought only of the miracle that could come out of this. The hope of sight weighed heavier than her concerns.

On the day of the surgery, the doctor lowered the back of the office chair and asked me to lie down. He and his partner, Norma, strapped my hands down at my sides, then nestled my head into the headrest. I tried shifting to a more comfortable position but could not move an inch. I took a deep breath, squeezed my eyes shut, and prayed for strength to endure the task ahead. I focused on the good that could come from this surgery.

Norma administered painful injections to numb the eye area. Then Dr. Herrick removed the original skin tissue from around the socket and eyelid. The medicine quickly wore off. I wondered if it was so old it had lost its potency.

As the doctor continued cutting away tissue, the agony became unbearable, and I cried out, "Enough! Let me be!"

"Okay," Dr. Herrick said. He injected me with more numbing medicine. "The scar tissue is making it difficult for the medicine to take its full effect. I can't increase the amount any more. I'm sorry. I'll try to go as fast as safely possible."

The pain was so great I believed I'd slipped into hell. But that was only the beginning.

Norma told me the doctor needed skin to cover the area around the eye. She rubbed numbing cream on my inner arm—the donor site.

I experienced an instant of insensibility as the knife in the handheld skin-cutting machine began severing tissue from my arm. But the blade kept bouncing off my arm like a rubber ball.

"This knife is too dull," Dr. Herrick told Norma. "It's not cutting a thing."

I heard his rapid footsteps walk away, then quickly return. A series of clicks told me he had inserted a new knife into the machine. He turned it on—I heard and felt its vibrations—then he began cutting away at my skin again.

Excruciating pain whipped through me. I struggled to pull my arm away but couldn't move. I squealed like a pig being slaughtered. Bitter hatred for Dr. Herrick swept through my heart.

They sewed up the new skin tissue to create eyelids and then bandaged the eye. When it was all over, I told them the surgery was inhumane, hellish, and unnatural. But after three months the eyelid had healed and was functioning properly.

When the time came for me to return to Dr. Herrick's office for my post-surgery examination and to schedule the cornea transplant, I hesitated for a long time. It took tremendous effort to even think about seeing him again. I certainly did not want to consider enduring another surgery with him, but he was the only doctor who had ever suggested doing surgery on my left eye.

I decided to at least meet with him. I wanted his honest opinion about my chances of regaining sight in the left eye.

At his office, Dr. Herrick took his seat in front of me and adjusted the microscope between us. I held on to the patient grips on either side and positioned my head for his exam. It seemed to go on forever, and I caught myself holding my breath at several points.

When he finished, Dr. Herrick said, "You've healed well, Carol. The first part of the surgery was a complete success. I know you must be a bit fearful of more pain, but I assure you, this next procedure is much simpler. It will also be far less painful."

As he discussed the details of the cornea transplant, I felt numb with terror at the idea of undergoing another barbaric procedure in his shabby, makeshift office.

He covered my hands with his. "I promise you Carol, I can restore your sight. You will see again!"

Though I wasn't sure if I could believe him, my shoulders rose slightly, and my head cleared. I felt as if my burdens had lifted. My soul seemed less troubled.

"For your case, I would recommend a cornea from the eye of a child between the ages of two and three," Dr. Herrick said. "A young child's cornea has twice the number of cells found in an adult's cornea. That would double your chances of success."

The thought sickened me. But the hope of finally receiving my sight back was too good to refuse.

Soon after, Dr. Herrick called to inform me that a cornea had become available. He scheduled my surgery.

On the eve of my procedure, I prepared meals and stored them in the fridge. I cleaned my home with anticipation. At midnight, standing in my bedroom, I envisioned my life with no more blindness, no more struggles. A magnificent radiance filled my soul.

In the early morning, I arose, excited about my future. As Linda drove me to the doctor's office, we talked about the things I wanted to do and the places I wanted to visit once my sight was restored.

At the doctor's office, the secretary escorted me into the surgery room. Dr. Herrick again transformed the upright chair into an operating table. He and Norma strapped me down again. Lying helplessly, I shut my eyes and prayed, *Please, God, let this time be successful.*

The doctor gave me an injection in my arm, and I instantly went into a half-asleep mode. After the insertion of numbing drops into the eye, the surgery began. This time, I felt no pain.

After six hours, I got up from the makeshift bed feeling incredibly tired. My head exploded with fiery pain.

Dr. Herrick gave me a snack and some juice, and pills to ease my discomfort. Linda took me by the hand and gently guided me to her car. The painkiller enabled me to have a fairly restful night.

The next day Dr. Herrick removed the bandages. I held my breath in fearful anticipation.

When I opened my eyes, I could see with my left eye! I looked at Dr. Herrick. His eyes sparkled, and he smiled broadly.

I looked around the examination room. The faucet glinted in the bright overhead light. I studied the machine where I had placed my chin on the half-moon support for the doctor to examine my eyes.

Dr. Herrick led me out into the lobby and directed my attention to a flyer tacked on a message board. "Tell me what you can see there."

The flyer said in bold letters, "HARVEST CRUSADE," followed by the date and time. I read it aloud to him, thrilled by my accomplishment. None of the words of gratitude I could think of seemed strong enough.

Dr. Herrick patted my shoulder. With a double-wide grin, I gazed up at him. His expression revealed his excitement at how well I could see.

He asked me to have a seat in the waiting room while he wrote some prescriptions for me. I glanced about the office, noting a few spaces in the blinds where pieces were missing. A small table in the center of the room held magazines. Bright-eyed celebrities, beautifully dressed and with well-toned bodies, graced the majority of the covers. One had a photograph of Hillary Clinton. I'd never seen a picture of her before.

I picked up a few of the magazines and flipped through them. Then I went into the bathroom—without help and without

bumping into anything. I saw the toilet, sink, soap, and towels. Seeing those simple things, which most people take for granted, brought great joy to me.

When Eileen came to drive me home, I stared at her for a long time. She had short blonde hair, combed back and down the sides of her face in a bob. Though she was not remarkably beautiful, I could see her inner loveliness shining through her blue eyes.

My sight brightened more each day. I stared at Dale until he became annoyed with me, but I couldn't help myself. Seeing his young face smiling at me brought unbounded delight. But behind the joy lurked bitterness for having missed seeing so much of the stages of his life.

I watched the television programs I'd listened to over the years. Kathie Lee Gifford fascinated me, the way her body swayed and her legs moved as she sang. I became mesmerized with foot movements. Happy children running, skipping, jumping, and moving in all directions at once drew me to the neighborhood park like a magnet.

When David Crawford came to visit next, I gazed at his face and his silver-rimmed eyeglasses. With a hesitant smile, he asked, "Can you really see me?"

I nodded and grinned. We laughed heartily.

When I met Wally, the pastor I'd been taking Bible study with, I stared at him with open-mouthed amazement. I was surprised to see him stooped over and wearing thick glasses. Not at all how I'd pictured him.

Everything seemed different from my imagination.

I went to Blockbuster Video, purchased the all-seasons set of Tamela's sitcom, and watched it over and over. Once, while I was out and about, I spotted Tamela on the cover of *Esquire* magazine. Inside was an article about her. In the interview, Tamela mentioned me and the Lions Club. I will keep that magazine forever.

THE FOURTH TIME

Standing on the porch of my apartment, watching the sunset with my new eye, nature's beauty held my gaze. Seeing things again after living in a dark, lonely world took my breath away. I clung to my moments of happiness, letting them fix in my memory.

At my desk, I typed a letter to all the supporters on my mailing list, updating them about my sight. I gleefully wrote, "I no longer need to be led everywhere. I am able to get around all by myself!"

I celebrated the miracle of sight, not only because of the long, painful process that was now behind me, but also because God had used so many people, means, and methods to accomplish this success.

About four weeks after my surgery, I experienced pain deep in my eye. My vision gradually became dimmer. The backs of my ears felt swollen. I called upon God, but the symptoms increased.

Afraid I might be losing my sight for the fourth time, I called Dr. Herrick. He had gone to another state, but he answered from there, suggesting I go to the hospital immediately and see a cornea specialist.

David Crawford rushed me to the hospital emergency room at UC Irvine. The ophthalmologist on call examined my eye. She urged me to make an appointment to see the hospital cornea specialist on his next clinic day, which was three days later. When she walked away from my bed, I overheard her phoning the specialist, Dr. Chuck, making an appointment for me.

On Tuesday morning Dr. Chuck examined my eye under a powerful microscope. "You have a bad infection in your eye that, in my opinion, has masked itself for about a month."

It took a few moments for me to generate speech. "I don't understand."

The doctor blew out a long breath and seemed to measure his words. "The infection could have started at the time of the surgery and not shown signs of its presence until now. There's no way of knowing for sure. But now it has taken root."

He handed me a prescription for eye drops and told me to use them in place of the medications Dr. Herrick had given me. I was to use the eye drops every hour of the day and night.

I used the drops as prescribed—depriving myself of sleep, but determined to see again.

Two weeks went by before the infected eye showed signs of healing. I could see images again, though not as bright as before.

I diligently continued to care for my eye, and my sight improved daily. The dawn of each new day brought more hope.

But then one morning I opened my eyes and my sight had diminished since I'd retired. Anxiety washed over me again. Three months after Dr. Herrick's miraculous surgery, my eye felt scratchier than ever.

Dr. Chuck walked me to an examination room. After checking my eye, he said, "The cornea implant has failed."

My heart sank in despair.

"However," the doctor said, "I can see clear spots around it under the microscope. So you can still see through it. When all the stitches are removed, you might be able to see even more. Continue using the anti-rejection eye drops, and in a month's time, I'll take out the stitches. At that point the eye will stabilize, and we'll decide where to go from there."

I sat motionless, absorbing the news of yet another defeat. I felt angry, disappointed, and frustrated. But with the faith of a

child, I held on to hope, believing God would revive my dead cornea and make it alive again…if He chose to.

Grateful for the limited amount of sight I still had, I took the doctor's arm, and we walked to the receptionist desk. I made an appointment to have the stitches taken out a month later.

Alone at home, I picked at my dinner, making up reasons the doctor could be wrong. Perhaps my cornea hadn't really failed. After all, I *could* see somewhat. Washing the dishes, I tried to bolster my courage and resolve.

As I glanced out the window onto the dark street, I hoped a friend would come by and offer to take me out.

No one came.

• • •

Desperate to have some positive motion in my life, I threw myself into writing again. When I had four hundred pages put together, I went in search of editorial support.

I heard about the Orange County Christian Writer's Fellowship and decided to contact them for help in finding an editor. I called the president, and she gave me the phone number and address for a small writing group in my neighborhood.

I called to learn more about their meetings and received an invitation to sit in on one of their critique sessions. If I felt they offered something of value to me, I could join.

The evening of the class I planned to observe turned rainy. Apprehension tormented me as I rode in a cab, fearing the weather portended another failure.

When I arrived, I learned that the rain had kept all but one other participant away from the hostess's house. The participant and the hostess both suggested I buy the *Christian Writers' Market Guide* and go through the editors listed there.

I traveled back home, uncomfortable with the thought of spending money for something that might not work out for me. For several days I pondered the pros and cons of buying the book,

and then decided I had to give it a try. I went to a bookstore and made the purchase. (Had I thought of it, I might have gone to the local library and saved my money.)

At home that evening, I asked Dale to read the entries describing each editor. I felt led to contact Shirl Thomas, even though her services were more expensive than some of the others. With a prayer on my lips, I composed an e-mail to her. My text-to-speech program read the message back to me. I hesitated before sending it off. I felt that if I failed in this attempt to find someone to help me, my story would never be in print. God's message, the lessons of my life, would remain unheard.

Finally, I worked up the courage to click send.

Shirl answered my e-mail promptly, and her words touched my soul. I believed this kindhearted woman was the one to bring my story to the perfect pitch. So at summer's end, I sent her the complete manuscript.

After reading my story, Shirl offered to let me pay for her services in comfortable increments. She was in the midst of editing fifteen manuscripts at the time, so I had to wait for her to get to mine. Once it was my turn, she assured me that my manuscript would receive top priority. I could ask for nothing more.

I shared the exciting news with my mother on our weekly phone call. "It seems too good to be true." I briefly described the process to her. "Maybe this will bring changes to all of our lives."

Grandmother, who'd overheard Mom's side of the conversation, insisted on speaking to me.

"I am all for it, my child."

I smiled, warmed by her unconditional support.

"Big as your handicap is," Grandmother said, "if you have a mind to work and make something of yourself, you can do it."

After our conversation, I no longer worried that time was running out with me going nowhere. I had a goal. I knew my direction.

E-mails zipped back and forth between Shirl and me, with her asking for clarifications and explanations of every little point. Sometimes my explanations required explanations.

Strengthened and encouraged by our progress, I continued to rewrite, and Shirl continued to tighten. Sometimes I felt ashamed of my poor writing skills, but I would do whatever it took to have my story published.

The difficult and time-consuming rewriting and editing process surprised me. I was grateful to be living in America, where resources to write a book abounded. I knew I would reach my goal.

• • •

When Dr. Chuck removed the stitches, I experienced a sense of release. The tightness that had been pushing on my eyeball since the surgery was gone. The eye pressure lessened. Yet my vision remained the same. Although I wanted more, I rejoiced that it had not decreased.

I remained marginally hopeful of a full recovery.

My sight was still cloudy but constant, and I enjoyed everything I could see. I prayed and applied the medication as prescribed.

On my follow-up appointment, the receptionist informed me that Dr. Chuck had moved his practice. An out-of-state hospital had offered him a position he could not refuse. Because his gentle wisdom and knowledge had soothed the rough edges of my path, I felt almost desperate to see him, but there was no way I could.

I accepted my life while, at the same time, clinging to the promise of a happy ending.

DALE'S TEEN YEARS

I was thrilled to have my son living with me, but I found myself facing the additional financial burdens of raising a teenager. Of course, he wanted what all the other kids his age had: clothes, spending money, a car, etc.

Dale had grown up quite a bit in New York. He had even discovered romance. He'd fallen for a classmate, a Nigerian girl named Chichi. She was enrolled in medical school, and her family had placed restrictions on her personal life. She was expected to study and was not allowed to date. Nevertheless, she decided she wanted to date anyway.

After school, she and her friends watched Dale and his teammates play soccer. Following a game one day, they all went to a fast-food restaurant where Dale and Chichi got to know each other. When he asked her out, she immediately said yes. They'd been dating for some time when Dale decided he could no longer live with his father. Their separation had been difficult for both of them.

Dale conversed with her over the phone from California almost every night for hours on end—stretching my limited budget to the max. Chichi called Dale more often than he called her, which helped with some of the long-distance expense.

One day Chichi's mother checked the phone messages and heard a message from Dale. She told her daughter to end the relationship immediately. When the time came, Chichi would

marry a Nigerian Catholic, just as her mother and generations of women before her had done. When Chichi complained about this, her parents sent her to their homeland so she could cleanse Dale from her heart and learn about her African culture at a prestigious boarding school.

My son was devastated. He moped around the house for weeks. I wondered if he regretted having left New York to come live with me, but he never said a word about that.

• • •

After Dale went to school every morning, the house seemed too quiet. I sat in my living room and stared out the window all day, sensing the sun shining on my skin. Even the sounds of my breathing seemed loud.

I got down on my knees at night and talked with God. "Why didn't You make the miracle happen for me, like other blind people whose sight was restored?" I heard no answer. Despondently I committed myself to the care of heaven and sluggishly crawled into bed. Then I would toss and turn in anguish all night.

In my dreams, I saw myself in school, writing final-exam papers. I sat in the back of the classroom, desperately trying to measure up. But no matter how hard I struggled, I could not answer even one of the questions.

"Failure! Failure!" rang like a death bell in my heart.

Then I awoke, my heart throbbing, goose bumps all over my skin, swamped with an overwhelming fear I could not combat.

When dawn broke and I felt the heat of the morning sun, I once again took possession of my senses. I wiped the sweat from my forehead, jumped out of bed, and prepared breakfast.

However as I went about my daily chores, dissatisfaction hounded me. The urge to try something new to support myself overwhelmed me.

I discussed my plight with some friends. They suggested I consider taking care of the elderly in their homes, but I would not

be able to read the prescription labels or medical instructions, and I could not drive my charges to their doctors' visits.

. . .

Dale came home one night and told me one of the teachers at his high school had taken him aside and had a heart-to-heart talk with him. Apparently Dale was not doing well in school, and he was hanging out with the wrong crowd. This teacher, Sal Tinajero, told Dale that when he was his age, he too was on a bad road. A man in his neighborhood did not like the path he was taking or the people he hung out with. But the neighbor believed in him and said the possibilities for his life were endless if he would only apply himself.

The neighbor's encouragement caused him to bring about change in his life. He went to junior college and later got a scholarship to Bradley University in Illinois where he earned a bachelor's degree in communications. He had even received a Teacher of the Year award. If not for that neighbor's guidance in his youth, Mr. Tinajero would not be living a respectable life with a family. Now he wanted to pass on the same kind of blessing he received to my son.

Dale said, "Mr. Tinajero wants me to join the speech and debate team. He says it'll do me good."

I encouraged him to follow his teacher's advice, grateful that this man had decided to take Dale under his wing and try to straighten him out.

Dale grew obsessed with speech and debate. He spent so much time researching and practicing that he ignored his other academic work. I told him he needed to have balance. Speech and debate was good, but his overall academic achievement had to be the first priority. He needed a well-rounded education to provide adequately for the future. I encouraged him to spend more time on schoolwork.

Nevertheless he continued participating in speech and debate contests as if there were nothing else in the world. Our living and dining areas became overrun with trophies and certificates and diplomas.

Dale entered the Lions Club and Rotary Club regional competitions. He beat all the other participants and won two monetary prizes of $500 each. David Crawford strutted about, proud as a peacock over Dale's success.

Mr. Tinajero decided to run for council in the City of Santa Ana. He asked Dale to work on his campaign, passing out flyers and the like. Things had definitely turned around for my son, and I felt grateful to the man who had stepped up and become such an integral part of his life.

If only I could find such success.

• • •

Determined to discover a business where I could prosper without eyesight, I switched on the television, hoping something would inspire me. I flipped through the channels, listening for God's gentle leading.

An infomercial for a business opportunity caught my interest. A company was recruiting vendors for their inventory. They sold a wide range of products for the home and garden: flower pots and stands, wall plaques, sculpted figurines, fountains, scented candles, vases, picture frames, refrigerator magnets, pens, pencils, clocks, music CDs—all kinds of odds and ends. The announcer described a catalog listing hundreds of items.

I listened keenly to the enthusiastic sales pitch, feeling this opportunity fit my situation perfectly. I could get some dear friends together to help me in my new venture. With their sight and my brain, I envisioned taking the first step toward again operating my own small business.

Barely daring to hope, I contacted the marketing corporation, SMC, and paid three hundred dollars to register as an independent

sales representative. They supplied me with catalogs and set up a basic website for my new business.

I hosted sales parties at people's homes. Customers looked through the catalogs and selected items to purchase. My friends checked invoices, counted money, and made deposits to the business account. I placed orders via the computer, and the company shipped the products to my customers.

My first year in this business turned out well, and I swelled with pride. I had such good success that the company refunded the registration fee I'd paid to join their team.

My landlord complained about UPS delivering so many boxes to my doorstep, saying he'd not rented me business space. He ordered me to quit or move out. I asked him to let me sell off the merchandise I already had in storage. I would have any new orders delivered directly to the customers or shipped to the homes where I would be having sales parties. Sandy reluctantly agreed.

Eileen contacted the women's ministry at church and asked if I could display my home-and-garden merchandise at the homes that conducted the church's garden tours. The leader agreed. That event was a tremendous success for me. I sold almost all the inventory I had in storage.

· · ·

Dale went searching for a job. He perused the want ads and contacted friends for referrals.

A member of the Lions Club who was part owner of a commercial graphic arts business mentioned to David Crawford that he needed some part-time help in his warehouse. David recommended my son for the job. The man hired Dale to assist the accountant and file papers. Dale was thrilled to have a chance to earn his own money. After school, he took a series of buses to his job, and one of the partners drove him home.

After a few weeks of this, Dale told me how much better things would be if he had a car. I signed him up for driving school, which he attended on weekends.

My business didn't provide enough income to afford such a luxury as a car. I'd heard on the radio that people donated their old vehicles to help the needy. The Catholic Car Charity of St. Vincent DePaul invited me to their automobile lot in Santa Ana. There a salesperson showed me various cars in different price ranges—from $400 to $4,000. None were free.

Disheartened but still determined, I went through my telephone book and called people who had helped me in the past, asking if they knew anyone who had an old car they'd be willing to donate. Tamela Johnson's mother, Dalena, said she might, but made no promises.

A few days later, Dalena's other daughter, Colleen, called to tell me she had just refurbished a car that had been sitting in the garage for years. She'd planned to sell it, but decided she wanted to give it to my son instead.

The next Saturday, Thomas's girlfriend drove Dale and me to Colleen's home. Colleen provided insurance for a year, paid for the registration, and gave Dale a one-year Auto Club membership. I felt incredibly blessed by the continual outpourings of Tamela's wonderful family.

MOVING ON

Once Dale had a car, life became easier for us. We could finally go places without having to find a friend to drive us. After about five months of working at the warehouse, Dale quit. He told me he hated his boring job. He was a people person.

Speech and debate propelled him into the local junior college, and he judged competitions for the high-school students. Eventually, one of the schools hired him to coach their speech and debate team. Off season, he worked at a hamburger joint. It helped pay for his education, but nothing beyond that.

Members of the high school speech club came to the apartment with boxes of files to work on cases before their competitions. Dale introduced me to one of his debate partners, a girl named Poojah. He started spending a lot of one-on-one time with her, in addition to the hours they spent on events associated with the speech club. Soon his school grades began to slip.

"Dale," I said to him one day, "it's normal for young people to think that a relationship with someone of the opposite sex will bring nothing but joy and happiness, with no consequences, sorrow, or pain. You learned that's not true with Chichi. The same kind of thing may happen with Poojah too. Her parents could decide that you don't fit their image of the kind of young man their daughter should date. Or Poojah may find someone more to her liking and break up with you. These things happen."

I thought about my ex-boyfriend, Carlton, who'd left me shortly after my acid attack, unable to stand the sight of my deformity. I had invested a great deal of my time and my heart in someone who hadn't stuck around when trouble hit. Of course, I also thought of Donald and all the heartache he had caused me.

"Are you trying to tell me I should never have a girlfriend?" Dale asked.

"No, Son. I'm just suggesting that you not spend all of your time with her. Don't neglect your schoolwork. Whether things work out between you and Poojah or not, your education will be instrumental in helping you live a life of ease and pleasure."

I didn't know whether my words had any effect on him, but I felt better having spoken to him about this sensitive subject.

• • •

I continued working hard to keep my head above the flood waters of month-to-month expenses, but in the ensuing months, my sales dwindled. Curious, I got on the computer and typed in the key words for my own website. Hundreds of similar businesses popped up. So many people all doing the same thing I was!

Weighed down by despair, grim determination took the place of hope. Nevertheless I did not let my discouragement break my spirit. I believed I could still find a silver lining behind the dark clouds. I made a conscious decision not to wallow in sorrow but to keep trying.

I had to find ways of advertising my business. Marketing companies constantly e-mailed and called me with offers to promote my business, but their monthly service fees were too high.

I continued marketing my business by word of mouth within the community and started handing out flyers with my website address.

Most of the people I approached responded negatively. Some told me I was wasting my time, implying that I was foolish to think I could rise above the average. I made myself ignore them. I had enough inner strength to determine my own worth and not be swayed by others' judgments of my accomplishments.

As sales continued to decline, I feared the defeat of my worldly dreams. Heartbreak and despair swept over me as I evaluated the second quarter of my second year of business.

Friends from church held meetings to strategize how they could help. One of the small groups, Sunlight Fellowship, took me on as their summer project, supplying groceries to my home. Karleen, a member of this group, came weekly with her teenage daughter, loaded down with groceries from a nearby market. They even assisted in putting the items in my cupboards.

Afterward, we sat on the sofa chatting. I learned that Karleen taught college English. She also helped unfortunates in the community by teaching them how to write job application letters.

When I told her of my desire to have my life story published, Karleen said, "I edited my husband's first book years ago." She told me she believed my story was worth telling. "Your tragedy is over and done with. This a new season, and you need to move on. I believe God will restore your life and bring you out better than you were before." I thought of Shirl editing my book.

I believed Karleen's words were counsel and encouragement from God.

When the sales of my small business continued to decline, I had to start the laborious fundraising process again. I wrote to the people on my mailing list, and my friends wrote to their friends and the people in their circles of influence. I trusted in God to meet my needs. Through Him, people graciously and liberally released their treasures to my cause.

One day in December, Pastor Wally's long-time friends Bob and Judy visited him at his home. During their conversation Bob told Wally, "It's December, and I'm feeling generous. I have ten thousand dollars I'd like to give away, but I'm not sure who it should go to."

Wally told Bob, "I know just the right person for that money." He shared my story with Bob and Judy. They said they wanted to meet me.

The following Saturday evening, Pastor Wally and his wife, Betty, brought Bob and Judy to visit me. They gave me a gift of fresh strawberries—in December! Betty handed me a vase of cut flowers from her garden. Dale came out of his room long enough to say hello, then returned to continue with his schoolwork.

I'd never had so many guests at one time. The only nice seats in my home were four dining-table chairs. (The young man who'd rented my apartment when I was in Boston had stained my sofa so badly that even after the landlord had it cleaned, I didn't want it, and I'd donated it to charity.) So I brought a plastic deck chair in from the porch, and we all sat around the table.

I felt them all staring at me, their invisible fingers turning my face side to side, but they spoke in friendly tones. I flushed with embarrassment.

At their urging, I described my childhood in Jamaica, told them about my family, and shared some of the history of my country.

"You amaze me," Betty said. "There's always a smile on your face. Like you are content with life."

"That's God's love shining through me," I replied.

I became more relaxed with my new friends as they opened their hearts to me. I was pleased that they shared the details of their lives with me. But as I listened, I felt more aware than ever of everything I lacked. I would never enjoy the luxuries they had.

"Carol," Judy said, "I noticed you have a little potted garden on the porch. I have beautiful gardens at home; I'd love for you to see them. I'd also like you to meet the rest of my family. Perhaps you could come to our home for a visit at Christmas."

"I would love that."

On Christmas morning, I joined Bob and Judy for breakfast. Bob baked cinnamon bread from a traditional recipe he'd enjoyed as a child. I also visited Judy's gardens and greenhouse. The family welcomed me like I was one of their own.

A few days later, Bob's son stopped by with a sofa. The next Friday, at Bible study, I learned that Bob had given Wally $10,000

to put toward my charity account. Their generosity renewed my faith yet again. To express my appreciation, I wrote to Judy, "I praise God every day for your good deeds on my behalf. You have refreshed my faith in the Lord. I pray that God continues to bless you as you have blessed others."

Judy wrote back, "We are grateful that God brought you into our lives through Wally. You have the will to persist and endure."

I had been given so much. I hoped I would be able to give back one day.

GIVING TO JAMAICA

Through the care-and-concern ministry of the Evangelical Free Church of Fullerton, a couple offered to pay my rent for three years. I moved to a new apartment across from the church. It was a much nicer place than the one I'd lived in for over ten years. Whenever I heard about a disaster on the news and I learned that generous, kindhearted people were offering victims food, medical equipment, and supplies, I often wondered if I could solicit similar contributions for the hospitals back home in Jamaica. I wanted the people of my birth country to taste a little of the generous gift of giving I had found in America.

One day Eileen took me out to lunch. Since she worked with several charities, I told her of my desire to find an organization that provided medical equipment and supplies to poor countries around the world.

She told me she served on the board of an organization called Giving Children Hope. She promised to share my desire to put Jamaica on the list at the next board meeting.

A few days later Eileen took me to meet the Giving Children Hope president and his wife. The couple interviewed me, with Eileen at my side. The president told me that he had been to Jamaica and knew what life was like there. After one of the country's worst hurricanes, he'd taken a shipment of tin roofing material to the victims.

He invited me to share my testimony at Giving Children Hope's first annual fundraising banquet.

At the banquet, I spoke of the degree of poverty suffered by most of the population of Jamaica. I contrasted the hospital where I'd stayed in Jamaica with the ones I'd visited in America. People in the audience gasped at the terrible conditions, deeply touched.

As a result of my presentation, Giving Children Hope agreed to send prescription medicine, medical equipment, and supplies to Jamaica.

Mom went to the Annatto Bay Public Hospital, ten miles from my village, to get me the contact information for the person in charge of receiving donations. I called the man and told him of my goal for the hospital. He forwarded all the information that Giving Children Hope had requested in order to ship and airfreight the much-needed items.

Eileen raised the money from her family and friends to pay the shipping costs. The organization air-freighted a large amount of prescription medicine from Europe, as well as a forty-foot container of medical equipment and supplies from America, to this hospital.

I rejoiced in the assistance I'd been able to provide through the help of my faithful friend and mother figure at the Evangelical Free Church of Fullerton.

● ● ●

Dale brought up his grades in junior college. His life seemed to be going in the right direction, and I relaxed some of my maternal vigilance.

Shirl continued to pick apart my writing, asking question after question, putting my words into proper order, finding several inconsistencies along the way. Sometimes I would share more than necessary with her in order for her to understand my life, my birth country's customs, and my internal struggles. She patiently sorted it all out.

I'd asked God, "Why?" many times. Now, after sixteen long years, I caught a glimpse of His plan for my life.

Writing brought me freedom from anxiety and grief. At night, as I lay in bed, I dreamed pleasant dreams of my future. I began to understand some of the things I had to do with my life and how I could honor God through writing about my experiences.

In the mornings, as soon as I rose, I meditated. I painted beautiful pictures in my mind, which I later transferred into words. A smile lit my face as I wrote. Finding meaning in every moment of existence, in every memory and every possibility, would now mold my future. In His timing, God would redeem everything I had gone through for His glory.

GATHERING OF FRIENDS

Sitting in a booth at the Olive Garden restaurant, I was thanking Eileen for taking me to lunch. Eileen said, "Carol, there is a special reason for this lunch today. I wanted to surprise you with some good news. I, and many others, realize you have not had much joy in your life.

It seems to us that the miracle of sight and restored beauty will not happen. You are at the bottom, so there is no place to go but up. Your life is worth living with dignity. Your circle of friends has planned a grand celebration party in your honor. We have named it 'Carol's Life Celebration!' We all love you and want you to remain in that beautiful apartment that is so convenient for you. Your friends do not want you to live with a sympathy vote the rest of your life. We don't want to see you playing the victim role either. *You are a survivor!*"

My expression was one of bewilderment; I could hardly believe what I heard. I could not understand why these folks cared how I survived in my daily life. I would have never suggested a fundraising party for me; however, it certainly was the answer to a great need I had.

Eileen continued, "There will be a lot of planning and work for this event to happen, but we are ready.

I considered the cost of living at the apartment for two years. It came to about $30,000. *That's a lot of money,* I thought.

Eileen continued, "I wish you could see just how beautiful your apartment complex is. Grounds are well-kept, surrounded by beautiful flowers, and there's a large pool in front of your apartment; you walk across the street, and you are at church. We are doing this because it's what we want to do and because we're able to do it. Two years from now, we prayerfully hope you can live an independent life, depending on your own resources, taking care of your own needs."

I responded with my excited thoughts, "Eileen, I have lived such a good life since coming to California, and now this show of love from many friends who will celebrate me. I will work with the goal my friends have set for me: within two years to emancipate myself from the act of begging for donations."

Eileen said, "Giving does come with expiration dates. This party is to point you to independence."

I smiled a big, warm smile of gratitude to Eileen's words. "I am amazed by the abundance of blessings I have received since my affliction. My circle of friends knows what's best to do for me. Not having to think of rent for my apartment for two years is the greatest gift to receive."

I considered that this was an affirmation that my life would take an upward turn; I was cut out for something other than a victim role and being poor. My future is in my hands, and no one else but God and I myself are going to make it happen for me.

As I left the car, I said to Eileen, "I will never understand the things God does. This act of kindness doesn't happen every day. God allowed me to experience the bad side of mankind, and now He is letting me experience the best of mankind."

Eileen replied, "He is God, and He is sovereign. You and I are mortals with finite wisdom and will never understand the ways of God. You and I will roll with life."

The night finally arrived. As the dusk was turning to darkness and the stars were coming out in a clear beautiful sky, Lisa picked me up for the party. We entered the parking lot to loud playing of

Calypso music, delicious aromas of jerk barbecue, scented candles, and coffee. I entered the crowded party room in a new flowery print dress, Lisa's elbow guiding me slightly. All around me people called my name. "They are waving to you, Carol; they want you to know they're attending this celebration," Lisa whispered. I couldn't see their waves, but I could feel their warmth. I realized there was no pity among them; they accepted me as their equal, and I was being celebrated!

Lisa took me around the different tables to greet the well-wishers. She described the table tops decorated with island décor. Going about the tables saying hello to the four hundred guests, it was almost like being at a wedding where people turned around to see the bride. They told me I looked lovely in the lights.

The care and concern pastor of the church, Jay Williams, led in the blessing of the meal, also praying that the folks would give generously for my need. It was a warm and heartfelt prayer. Our missions pastor, Dan Crane, was to be the emcee in full Jamaican outfit, including a Rastafarian wig. He was hilarious using his Trinidad brogue to sound like the great Jamaican music star, the legendary Bob Marley.

Susan sang two beautiful songs from South Pacific in her lovely soprano voice. Jonathan and Natalie sang to me Harry Belafonte's "There's a Hole in the Bucket, Dear Liza." Jonathan came near me, and then sang, "You Are So Beautiful to Me." Imagine that! He was not seeing a woman with many scars and her eyes blind and distorted. I felt myself smiling widely with that slightly questioning way. The evening ended with my favorite hymn, "Amazing Grace."

The voices of the four hundred singing friends soared up to the heavens with the balloons. Smiling joyously, I sang with the four hundred voices as if there were no ending. At that point I lost it. Knowing the money for two years' rent at the apartment was raised, I was having tears of great joy. It was a wonderful party.

I would be secure in a lovely, safe area. The Lord was planning every detail and all the timing for my life.

The greatest surprise of all was realizing that all of these folks who came and cared for me were not "fair weather friends" but forever friends who loved, admired, and respected me. This was surely from God. He alone could turn my life into such a full life of contentment. Overwhelmed with the love I experienced, I felt compelled to address the gathering. I rose to my feet, and said, "Friends, "If a tree is cut down it can sprout again, for its tender shoots remain. Though its roots may grow old and its stump may die, at the scent of water it will bud and bring forth branches. This night bears the proof that God does deliver me in my affliction. I am filled with hope. Thanks for giving me the best of yourselves.

Many nights, as I lie in bed full of dreams for my future, I look forward to being able, with God's help, to financially support myself. In the meantime, life is overflowing with God providing for my needs with bountiful surprises.

 e|LIVE

listen|imagine|view|experience

AUDIO BOOK DOWNLOAD INCLUDED WITH THIS BOOK!

In your hands you hold a complete digital entertainment package. In addition to the paper version, you receive a free download of the audio version of this book. Simply use the code listed below when visiting our website. Once downloaded to your computer, you can listen to the book through your computer's speakers, burn it to an audio CD or save the file to your portable music device (such as Apple's popular iPod) and listen on the go!

How to get your free audio book digital download:

1. Visit www.tatepublishing.com and click on the e|LIVE logo on the home page.
2. Enter the following coupon code:
 6f42-a31a-44cb-5912-48dc-69ed-8348-2b54
3. Download the audio book from your e|LIVE digital locker and begin enjoying your new digital entertainment package today!